Art Escapes

Daily Exercises and Inspirations for Discovering
Greater Creativity and Artistic Confidence

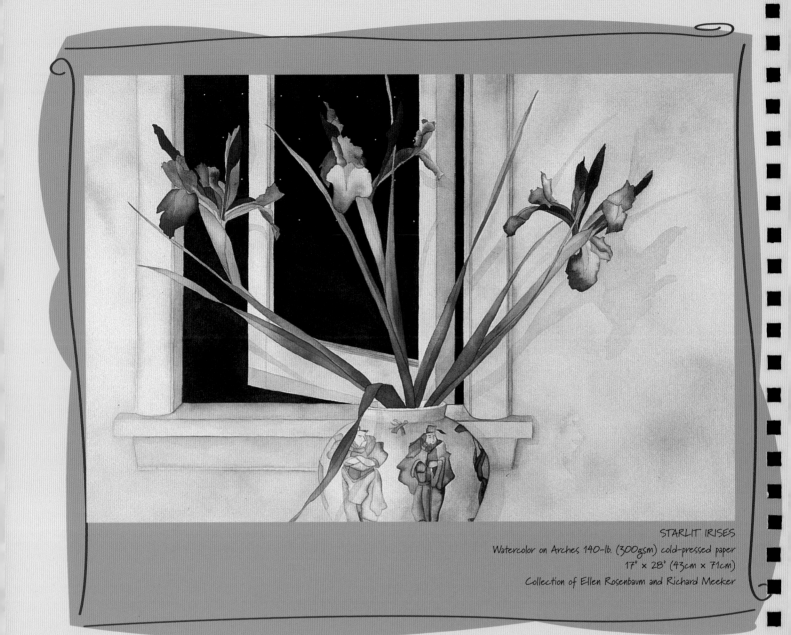

STARLIT IRISES
Watercolor on Arches 140-lb. (300gsm) cold-pressed paper
17" × 28" (43cm × 71cm)
Collection of Ellen Rosenbaum and Richard Meeker

Art Escapes

Daily exercises & inspirations for discovering
greater creativity & artistic confidence

Dory Kanter

NORTH LIGHT BOOKS
CINCINNATI, OHIO
www.artistsnetwork.com

About the Author

Dory Kanter earned her master's degree from Reed College and is a noted artist in the American Northwest. A member of the Watercolor Society of Oregon since 1985, she is the recipient of many awards and juried honors. Her work is found in private and corporate collections throughout the United States and overseas. She is the illustrator of three creative educational CD-ROMs, and a children's book, *The Bear and the Blackberry*. While on sabbatical with her family, she lived for a year in China and a year in Greece, and exhibited extensively while abroad. She teaches painting and journaling workshops throughout the Pacific Northwest. Dory has a well-earned reputation for being a motivating art teacher; her workshops speak to and inspire beginners as well as experienced professional artists. In 1995, she founded Art World Tours, and has conducted painting tours to Provence, Corsica, Italy, China, Greece and Turkey. Her work is shown in Portland, Oregon, at her studio and at the Portland Art Museum sales gallery. Visit her website at www.dorykanter.com.

PHOTOGRAPH BY COLLEEN CAHILL

Other fine North Light Books are available from your local bookstore, art supply store or direct from the publisher.

07 06 05 04 03 5 4 3 2 1

Library of Congress Cataloging in Publication Data
Kanter, Dory,
 Art Escapes : daily exercises and inspirations for discovering greater creativity and artistic confidence / Dory Kanter.— 1st ed.
 p. cm
 Includes index.
 ISBN 1-58180-307-9 (hc. : alk. paper)
 1. Art—Technique. 2. Notebooks. I. Title.

N7430.5.K35 2003
702'.8—dc21 2003042075

Edited by James A. Markle
Designed by Wendy Dunning
Production art by Christine Long
Production coordinated by Mark Griffin

METRIC CONVERSION CHART

To convert	to	multiply by
Inches	Centimeters	2.54
Centimeters	Inches	0.4
Feet	Centimeters	30.5
Centimeters	Feet	0.03
Yards	Meters	0.9
Meters	Yards	1.1
Sq. Inches	Sq. Centimeters	6.45
Sq. Centimeters	Sq. Inches	0.16
Sq. Feet	Sq. Meters	0.09
Sq. Meters	Sq. Feet	10.8
Sq. Yards	Sq. Meters	0.8
Sq. Meters	Sq. Yards	1.2
Pounds	Kilograms	0.45
Kilograms	Pounds	2.2
Ounces	Grams	28.4
Grams	Ounces	0.04

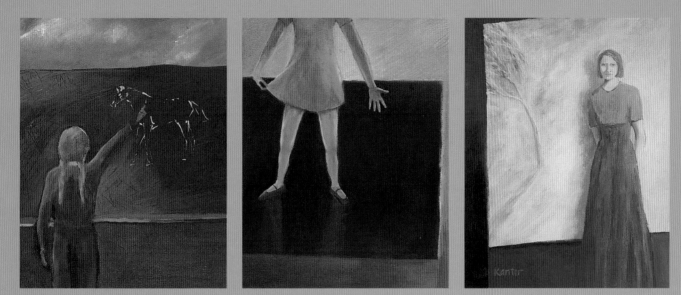

Self-Portrait: Discovery, Inspiration and Resilience

A Note From the Author

Several years ago at a painting workshop, a student asked me a thought-provoking question. She wanted to know if it was difficult for me to let go of my paintings. I told her that I love when people enjoy my paintings in their homes and offices, but my artistic journals are different. I would never let go of them. They are a personal, private legacy I like to keep close by me. I was quite surprised by the strength of my emotion as I said this! At that moment I became vividly aware that my daily artistic journals ground me, comfort me and inspire me.

The freedom I feel in my journals reminds me of the playful way I entered the world of art. When I was eight years old, I discovered the miracle of mixing red and blue paint. The self-portrait on the left shows me making finger outlines of horses in the night sky with my newly discovered purple. Whether you're eight or one hundred and eight, I hope the creative exercises in this book will help you to discover the joy of creating personal art, every day.

Dedication

This book is dedicated to my mother who showed me how life is enriched by art. Her hands were always creating beauty: spirited piano music, hand-made clothing for me and my dolls, quilts, china paintings, ever-evolving gardens, and food that warmed the body and heart.

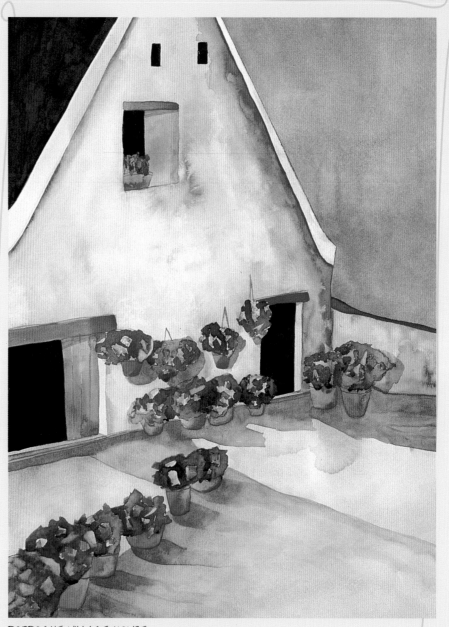

DORDOGNE VILLAGE HOUSE
Watercolor on Arches 140-lb. (300gsm) cold-pressed paper
27" x 20" (69cm x 51cm)

Acknowledgments

First of all, my heartfelt thanks go to my husband, Steve, for believing. You sweetly tolerated my long hours at the computer and studio, faithfully guarded my quiet work time and never wavered in your confidence in me. Thank you to my cherished children, Jordan and Laura, for your constant encouragement. You both inspire me by example to escape the ordinary.

I want to thank my loyal circle of friends who guided me, supported me and cheered me on during the writing of this book. Thanks to each of you for understanding all the times when I couldn't come out and play! I want to especially acknowledge my friend, Kelley Petkun, whose enthusiasm, creativity and wit helped me launch this project. A big hug and thank you to my dear friend, Andrea Baker, who always made time and always found the diamonds in the rough drafts. Special thanks to Rick Samco, who got me over my photography phobia. Much appreciation to Bob Cantor for answering my phone calls with burning questions, day and night. Lots of love to Bill Baker for nourishing my soul with the world's best barbecued chickens. And many thanks to Karin Harris, studio partner extraordinaire, for your dancing paint brush and spirit.

I want to thank the contributing artists, Jeanne Henry, Gary Hang Lee, Sue Greenbaum, Karin Harris, Ann Smith, Robert Cantor, Monica Wheeler and Laura Kanter for generously sharing your artistry and incredible ideas with me. My gratitude also goes to my CD buddies, Bob Dylan, Sade, the Grateful Dead, Miles Davis, J.S. Bach, Maurice Ravel, Paul Simon, Bob Marley and Josh Groban who provided musical companionship in the studio.

Many thanks, Rachel Rubin Wolf, for seeing the light of a book in my work, and helping me find the right focus and direction. And, finally, boundless gratitude to my wonderful editor, Jamie Markle, who gave me advice when I needed it, always trusted in me, and gently guided me through the process of creating this book. You unfailingly encouraged me to show my true colors and write the book within me. I could always count on your humor, patience, compassion and wise answers to a million questions. Thank you, Jamie!

D Kanter

Table of Contents

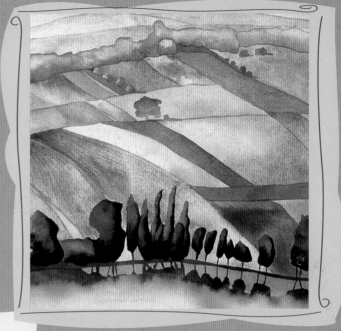

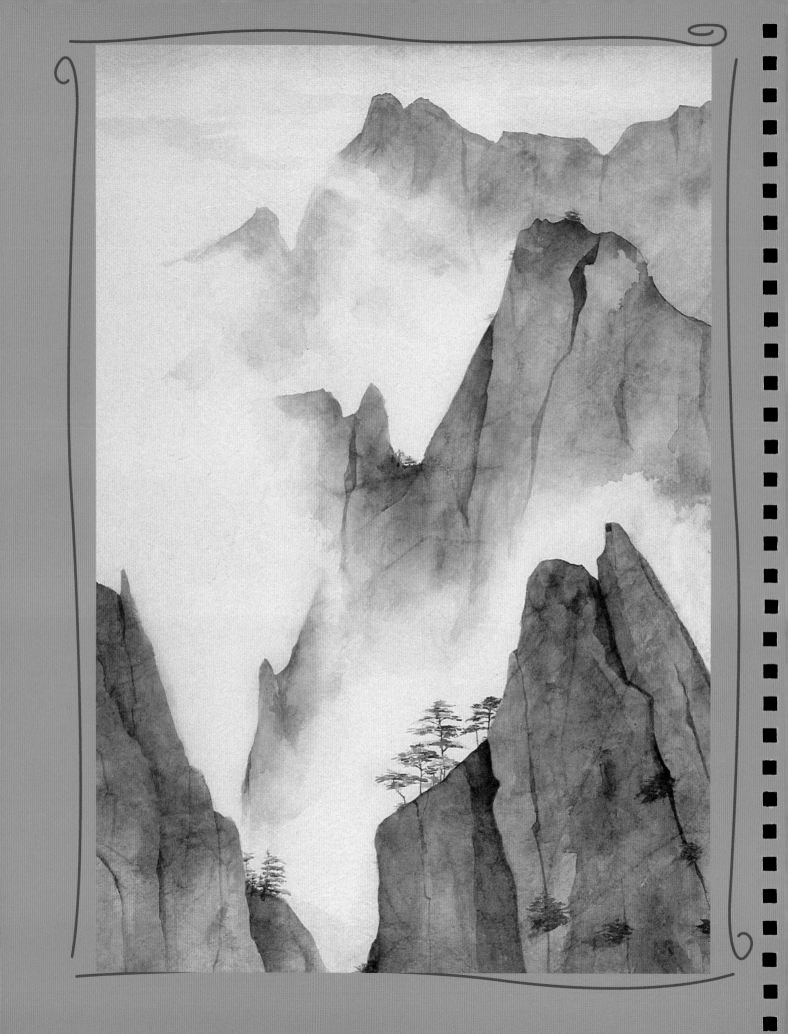

The more I draw and paint, the more I value what I call private art—daily creative exercises in my artistic journal. They are an account of ideas, questions, dreams, explorations and experiments of the hand and the heart. They are a witness to an awakening to the full spectrum of ordinary life. They mirror the gentle stirrings of the eye, mind and soul. And, they are done with no thought of public viewing.

I believe there are two purposes for keeping an artistic journal. First, you want to record personal sensations, whether at home or away. And, secondly, you will accumulate a cache of remembrances to develop further, if you choose. The important thing is to do at least one page each day. Write all over the page, or not at all. Use color, or shades of gray. Use pencil, pen, collage or watercolor. Make quick notations or fully developed paintings.

Many years ago, my son's four-year-old playmate asked me what I had done that day. I told her that I painted a flower. "Oh," she said, "wasn't it pretty enough already?" Her fresh and natural response delighted me. She had the enviable gift of still being startled by life. One of the joys of being an artist is an excuse to look at life closely, and to nurture a sophisticated innocence. The replenishing solitude of my journaling practice revives my own four-year-old beginner's eyes.

Try a different *Art Escapes* project every day. This is an idea book of creative exercises organized to make it easy to have success making art—wherever and whenever. The only rule for the artistic journalist is that there are no rules. Results are not important, creativity and innovation are. Cultivate a curiosity of the ordinary and a passion for everyday life. Give wings to your playful creativity with *Art Escapes* in your own artistic journal!

The palest ink is better than the best memory.

Confucius

YELLOW MOUNTAINS, CHINA
Watercolor on crinkled Masa paper collage mounted
on Arches 140-lb. (300gsm) cold-pressed paper
20" x 13" (51cm x 33cm)
Collection of Eloise Spiegel

Secrets to Successful Artistic Journaling

A journey of a thousand miles begins with a single step.
~ Confucius

A journal of a thousand images begins with a single page. Reframe everyday activities into artful expressions in your artistic journal. Gently filter art into your life at the same time you build a momentum of artistic confidence. Stop, relax and claim a moment each day for creativity. My artistic journal practice helps me isolate moments of awareness, and the creative avenues to reveal them.

How to Make Art Everyday
Make it your personal practice to create a page in your journal—each day. It can be a sketch, a collage, a poem, a quote, a memory or any combination that fits your mood. Research shows that if you do something consistently for a month, it can become a habit. Who doesn't want to develop an art habit?

June 14

Last night the stars winked at me.

Honor an Event
Fill a page to mark an occurrence, an encounter or moment that is important to you—whether contemporary or past, private or public, with or without explanatory text.

QUANTITY EQUALS QUALITY—In my experience, the more you paint and draw, the more your skills of expression grow and blossom. Your artistic journal is the perfect place for permission to paint and draw without judgment. It's simple: The more you do, the better you get. Rather than getting stuck focusing on perfect results, focus on having fun filling up the pages of your journal.

JOURNAL BUDDIES—Share your journal with friends. I get together with a group of journal artists once a month. We show each other what images we've each put into our artistic journals during the month, encourage each other's efforts and share great new ideas.

ADMIRE YOUR JOURNAL—Open your artistic journal and admire past pages. It's marvelous to see what pops up in the messages you send to yourself. At the heart, your artistic journal is a letter to yourself, slowly revealing itself over time. Open your journal, and savor the spontaneous field notes of your life.

COMMIT RANDOM ACTS OF ART—Turn to any project in this book, and give it a go. You might surprise yourself with a memorable journal entry, even if you believe you have no known painting or drawing skills. Uncover and discover your inner artist.

ESTABLISH A DAILY RHYTHM—Are you a morning, afternoon or evening journal person? Notice the rhythm and pattern of your entries. Do you tend to prefer a specific time of the day? If so, structure your day around your creative patterns.

I have a friend who loves to journal late at night, when the day is over and she can quietly reflect. I prefer to journal first thing in the morning to clear my head and heart for the day. Travel to your own artistic drumbeat.

GO PLACES AND EXPLORE—Have you always wanted to see a stone quarry? The dismantling of a circus tent? A city from the top of a skyscraper? Go ahead and satisfy your curiosity. You have the perfect excuse—you're an artist.

BE SITE SPECIFIC—Art makes you more receptive to the world around you. Draw, paint and write about what you see, smell, taste, hear and feel, wherever you are. The biggest secret to artistic journaling is to relax and open your heart and mind to what is in front of you right now.

How to Get Started
The best way to get started is to adopt the page-a-day journaling approach. Liberate yourself from the pressure to perform. Instead, relax and let yourself play. I've found that one page often leads to another page or to a larger work of art. Make note of what gets you going and establish your own personal rituals. Brew a cup of tea; put on some music; light a candle. Then, open your journal and have fun.

ASSEMBLE YOUR TOOL KITS AND PORTFOLIO—Make it easy to indulge your creative impulse by having your supplies ready. Chapter one will explain what you need with full details and step-by-step instructions.

Illuminate First Letters
Enlarge the first letter of a written entry. Embellish the letterform in a style reminiscent of medieval illuminated manuscripts. This is a great way to begin a new journal page.

Design Facing Pages
Think of your journal as a book that is created as a series of facing pages. I often use double stick tape to adhere two pages together, in case the previous page has buckled as a result of using watermedia or if ink marks show through the paper. This journal entry is a painted *carpet* of Turkish memories, made on the airplane ride home while my impressions were still fresh. Using facing pages gives me room to record more images in my designs.

Decorate Your Journal Cover
Embellish your journal cover with decorative paper, a painting or a collage. Celebrate the miracle of uniqueness in each of your journals. You'll be surprised how quickly they will accumulate.

START EACH JOURNAL WITH A FRONTISPIECE —Reserve the first page of your journal to record your name and the date. I always put a note at the bottom of the first page, with my phone number, asking that my journal be returned to me if lost.

ADD A SECTION FOR LISTS—I dedicate the last four pages of each of my journals for notes, suggestions and bits of information I want to remember. These pages are saved for lists of miscellany—books to read, art supplies to try, places to go, CDs to buy, restaurants to try.

How to Find Time
What does it mean to have time to create art? It means learning to slow time down by paying close attention to life's everyday details. Making art is a wonderful way to fill your sails with the fullness of each available moment. Here are some strategies to help you find time for art everyday.

PLAN FOR CREATIVITY—Sit down every Sunday evening and look ahead in your schedule to anticipate creativity breaks in the coming week. Look for half hours here and there that would normally be squandered, and reclaim it for your art. Identify windows of opportunity in your daily planner for your artistic journal. Use breaks at work to create café art. Refresh your spirit with some creativity, even in the middle of your workday.

TIME EXPANDS WHEN YOU DO ART—The moments seem longer when you are fully focused and your creative self has some breathing room. The elation you feel from taking a creativity break stays with you throughout the day. A half hour can seem so much more expansive than a mere thirty minutes.

SHORT ASSIGNMENTS—Limit yourself to the smallest of subjects—the cloud formation of the day, purchase of the day, laugh of the day, phone message of the day, E-mail of the day. Remember, less is more.

PRACTICE CREATIVE WAITING—Open your journal while you wait at the doctor's office for your appointment. I've been known to do a page of one minute drawings while standing in line. I know a journal artist who draws everyday on the subway on his way to work. His journal is filled with drawings of the interesting strangers he encounters on his commute. He comes prepared everyday with his journal, drawing tool kit and hopes for a seat.

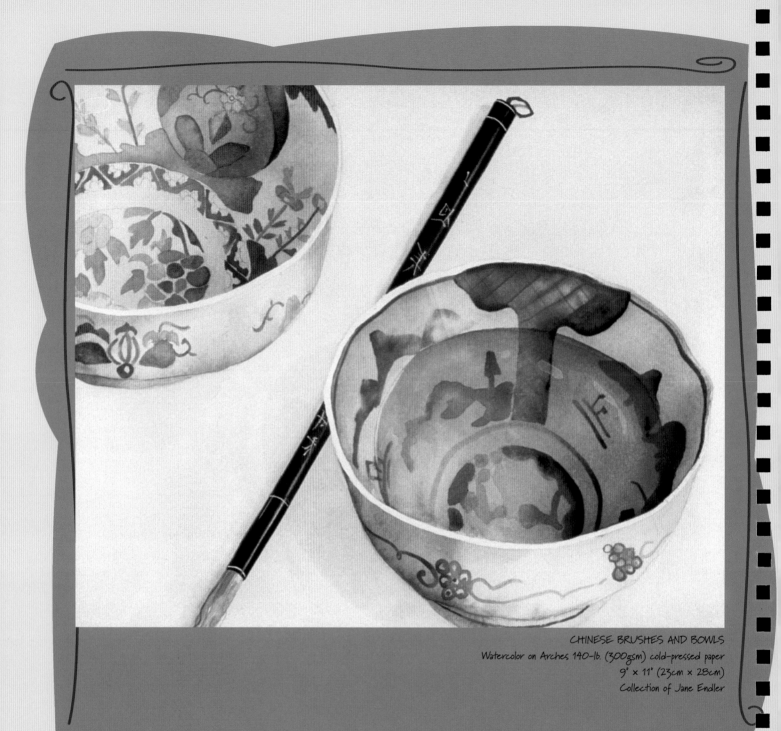

CHINESE BRUSHES AND BOWLS
Watercolor on Arches 140-lb. (300gsm) cold-pressed paper
9" x 11" (23cm x 28cm)
Collection of Jane Endler

1

Assemble Your Supplies for Creativity

Streamline your supplies to free your artistic impulse. Simplicity is often the catalyst for creativity. I keep all my materials in three trim tool kits—one for drawing, one for collage and one for watercolor. I keep my sketchbook and watercolor palette in a light and slender portfolio. It's a breeze for me to grab my three essential tool kits and my portfolio and bring them along with me wherever I go. This practice truly extends my studio out into the world at large.

You'll never have time for art unless you claim the time. One way to make time is to have your art supplies organized and ready to go. In this chapter, I show you how to make a portfolio case, uniquely designed to fit your own sketchbook. I also show you how to make your own tool kit supply cases, customized to match your personal choice of materials. The materials you need for the projects in this book are included in the portfolio and three tool kits. The promise of art day-by-day is sewn into your portfolios and three roll-up cases.

The idea for these tool kits came to me while packing for a trip. After years of travel, I have learned to keep my toiletries case pre-packed. I don't worry about remembering my toothbrush because everything is already there. Having a compact and complete set of art supplies ready to go propels creativity by eliminating packing obstacles. Make a quick transition from the responsibilities of life into a creative moment in your artistic journal simply by having all your materials portable and ready for action.

Although I have a studio, it is not the only place I create art. At our cabin on the Metolius River in Oregon, I paint and draw at the kitchen table, outdoors by the river or even on a mountain hike. I am often on the road, overseas in foreign countries, teaching workshops or visiting friends and family out of town. Like you, I must attend meetings, and cool my heels in waiting rooms and airport lobbies. But, wherever I am, I am confident I have everything I need for everyday *Art Escapes* in my artistic journal.

Sketchbook Portfolio

Keep your sketchbook in an easy-to-make portfolio. I designed this portfolio to hold my favorite sketchbook, the Aquabee 9" × 12" (23cm × 30cm) spiral-bound sketchbook. I have filled more than twenty of these books so far, and plan to keep on going. I am drawn to this size because it gives me enough room for my drawings, paintings and collages, yet is still very portable. You can easily alter the dimensions of the pattern if your current sketchbook is a different size. One of the most important features of a great sketchbook is spiral binding, so the pages lie flat when open. Good, durable paper that takes a lot of abuse is also an essential. The Aquabee sketchbook accepts water media, as well as pen and pencil, surprisingly well.

Make a Portfolio for Creative Portability

This folded portfolio is a compact way to carry and protect your sketchbook, as well as other essentials for painting and collage. And it is fun to make. I slide my sketchbook into one side, and everything else fits neatly into the other side.

Watercolor Palette

I tuck my watercolor palette into one side of my portfolio. The Jones Color Round palette is compact enough to fit inside my portfolio and it has all the features necessary to make watercolor paintings—whether large or small.

Values Filter

Clear, red acetate taped inside a 5" x 7" (13cm x 18cm) mat is an effective aid for distinguishing tonal values, especially when viewing the landscape. Refer to chapter six for a complete explanation.

Drafting Tape

A roll of drafting tape to secure and tape off the edges of watercolor paintings.

Watercolor Paper

Pieces of Arches 140-lb. (300gsm) cold-pressed watercolor paper in various sizes, cut to fit my sketchbook.

Mounting Tabs and Laminating Paper

Double stick mounting tabs and clear laminating paper for use in collages.

Paper Scraps

Small pieces of decorative papers, ticket stubs, stamps and paper scraps for collage work.

Collage Papers

A variety of decorative papers for collage in a 9½" x 13" (24cm x 33cm) clear plastic envelope.

Make a Sketchbook Portfolio

MATERIALS

Felt One 14" × 22" (36cm × 56cm) piece
 Two 14" × 10½" (36cm × 27cm) pieces
Grosgrain ribbon Four pieces, ⅝-inch
 (12mm) wide, 8 inches (20cm) long
Needle and thread or fabric glue
Pencil
Pinking shears
Pins
Spiral bound sketchbook 9" × 12" (23cm ×
 30cm)
Straightedge or ruler

At the fabric store, you will find bolts of polyester craft felt in a spectrum of colors. For a 9" × 12" (23cm × 30cm) sketchbook, you will need one piece of felt measuring 14" × 22" (36cm × 56cm). You will also need two pieces of felt, each measuring 14" × 10½" (36cm × 27cm). Make adjustments to the dimensions if your current sketchbook is not 9" × 12" (23cm × 30cm) in size.

It is not necessary to use pinking shears, as felt will not unravel even if cut with regular scissors. However, I like the finished look of the zigzag edge. If you prefer, you can use fabric glue rather than sewing.

1 Cut Three Pieces of Craft Felt
Use pinking shears to cut one piece of felt measuring 14" × 22" (36cm × 56cm) and two pieces of felt, each measuring 14" × 10½" (36cm × 27cm). Be sure to make adjustments to the dimensions if your current sketchbook is not 9" × 12" (23cm × 30cm).

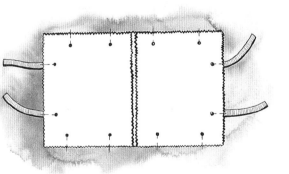

2 Place the Two Smaller Pieces on Top of the Larger Piece
Place the two smaller pieces of felt on top of the larger piece, leaving a 1-inch (25mm) gap between them in the middle of the large piece of felt. This gap allows for the width of the sketchbook and palette when the portfolio is folded in half. Cut four 8-inch (20cm) pieces of ⅝-inch (12mm) grosgrain ribbon. Tuck the ribbon pieces between the top and bottom layers of the fabric, on each side, as shown. Pin all the materials in place.

3 Sew or Glue the Edges
Sew (or glue) around all the sides ¼-inch (64mm) from the outside edge, as shown, leaving the inner edges of the small pieces of felt unsewn so that they form pockets.

Drawing Tool Kit

All I need for drawing is rolled up into this colorful little bundle. I've refined my selection of tools over time to identify just the supplies I need—no more and no less. I always plan with portability in mind and these tools are my drawing essentials. I know that my purple pouch has all my drawing supplies—collected, organized and ready for action. It's an invitation to dive into my artistic journal!

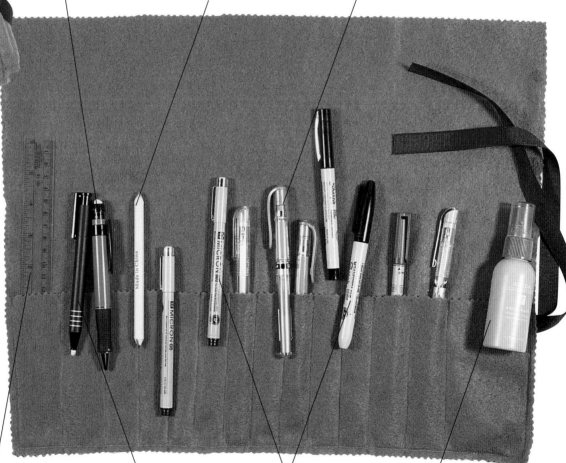

Mechanical Pencil
I use a mechanical pencil so I don't have to fuss with sharpening the point. I like softer leads, B or 2B for instance, so I can smudge the graphite for shading.

Blending Stump
I used to use my finger for smudging pencil lines in my drawings, but now rely on a much better tool: the pointed blending stump. Such a modest object; such a nice effect.

Gel Pens and Metallic Markers
I carry gel pens for light and colorful accents over drawings and paintings. I love to write with metallic gel pens in my sketchbook, especially over dark papers.

6-Inch Straightedge
I tuck a small 6-inch (15cm) plastic ruler into my drawing kit. It comes in handy to draw straight lines, as an erasing shield, to texture my watercolors and, occasionally, to measure.

Click Eraser
I always carry a pencil-style white eraser stick. I especially like ones with a small erasing diameter, perfect for touch-ups both big and small. The ones that click to push out the eraser are easy to load.

Felt Pens
I always have a small stash of felt-tip pens in different sizes and colors. The Pigma Micron pens are permanent waterproof India ink. I like pens with both fine .35mm and wider .50mm pen widths. I also like both the Sharpie fine and ultra fine point pens that are also permanent. Sepia Staedtler Lumocolor pens are great, too. They are nonpermanent and the lines soften when brushed with water over top of a drawing.

Fixative
A small plastic container of non-aerosol hair spray is a key feature in my drawing tool kit. Pencil drawings and writing will smear, and leave traces on the facing page, if they are not coated with a fixative. Hair spray works fine and has the added benefit of being nontoxic, unlike commercial fixatives. Look for small bottles of hair spray in the travel section of cosmetic and drugstores.

Collage Tool Kit

Everything you need for creating collages is included in this tool kit. A few well-chosen supplies consistently do more for your creativity than a room full of supplies you don't use. This yellow bundle, wrapped with a purple ribbon, entices me to open it, and have fun making collages in my sketchbook. Choose lively colors of felt and ribbon—why not put color into your art supply cases? You'll see how to use these supplies to create an exciting array of assemblages and collages in chapter five.

Glue Brush
I keep a worn-out brush in my collage tool kit to use when applying white PVA glue. I don't want to ruin my good watercolor brushes by using them to brush on glue.

White Glue
Include a small plastic container of white PVA glue. Be sure it is acid-free to protect your artwork. There are a number of white glues on the market; they all dry clear and are permanent. I pour a small amount of glue into a plastic container with a pouring spout, purchased separately.

Metallic Pens
I love the Krylon gold and silver leafing pens. They add an extra sparkle and dimension to collages.

Rubber Cement Pick Up
This small square picks up dried rubber cement and cleans up any errant spots of glue.

Rubber Cement
A small plastic container of acid-free rubber cement makes collage work easy and fun. The bottle of glue comes with a brush for easy application. Be sure to buy rubber cement that is acid-free for the preservation of your artwork.

Glue Stick
An acid-free glue stick is invaluable for collage.

Brayer
A small 1½-inch (38mm) brayer helps flatten pieces of paper in the gluing process, especially when making crinkled paper collages.

Scissors
A small but sharp pair of scissors is essential to collage work.

Craft Knife
Sometimes it's hard to cut small pieces of paper with a pair of scissors and the craft knife can do the job nicely.

Watercolor Tool Kit

This selection of supplies is a comprehensive collection of what I consider the essentials for watercolor. I recommend felt for my supply case design because it is a highly absorbent material and perfect for soaking up dampness from brushes or other watercolor tools. This red roll-up case invites me to paint. I know it has all I need to get started, and keep going. All I need to do is take my journal and watercolor palette out of my portfolio, unroll my watercolor tool kit, and start playing in full color.

Bamboo Pen
I use a bamboo pen to inscribe marks onto wet watercolor and create textural effects.

Toothbrush
Spattering clean water, or wet paint, onto watercolors with a toothbrush creates lively texture.

Watercolor Pencils
Watercolor pencils let you draw with watercolor—without using a brush. There are a variety of ways to use watercolor pencils. Use them dry-onto-wet or dry paper. Or, wet your pencil tip, and draw over wet or dry paper. Or, use dry pencil, and brush over with clear water. These twelve pencils replicate the twelve colors in my watercolor palette.

Spray Bottle
A small plastic spray bottle of water is an essential for many watercolor effects. Also, I spray the paints in my palette to wet them before painting.

Salt Shaker
Sprinkling salt onto wet watercolor creates a great special effect.

Brushes
Three round brushes, nos. 2, 4 and 6, are all I need for painting in my artistic journal. I love to paint with kolinsky sable brushes because they are so responsive and hold a lot of water. However, synthetic brushes, or ones with a mixture of synthetic and natural fibers, are less expensive and work quite well.

Disposable Dish Towel
These disposable dish towels, available at the grocery store, are super absorbent. Instead of paper towels, I've found that one of these dish towels is all I need to keep my brush tips dry and to dab up puddles.

Make Your Own Tool Kits

MATERIALS

Felt One 14" × 18" (36cm × 46cm) piece
 One 5" × 18" (13cm × 46cm) piece
Grosgrain ribbon two pieces, ⅝-inch
 (12mm) wide, 12 inches (30cm) long
Needle and thread, or sewing glue
Pencil and straightedge
Pinking shears
Pins

Make a supply case that fits your supplies, instead of the other way around. I have a bunch of zippered cases, brush holders, portfolios, carriers and totes in all sizes and shapes that almost work for me. But the only way for me to get exactly what I need is to make it myself. I designed this easy-to-make roll-up supply case for my three essential tool kits—one for drawing, one for collage and one for watercolor. Choose different colors for each of them for quick identification. All I do to make art is grab and go. My friends love when I make a colorful supply case for them as a gift.

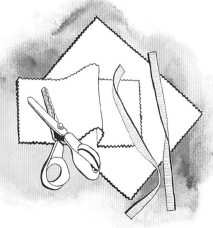

1 Cut Two Rectangles of Craft Felt

Cut one piece of craft felt into a 14" × 18" (36cm × 46cm) rectangle using pinking shears. Cut a second piece of craft felt into a 5" × 18" (13cm × 46cm) rectangle with the pinking shears. Next, cut two pieces of ⅝-inch (12mm) grosgrain ribbon 12-inches (30cm) long.

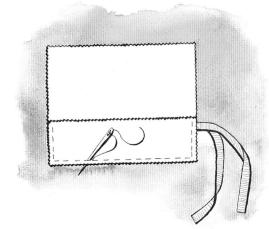

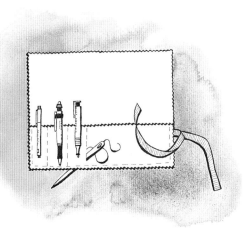

2 Sew the Sides and Bottom Edges

Place the smaller rectangle of felt on top of the larger rectangle as shown and pin together. Tuck the ends of the ribbons between the larger and smaller rectangles, on the right edge, close to the top of the small piece of felt and pin together. Sew (or glue) along the two vertical sides and bottom, ¼-inch (64mm) from the edges, as shown.

3 Make Pockets for Each Tool

Place your tools on top of the supply case and mark where you want to create a pocket. Use a ruler to make a straight line. Sew (or use fabric glue) along the vertical lines to create slit pockets to accommodate your tools. A good rule of thumb is to allow a 1-inch (25mm) width for the average pen or pencil, adjusting as needed for the size of your tools.

Have Fun and Keep It Simple

2

Every child is an artist. The problem is how to remain an artist once he grows up.

~ Pablo Picasso

When I was little, I drew everywhere—on scraps of paper, on my walls, in the night air with my finger. It was magical. Today I keep that spirit of pure joy alive in my sketchbook. This is where I play with paint and create drawings for enjoyment alone. My sketchbook habit is an oasis in my day, a way for me to savor the moment.

Experiment this month by taking your sketchbook with you everywhere you go. In this chapter, I give you suggestions for illuminating your daily life in drawings and paintings that are simple and fun. I show you how to sketch and paint at a café, on the road and at meetings. You will see how to create a journal page a day in many different kinds of ways, and in unexpected places.

All the painting projects in this chapter use only three pigments—my versatile full-spectrum triad. A few well-chosen art supplies make it easy to explore artistically each day. Remember: the world is your best studio.

WATER PATTERNS
Watercolor on Arches 140-lb. (300gsm) cold-pressed paper
22" x 30" (56cm x 76cm)
Collection of Carol and Edwin Wright

One Minute Drawings

Prepare Your Journal

Prepare your journal by drawing six little boxes on a page—hand drawing is fine, there is no need for a ruler. Each little box should be roughly 2" × 2" (5cm × 5cm), drawn with a 2B pencil. Now you are ready to fill them in with quick small frame impressions of whatever catches your eye. Those six little empty boxes will inspire you to fill them up!

Sketching is fun—especially when doing one minute drawings. Draw a page of little sketches, and leave the editing and erasing out of the picture. Experiment with both the small frame and open page formats to see which enhances your sense of freedom and creativity. When you first begin, time yourself or enlist the aid of a friendly timekeeper. I do a few thirty-second drawings to warm up. You will be surprised by how long a minute seems after that. Let your eyes do the drawing for you. Keep your gaze on the object more than on the paper in front of you. Don't expect finished drawings. This is the art of the rough sketch. You will get better and better at capturing the essence of a scene or subject in just a short amount of time. Remember, let yourself draw without judging. The art critic is on vacation. Draw quickly and draw often.

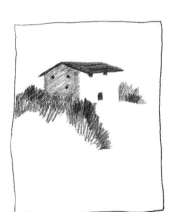

Small Frame Format

These pencil drawings are from a recent trip to Italy, made while traveling on a bus. The small frame format inspired me to fill in the little drawn boxes with details from the scenery outside the window. The small frame format is a marvelous way to freeze-frame a sequential experience. I once drew a page of little one minute drawings of our arrival by ferryboat to a harbor. As we moved, the island and harbor town we were approaching came closer and closer into view, and the composition of sky, island and water changed rapidly. Be sure to make the little boxes on your page first, so you can draw in each one in quick succession.

Try Different Drawing Tools

Take a look at one of my workshop student's first attempts at one minute drawings. She decided it was reassuring to have the structure of the small frame format. She experimented with several drawing tools—pencil, black felt-tip pen and red ink pen—to see which appealed to her the most.

ONE MINUTE JOURNAL DRAWINGS
Jeanne Henry
Pen and pencil on journal paper
8" x 10" (20cm x 25cm)

Embellish Your Drawings With Color

Jeanne continued to work in the small frame approach in more one minute drawings. She was so pleased with her efforts that she embellished these with colored pencils. It was a joy to see her drawing confidence increase with her new one minute drawing habit.

ONE MINUTE JOURNAL DRAWINGS IN COLOR
Jeanne Henry
Pen and pencil on journal paper
8" x 10" (20cm x 25cm)

Open Page Format

Scatter quick sketches all over the page, without confining them to drawn borders. Some of your sketches may overlap others. Draw some subjects close up and some from far away. There is no need for perspective consistency in the open page style. It all adds to the fun. Draw for enjoyment! I promise you will never forget the place or subject you stop for just one minute to draw.

Take Your Sketchbook Out for Dinner

These one minute drawings were done in the open page style. I wanted to record each course of a memorable lunch at L'Aubergade Restaurant in the Dordogne region of France. Starting with the first course in the upper left corner, I drew with a Pigma Micron .35mm marker pen in my Aquabee 9" × 12" (23cm × 30cm) journal. I had to draw fast before eating each dish!

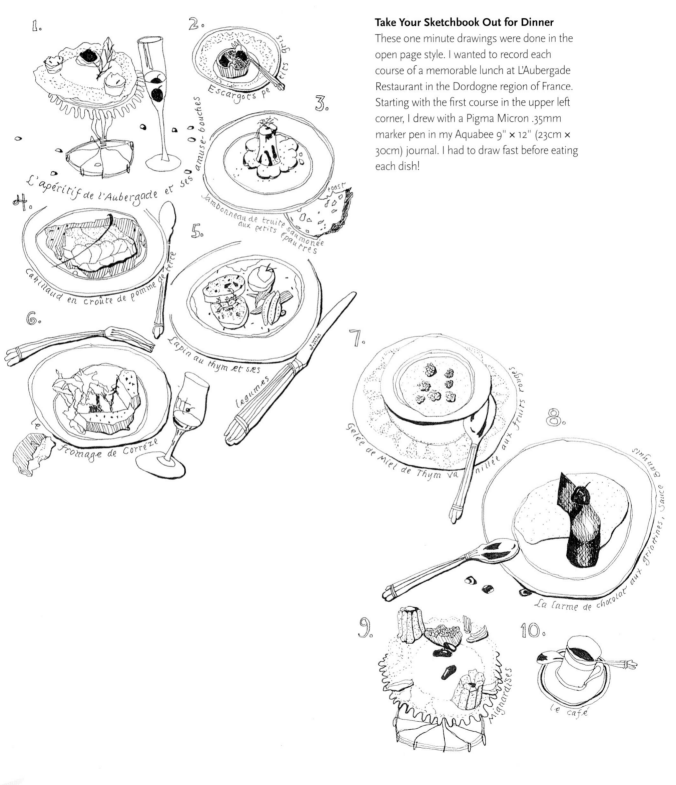

zebra doodles
pages from the long trip back from Joburg!

you can never have enough photos, you can never draw enough zebras

short thick neck
stocky body
short stubby legs

skull as circle
muzzle extension

Overlap Your Drawings

Gary Hang Lee's sketchbook on safari to Botswana is filled with open page one minute drawings of wildlife in their natural setting. He doodles with felt-tip pens in a delightful combination of drawings and text. His page is completely covered with quick studies creating a vibrant jungle of images that reflect the richness of his experience. You can almost feel his excitement.

SAFARI SKETCHBOOK DRAWINGS
Gary Hang Lee
Pen on journal paper
9" x 12" (23cm x 30cm)

Don't Bother With Erasing—Who's Got Time?

I notice that when I let go of trying to make a perfect drawing, I relax and enjoy myself. And, as a result, my sketches are full of life and personality. They become a reflection of the swirl of life around me. In my artistic journals, I want to record rapidly what I see. I especially like to use these three sketching techniques because they encourage no erasures. They release you from the temptation to seek perfection. Try each of these one minute drawing methods. They will help you fill your artistic journal with lively and whimsical interpretations of your day.

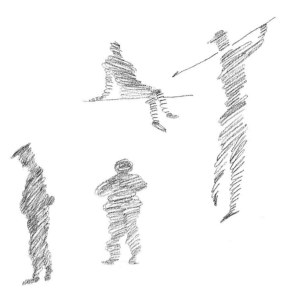

Loop Drawing

I like to draw people in motion using only loops, again without lifting the pencil off the page. Loops are stacked on top of loops to form the shape. These loops give a sense of weight and volume to the figure. Learn to draw people quickly—people like to move. The most interesting people are usually in the act of doing something. Drawing with loops will help you to capture them. These examples were drawn with a 2B pencil.

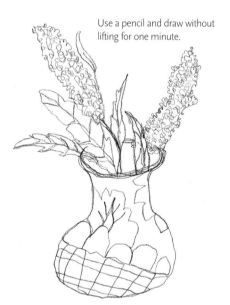

Use a pencil and draw without lifting for one minute.

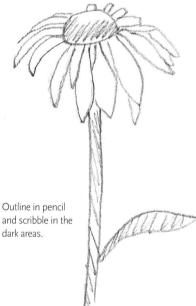

Outline in pencil and scribble in the dark areas.

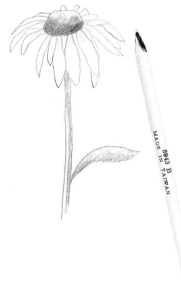

Smudge with a blending stump to create shaded areas.

Draw Without Lifting

Pick a subject and draw it without lifting the pencil or pen off the paper. You will crisscross over lines and retrace your steps—that's fine. Give yourself a pencil with a lot of lead so you don't run out in midstream. Darken lines by going over them several times to reinforce shapes. As you go over the lines you want to emphasize, your subject will emerge out of the tangle.

Smudge Shading

Outline your subject with a soft pencil like a 2B. Then scribble in a few lines to indicate dark areas and shadow areas. Use a blending stump to smudge these lines into a blurred gray tone. I have used my finger to smudge on occasion, but a blending stump works much better. You can give a very simple drawing a lot of character with a little shading.

Turn One Minute Drawings Into Paintings

"My sketchbook serves me as a cookbook when I am hungry. I open it and the least of my sketches can offer me material for work."

~Georges Braque

One of my secrets is to use one minute drawings to jumpstart myself into opening my journal and start to sketch. I tell myself I am only going to spend one minute per sketch, six on a page—that's only six minutes of my busy day. The truth is that as soon as I get going, I want to keep on going. Often I am enjoying the process so much that I choose to fiddle with one or more of the drawings to refine them, just for the pleasure of it. Sometimes we have to trick ourselves into having fun.

Art Enroute

While enroute—on your daily commute to work, as a passenger in the car on the way to the grocery store, at the airport or on an airplane—make a page of one minute sketches in the small frames format, and one in the open page format. You will be surprised by all the interesting things you notice when you stop to draw what is around you, even in your own neighborhood. When you are done, ask yourself which format most inspires your creativity. Or, perhaps you will enjoy them both, as I do.

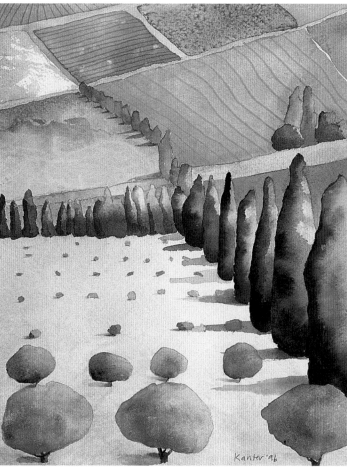

VIEW FROM LES BAUX DE PROVENCE
Watercolor on Arches 300-lb. (640gsm) cold-pressed paper
19" x 24" (48cm x 61cm)
Collection of George Fabel

Gather Reference Material
These pencil drawings were made in my artistic journal as I sat on the ground on top of a windy hill in Les-Baux-de-Provence, France. I drew quickly —not just one minute, but not much more.

Finished Painting
When I returned to my hotel room later that day, I painted this watercolor in my journal from one of the sketches. Can you see which one I used? I added some dark shadows with a Pigma Micron .35mm pen to the drawing to emphasize the dark shadows under the tall cypress trees. The full-spectrum triad helped me create a beautiful range of bright hues and lively, expressive darks. You can see that there are two more paintings waiting to happen from just a few minutes of sketching.

Look What Just Three Colors Can Do!

The Color Library

Building a color library is a great way to explore the color possibilities of the full-spectrum triad. I call this a color library because, like a library, it is full of many selections. I like knowing what color options are possible, so that later on I can choose the ones I want to use in a painting—just like choosing books from a library. I don't want to use all the colors possible from a triad in one painting, just as I wouldn't want to take out all the books in the library at one time. But I love knowing all the choices I have. For that reason it is invaluable to build a color library of each of the four triads. See chapter six for a full explanation of all four triads.

Step 1 Mix a large puddle of Winsor Lemon on your palette. Paint a swatch of pure yellow pigment at the top of the triangle.

Step 2 To the pure yellow puddle, add a tiny bit of Winsor Blue to create a warm, yellow-green hue. Paint that color mix next to the pure yellow.

Step 3 Continue adding tiny additional amounts of Winsor Blue until you mix all the way to pure Winsor Blue, recording each mixture. The more gradations you make, the better you are able to explore the unlimited possibilities of triadic painting.

Step 4 Now try making graduated color mixtures between Winsor Lemon and Permanent Rose.

Step 5 Finally, mix Winsor Blue and Permanent Rose to complete the triangle.

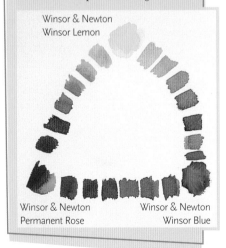

Winsor & Newton
Winsor Lemon

Winsor & Newton
Permanent Rose

Winsor & Newton
Winsor Blue

The journal artist's best friend is the full-spectrum triad. With just three colors you can mix an infinite and expressive range of hues. Simplify your palette and enhance color harmony all at the same time. There simply are no *wrong* colors because they all relate to each other. The painting projects in this chapter are a perfect way to get acquainted with the full-spectrum triad.

Four Ways to Mix Triads

To fully appreciate the potential of the full-spectrum triad, you need to know the four results you can obtain by mixing with color triads: pure pigments, brights, shades, and grays and darks. This understanding is key to adding virtuosity to your color mixing vocabulary.

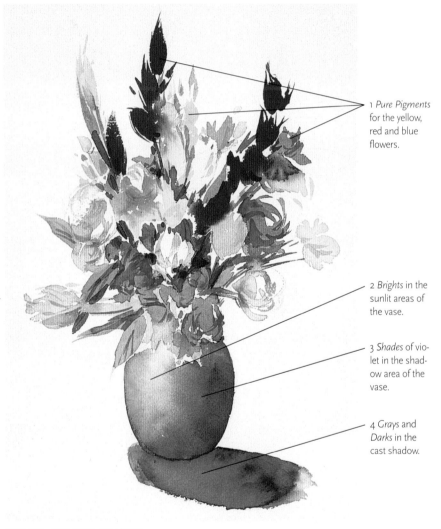

1 *Pure Pigments* for the yellow, red and blue flowers.

2 *Brights* in the sunlit areas of the vase.

3 *Shades* of violet in the shadow area of the vase.

4 *Grays* and *Darks* in the cast shadow.

PEONIES AND FIRE ORCHIDS
Karin Felker Harris
Watercolor on Arches 140-lb. (300gsm) cold-pressed paper
10" x 14" (25cm x 36cm)

Winsor Lemon Permanent Rose Winsor Blue

Pure Pigments

The first way to use the colors in a triad is to paint with pure pigment directly from the tubes. The full-spectrum triad is made up of the three primary colors. Use them unmixed as red, yellow and blue. You may be surprised to see what optically true primary colors look like. They are the basis of the color wheel and, theoretically, all colors can be mixed from them. Be sure you use the pigments I specify so you can experience the complete sweep and scope of the full-spectrum triad. Dilute with water for lighter colors or use a lot of pigment with just a little water for more intensity.

This orange was created by mixing Winsor Lemon and Permanent Rose.

This violet was created by mixing Winsor Blue (Red Shade) and Permanent Rose.

This green was created by mixing Winsor Lemon and Winsor Blue.

Brights

The second way to use triad pigments is to mix brights. Brights are created by mixing together two of the three pigments in the triad, without the addition of the third. In the full-spectrum triad, these are the secondary and tertiary colors. The exact amount of each pigment in your mixture will determine the color. You can vary the proportions infinitely and, likewise, vary the colors infinitely. You already know how to create brights by building your color library.

I added a tiny bit of Winsor Blue (Red Shade) to the orange to gray the color to this beautiful orangish shade.

I added a tiny bit of Winsor Lemon to the violet mix to gray the color to this lovely eggplant shade.

I added a tiny bit of Permanent Rose to the green to gray the color to this beautiful, shaded green.

Shades

The third way to mix colors with a triad is to create shades. Think of a shady garden in comparison to the same garden in the bright sunshine. You are creating the shaded version of the same color by adding a little bit of the third pigment in the triad. You are really adding the complementary color without having to study a color wheel. This is called *graying* a color, but it doesn't mean you have to get mousy grays. It means you have the power to create gorgeous, rich shades with character and nuance. Again, you can vary the proportions infinitely and, likewise, vary the colors infinitely.

Grays and Darks

The fourth way to mix pigments in a triad is to create grays and darks. Mix all three pigments together, in approximately equal proportions, and you will make a gray or dark black. You can vary the color of the dark by adding more of one pigment than the others. For instance, you can mix a reddish dark or bluish dark. I find these richly colored darks to be much more attractive to the eye than a premixed black. The less water and more pigment you use, the darker your mixture will be. Dilute with water to create light grays.

First Paint, Then Draw

Color Notes

Play with the pigments of the full-spectrum triad by creating a page full of beautiful blends. Look out your window and paint swatches of the colors you see. Free yourself from painting shapes; just let yourself go in an exploration of color possibilities. Spray your paper with water first for a loose, wet-in-wet paint application. Look for as many colors as you can and then recreate them in watercolor. If you wish, add pen lines when the paint is dry to describe the view out of your window.

My sketchbook is a jewel box of impressions of the beauty of the world around me. When I want to capture both color and subject quickly, I often use the *first paint, then draw* method. Usually the watercolorist draws first, then adds color to the shapes in the composition. For the sketchbook artist a great way to work in watercolor is to reverse the usual order. Paint first, then draw afterward. The advantage is that I am sure to get some crucial color notes on my page before the light changes, or I run out of time and have to leave. Adding pen lines to describe the subject on top of the color notes completes the picture in a very short amount of time. Use what you know about color mixing with the full-spectrum triad to get just the colors you want to recreate in your atmospheric underpainting.

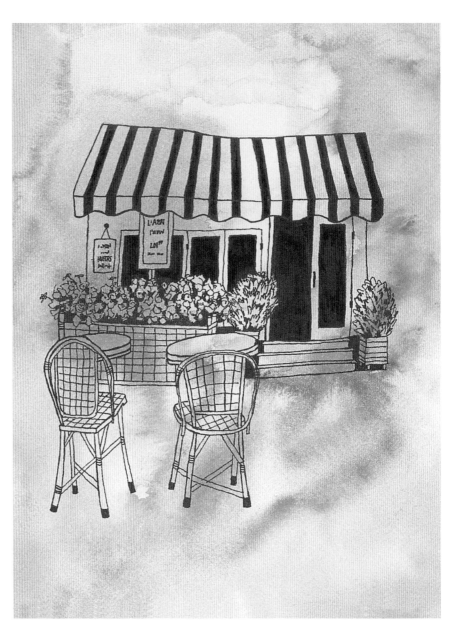

Draw Over Your Colors

This page in my artistic journal was created by first painting, then drawing on a 10" × 8" (25cm × 20cm) piece of watercolor paper. I applied watercolor in a loose fashion, trying to mirror the colors of the Parisian street scene in front of me. I didn't worry about the placement of the colors at all. The aqua blue of the sky, the reds and oranges of the flowers, and the yellow of the awning all appear in my underpainting. I added the drawing after the paint dried, using both fine and ultra fine waterproof felt-tip pens.

Les fleurs de Provence

First Paint, Then Draw
This painting of the flower market in Nice, France, uses the full-spectrum triad of Winsor Blue (Red Shade), Winsor Lemon and Permanent Rose. Paint the colors you see all over the page without regard to placement or shape of the subject. Mixing all brights gives the painting a warm friendly feel.

SKETCHBOOK PAINTING
Sue Greenbaum
Watercolor on Aquabee journal paper
6" × 9" (15cm × 23cm)

Collage the Colors You Love
Do you love the brights? Or do you prefer, as a French friend of mine says, "the colors which have no name"—the shaded, grayed hues? Often you can tell which color palette a person prefers by the clothes they wear. My French friend always dresses in heather-like shades, never bright, primary colors. Another friend always wears brilliant, flowerlike colors—bright fuchsias and reds, brilliant yellow-greens—that are a fine reflection of her vibrant personality. Color choices are a part of the way you see the world, and are reflected in your art. Cut out examples of the colors you are most attracted to from magazines. Collect postcards of artwork, and scraps of fabric with color preferences matching your own. Make a collage in your journal of all you collect. See if you find a pattern to the colors you like. Are they mostly brights? Pure pigments? Shades? Grays and darks? A combination?

Add Fine and Wide Pen Lines
Sue used both fine and ultra fine point waterproof felt-tip pens to draw on top of the painted background. Add emphasis with wider pen lines and dark background passages between the flower shapes to bring them into focus. Sue captured both the colors of the market and the shapes of the flowers all within a few moments.

Explore Color Possibilities
Create beautiful color variations using just three pigments. For example, look at the richness and variety of the greens.

Prismatic Painting

Café Art

One of my favorite journaling activities is what I call café art. I complete a page in my journal in the time it takes me to finish sipping a drink. I discreetly write, draw and paint my daily journal entry while enjoying a private moment, away from the demands of others. Treat yourself to a café art date each week and take advantage of a perfect page-a-day journal opportunity. Make a prismatic painting of your cup or glass, and learn to mix beautiful rainbow colors with the full-spectrum triad, all at the same time.

Do you remember the first time you looked through a crystal, and brilliant, multi-colored fragments of light appeared? When you pass white light through a prism, it disperses into a kaleidoscope of rainbow hues and patterns. This is an example of looking at the ordinary in an extraordinary way. Prismatic painting is my way of bringing the everyday into a different focus and finding beauty in the commonplace.

Create Instant Backgrounds

Prismatic painting is an inventive way to resolve what to put in the background—always the hardest thing to compose. The background is composed for you by the intersecting scribbled line shapes. A powerful image emerges from a very simple subject.

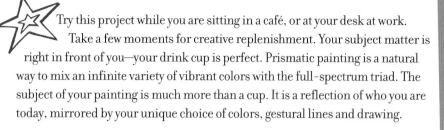

MATERIALS

Aquabee sketchbook 9" × 12" (23cm × 30cm) or Arches 8" × 10" (20cm × 25cm) paper

Full-spectrum triad pigments *Winsor Blue (Red Shade), Winsor Lemon, Permanent Rose*

No. 4 round

2B pencil

Try this project while you are sitting in a café, or at your desk at work. Take a few moments for creative replenishment. Your subject matter is right in front of you—your drink cup is perfect. Prismatic painting is a natural way to mix an infinite variety of vibrant colors with the full-spectrum triad. The subject of your painting is much more than a cup. It is a reflection of who you are today, mirrored by your unique choice of colors, gestural lines and drawing.

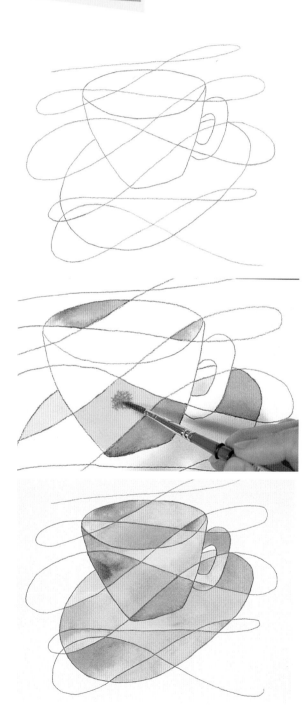

1 Scribble on Top of Your Cup Drawing

Open your journal to a new page (or pull out a piece of watercolor paper, cut to fit your journal). With a 2B pencil, use your one minute drawing skills to create playful, uncomplicated cup and saucer shapes.

Next, scribble a few swooshes, loops, swirls, figure eights or chevrons all over your drawing. Your energy, mood and spirit will carry through your body and into your hand to create lively line patterns. Let yourself go with the flow of the moment. Prismatic shapes will emerge in front of you as the lines intersect with each other. Keep these intersecting shapes large enough by not adding too many lines.

2 Drop in Color

In each prismatic shape, paint a different color, created from the three pigments in the full-spectrum triad. Paint by mixing on the paper. With a no. 4 round, underpaint a prismatic section with a diluted glaze of Winsor Lemon. While the paper is still shiny and wet, drop in Permanent Rose.

3 Paint Each Shape Uniquely

Paint each prismatic section separately, creating a kaleidoscope of rainbow colors in each one. Try this wet-in-wet technique for beautiful diffused color mixtures. Be sure to let each section dry before painting the one next to it.

Paint Past the Photo

Photo Art

Go through your albums, and select special photos of fond memories. Perhaps you have a photograph of the house where you grew up, or from a recent vacation. Find several that appeal to your eye and speak to your heart. Or, if you like, make a color copy of the photograph in this book, and follow the steps to make your first painting past the photo. Then try your hand at creating one from your own image bank of photographs. Remember: most of the painting is already done for you. All you have to do is soften the edges a few inches beyond the borders of the print.

Soften the hard edges of a photograph by adding an inch or two of watercolor liveliness at the borders. Use your favorite photographs as the starting point for original watercolor paintings. Add, invent, embellish and extend beyond the four edges of the photo using watercolor. Did the camera cut off the giraffe's head? Paint it in. Do you wish there was a colorful flower garden in front of your house? Take artistic liberties and invent beyond the photo what you would like to see. Transform the frozen reality of a photograph into a living image of your memory and imagination.

Original Photograph

Expand Your Horizons

Look how expansive this scene becomes with the addition of an inch or two of watercolor border. I started with a photograph of the sailboat in Turkey where I taught a painting holiday. I glued the 4" × 6" (10cm × 15cm) photograph to a 10" × 14" (25cm × 36cm) piece of Arches cold-pressed watercolor paper, and painted past all four edges. The finished photo artwork reflects my fond memories so much better than just the photo alone.

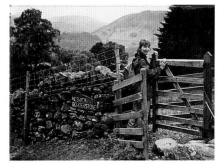

Original Photograph

Turn a Photo into a Vignette

Artist Ann Smith added the missing tree shapes, stone wall and path to the edges of the photograph. Her watercolor touches at the borders add so much life to this photograph.

PAINTING PAST THE PHOTO
Ann Smith
Photograph and watercolor on Arches 140-lb. (300gsm) cold-pressed watercolor paper
8" × 10" (20cm × 26cm)

Take Artistic Liberties

I used part of two photographs as the basis for this photo painting. I cut out sections from two photographs, matched them at the edges, and glued them onto a piece of watercolor paper. I painted in a bit more of the figures cut off in the photos. That's me with the black visor hat, listening intently to instructions before playing my first-ever game of bocce ball.

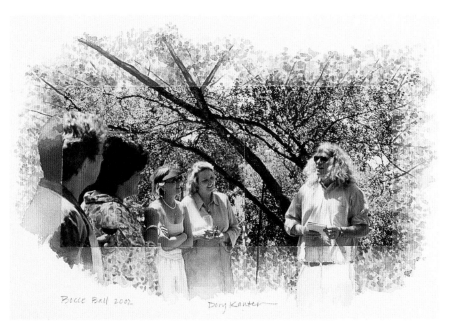

Original Photographs

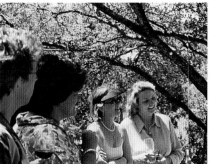

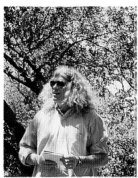

MATERIALS

Arches 10" x 14" (25cm x 36cm) 140-lb.
 (300gsm) cold-pressed paper
Full-spectrum triad pigments *Winsor Blue*
 (Red Shade), Winsor Lemon ,
 Permanent Rose
Glue
No. 4 round
Photograph or color copy of a photograph
Scissors
2B pencil

This is a painting of my front gate. Can you see where the photo ends and the painting begins? I loved being able to cut the power line out of the photo in the sky above the trellis. What was a rather pedestrian photograph is now a much more romantic depiction of my old fashioned front yard with the clematis blossoms in their full glory.

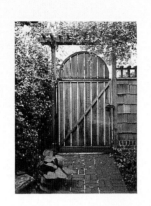

1 Glue Photo to Watercolor Paper

Glue your photograph to the middle of a piece of Arches cold-pressed watercolor paper, or a page in your artistic journal. Crop the photograph as you wish. If you don't want to cut or glue your photograph, use a color copy.

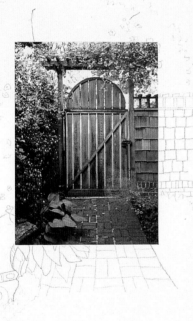

2 Draw With a Pencil

With a 2B pencil, lightly draw in a continuation of the photograph to give you a guideline for painting. It helps to draw in the architecture of buildings or, in this case, the fence, to give your finished painting a convincing look.

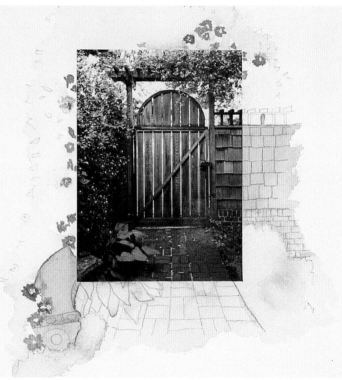

3 Underpaint at Each Edge

With a no. 4 round, underpaint a pale version of the colors you see at each of the four edges. This will define the outside edges of your painting and give you a color plan to work from. Use the full-spectrum triad for a complete range of color possibilities and perfect color matching.

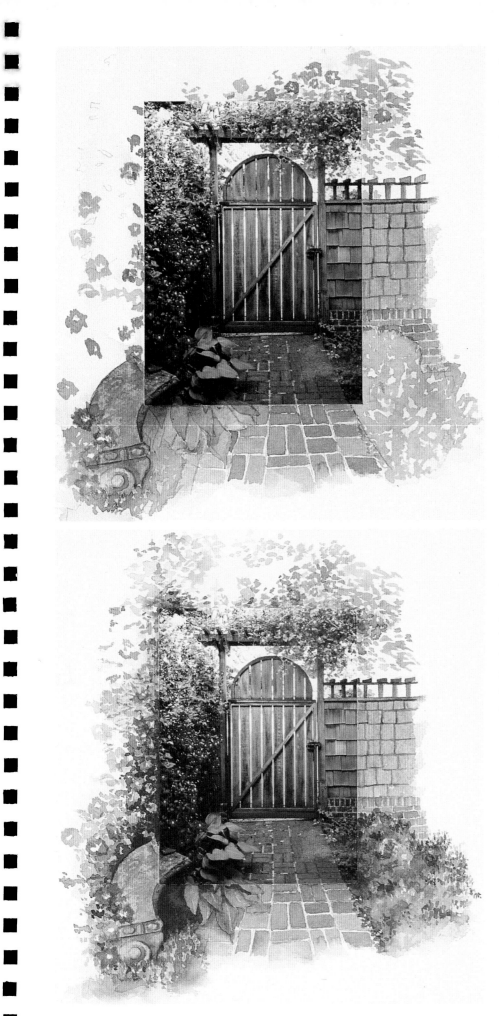

4 Refer to Your Color Library

Match the shapes and colors at the edges by using all four methods of mixing with triads: pure pigment, brights, shades, and grays and darks. Maintain a loose, vignette quality to your painting at the edges—it will breathe life into the photographic image.

5 Snap It Into Focus With the Darks

This last step really makes the painting sing. Add the darks that you see in the photograph, especially at the edges. Match both the light and the dark colors from the photograph into your painting. This is the way to make sure the transition from the photograph to the painting is smooth. Often it is the addition of the very darkest colors that make the painting snap to life.

3
Opportunities for Everyday Creative Moments

I believe that when it comes to art, quantity equals quality. The more art you do, the better you get. The sheer quantity of creation leads to an enhanced quality of self-expression. The more images you create, the more fluid your imagination becomes. That's where keeping an artistic journal comes in. Fill your pages with observations every day—the more the better. This chapter is designed to help you discover creative moments in your day that you may not have realized were there. Imaginative opportunities lie camouflaged in our everyday lives. The projects in this chapter will help you create art out of the unexpected, and find inspiration for paintings from surprising sources.

RIVER REFLECTIONS
Watercolor on Arches 140-lb. (300gsm) cold-pressed paper
26" x 20" (66cm x 51cm)
Collection of Jean Auel

Creative Doodling

Life is full of situations where it is easy to feel creatively trapped. Do you have a lengthy meeting to attend, or anticipate a long wait at the airport? Commit an act of creativity. These are perfect moments for creative doodling. Don't we all love to doodle? Let your pencil do what it wants, without censoring—even though your concentration might be centered elsewhere. I love to doodle while talking on the telephone. Creative ideas flow when you are not trying so hard to be ingenious. Journal opportunities will abound.

Why Can't Business Meetings Be Fun?
Take meeting notes by adding the figure to a quickly sketched face. This mustachioed caricature started as a doodle of a gentleman's face as he was speaking at a meeting I attended. My handwritten notes of his comments form the simple body shape.

The Caricature Doodle
Next time you're at a lecture, convention or meeting make quick cartoon caricatures of the participant's faces. Pick out one distinguishing feature—earlobes with dangly earrings, a thick head of curly hair, arching eyebrows, a pointy chin—and draw that first. Next, add the outline of the jaw and chin shape. Add a squiggly line for the hair. You can scribble just a pair of glasses on a circle, or a big mustache on an oval. This is not a drawing, not a sketch—it's a doodle! Jot down the name of your subject by your caricature for an artful way of remembering names and faces.

Frame Your Day With a Doodle Border

Some days all I want to do is create a border design in my artistic journal. Maybe I'll return to it later on, and fill in the empty space in the middle, or maybe not. I find it energizing to make spontaneous, unplanned designs. First, make doodles, in pencil or pen, all around the four edges of a new page in your journal. Play with simple shapes and repeating patterns in a free-form kind of way. There is no right or wrong. I don't try to draw anything from reality—just squiggles, lines, dots and shapes. Doodle while on the telephone, at a meeting, listening to music or even watching TV. With your conscious mind occupied, you liberate your unconscious to reveal itself.

Discover Personal Symbols in Your Doodles

The design for this watercolor painting came directly out of the doodle border. Take note of the shapes or marks that appear in your doodles. They are your personal hieroglyphics. I noticed that both circles and squares, and parts of them, turned up over and over again in my doodle. I enlarged two elements of my doodle border into this composition of overlapping spheres. Aristotle said that "the soul never thinks without a picture." Bring meaning to your work by awakening to this rich source of personal imagery.

The Creative Matrix

Growing up, one of my favorite summer activities was catching fireflies at night. Those few seconds holding the glowing insect in my loosely cupped hands, examining it for just a moment before letting it go free, delighted me. The creative matrix permits a similar kind of momentary examination of fleeting but precious moments. Celebrate a day, week, weekend, workshop, travel adventure or any other life experience. Visual and written note taking raises the ordinary to the extraordinary. The creative matrix is a private diary that helps you hold onto meaningful everyday moments and illuminate personal memories.

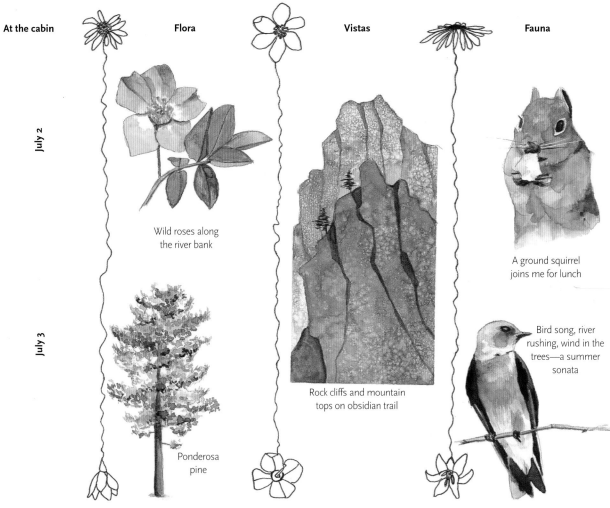

At the cabin **Flora** **Vistas** **Fauna**

July 2

July 3

Wild roses along the river bank

Ponderosa pine

Rock cliffs and mountain tops on obsidian trail

A ground squirrel joins me for lunch

Bird song, river rushing, wind in the trees—a summer sonata

Weekend Matrix

This is a creative matrix I made while at our vacation cabin in central Oregon. There are so many things I love about being there. The matrix framework helped me to focus on just three of these—the flora, fauna and mountain vistas. In trying to decide upon my matrix categories, I realized that these were the subjects I was most interested in during a short two-day visit. Creative limits encourage self-discovery. The framework of the matrix keeps me from being overwhelmed by the possibilities and helps me focus my attention on the slice of life truly important to me right now.

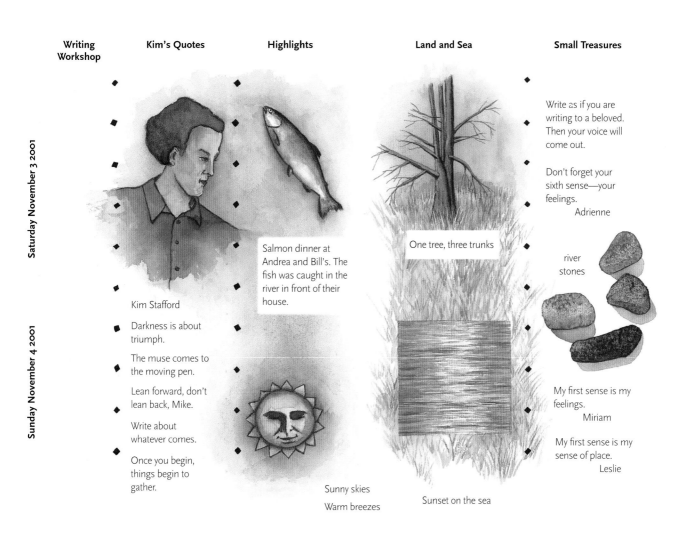

Writing Workshop	Kim's Quotes	Highlights	Land and Sea	Small Treasures

Saturday November 3 2001

Sunday November 4 2001

Kim Stafford

Darkness is about triumph.

The muse comes to the moving pen.

Lean forward, don't lean back, Mike.

Write about whatever comes.

Once you begin, things begin to gather.

Salmon dinner at Andrea and Bill's. The fish was caught in the river in front of their house.

Sunny skies

Warm breezes

One tree, three trunks

Sunset on the sea

Write as if you are writing to a beloved. Then your voice will come out.

Don't forget your sixth sense—your feelings.
Adrienne

river stones

My first sense is my feelings.
Miriam

My first sense is my sense of place.
Leslie

Workshop Matrix

I made this creative matrix while I was attending a writing workshop on the Pacific coast. I used two facing pages of my journal, which gave me more room to draw, paint and make written notations. This matrix is a valued remembrance of a wonderful weekend staying with good friends and being inspired by writer Kim Stafford. I kept notes of this delightful weekend within the framework of my artistic journal matrix. The first creative choice is deciding which categories to illuminate. I'm glad I preserved some of the essence of my experience by focusing on Kim's quotes, highlights, land and sea, and small treasures. After I decided on the categories, the matrix gave me a structure for reflection, a creative way to reveal delicious morsels of meaningful memories.

Make a Creative Matrix This Weekend

What do you love about each season? How do you mark the turning from summer to autumn? Winter to spring? Use the creative matrix as a way to chronicle the changes you observe. Pick several categories or qualities about each season to investigate. Another approach is to make four identical seasonal matrices maintaining the same categories for each one for an ongoing investigation of the progression of the yearly cycle. Colors, foliage and birds are examples of facets to explore. Leave room in your journal for the four matrices so one can flow right after the other. Sometimes, we overlook the rich creative opportunities—such as the seasons—that are all around us.

Saturday　　　　　　　　　　　**Sunday**

Simple Pleasures

Delicious Flavors

Natural Wonders

Copy This Matrix Template Into Your Journal

Use this design as a template for your first weekend matrix. Enlarge it to the size of one of your journal pages. Photocopy or trace it into your sketchbook. This is an invitation to make a hand-drawn, handwritten illuminated manuscript of your weekend. Interpret the categories as broadly as you wish. Draw, write, collage, doodle, make lists—anything goes. Don't stick to strict grid boundaries, I never do. Pick a weekend with nothing special going on. The matrix is about moments, not the momentous. You'll find there is a lot more to remember than you would have guessed.

Matrix Categories to Get You Started

This list contains some areas of observation that you might find useful in building your own matrix. This is just a beginning: There are as many possible categories as there are facets to your life. In other words, they are endless. The important thing is to create categories for your matrix that encourage you to focus in on slender, but precious, aspects of your experience. Each matrix you make will be different. Through each one, by committing to a few choices out of the myriad of possibilities, you intensify your powers of observation. Not only is this true of making a matrix, but it is true of life itself. Art imitates life, once again!

Senses
Sights
Scents
Sounds
Tastes
Touch/textures

Nature
Flora and fauna
Feathers and beaks
Land and sea
Waves and clouds
Sun and rain
Sticks and stones
Light and shadow
Natural wonders

Travel
Getting ready
Getting there
Being there
Going home
Local color
Vistas and views
Bathrooms everywhere
Cafés of note
Joys and woes
New friendships
Hotels rooms
Cameos and brief encounters
Cultural differences
Les faux pas
Architectural details and decorative motifs
Trains, planes, automobiles and boats: the details
On the go and slowing down
Shopping memories
Crossing boundaries
Street signs and lamp posts
Packing tips
Local cuisine and personal picnics
My own maps
In the market today
What I miss about home
Books I took and books I read

People and Family
Friends, yesterday and today
Making connections
Building bridges
Hurdles and agonies
Quotable quotes
Truth and lies
Love and admiration
Still growing
New best friends

Just About Me
Simple pleasures and little luxuries
Choices and challenges
Foolish fun and folly
Life's little lessons
Awakenings and inspiration
Rest and recreation
Random thoughts
Dreams and imagination
Moments of grace or virtue
Fun and laughter
If I could do it all over again…
Advice taken and not taken
Being alone
Highlights of the day
Memorable moments
Books to read
Moments of celebration

Emotions
Everyday magic
Spontaneity
Reactions
Passions
Clarity or confusion
Surprises and questions
Worries and scary moments

Windowpane Painting

Life is a Verb

Discover a symbol of yourself by looking through magazines for illustrations of people in motion—dancing, flying, jumping, digging, falling, sleeping, swimming and so on. Don't overlook illustrations or photographs of animals in action. Animals are powerful symbols of the self. Think about your life in terms of a characteristic movement or pursuit. What action suggests your life right now? What verb describes your current energy and essence? Borrow an image from a book or magazine illustration that speaks to you. As Pablo Picasso said, "Good artists copy, great artists steal." Rework your borrowed image into a simple drawing representing your present state of mind. The key is simplicity. Use this image to make a symbolic self-portrait windowpane painting.

Many of these journal projects are designed to nudge you, the artist, into framing or reframing what you see. Windowpane painting asks the artist to imagine an uncomplicated image, bordered by the architecture of four windowpane sections. Each windowpane alters the image slightly, tinting it with different textures and hues. The simpler the subject, the stronger the windowpane painting—a perfect combination for sketchbook art. I love to watch how one image comes together like four separately hand-painted tiles.

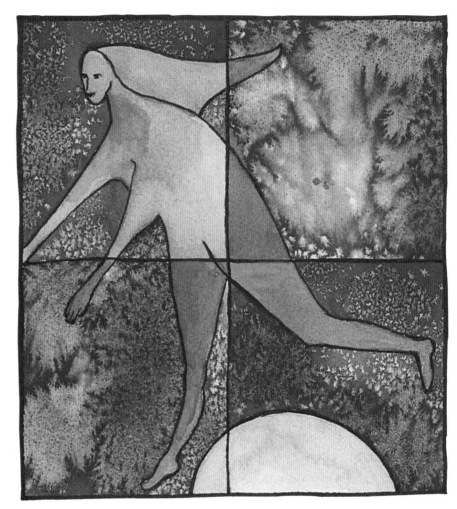

The Escape Artist
This windowpane painting came from a tiny sketch made while my husband and I were driving in rural France. I saw a billboard with a childlike figure and did a quick one minute sketch while on the road. Later on, I designed a figure of my own and had her fly in the sky over a full moon. I call this painting *The Escape Artist*. It is a favorite private symbol. With sketchbook and pencil in hand, I can escape to a personal place of reverie, no matter where I am. The background areas were sprinkled with salt while the paint was still wet to create the star patterns.

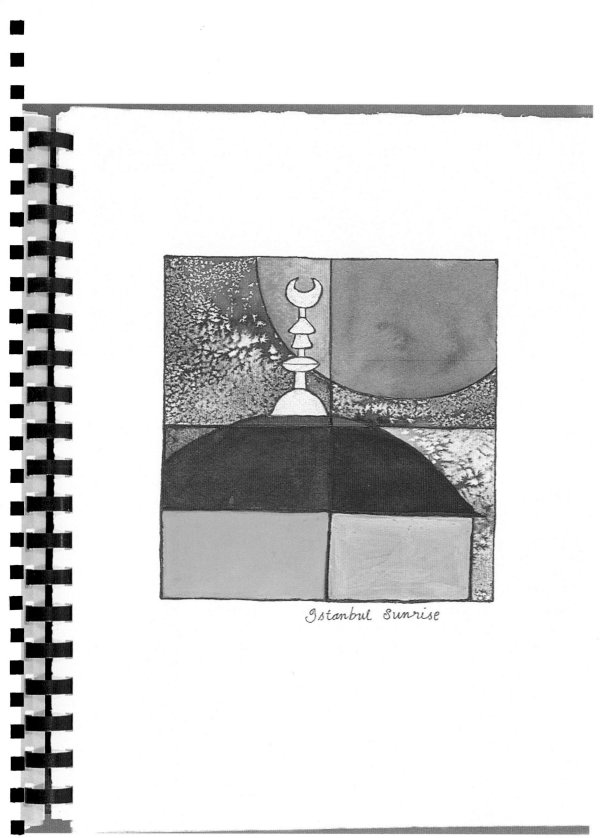

Istanbul Sunrise

Turkish Colors Grace a Painting

I painted this windowpane painting in my Komtrak binder journal, using watercolor paper that can be inserted into the binding. While in Turkey, I admired the luminous effect of the remarkable Iznik tile work facing the interior and exterior of many Ottoman buildings. I borrowed the colors characteristic of Iznik tile work for this painting of a mosque at sunrise—rich red, orange, turquoise, blue and green. I finished the painting by adding metallic gold accents from my Krylon gold leaf pen. All the elements of this design, including the crossed lines of the *windowpanes*, were outlined with black felt-tip pen.

Don't Just Shop for Dinner

MATERIALS

Arches 140-lb. (300gsm) cold-pressed
 paper
Drafting tape
Full-spectrum triad pigments *Permanent
 Rose, Winsor Blue (Red Shade), Winsor
 Lemon*
Pencil
Pigma Micron .50mm black pen or water-
 proof felt-tip pen
No. 4 round
Table salt

Use the hidden opportunity of your routine grocery shopping to beckon a creative moment into your day. Pick out one beautiful piece of fruit or vegetable to use as a subject for a windowpane painting. Who knows? This could be the beginning of a charming kitchen series.

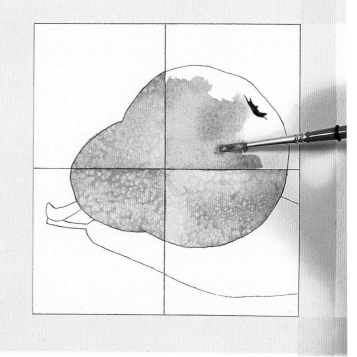

1 Trace the Design

Enlarge this drawing of a pear on a photocopier and trace it onto a piece of 140-lb. (300gsm) cold-pressed watercolor paper sized to fit inside your journal. An easy way to trace is to place the photocopy behind your piece of watercolor paper and secure them to a bright window. You will be able to see the photocopy from behind the watercolor paper. Be sure to draw the crossed lines creating the four squares. Tape the edges with drafting tape to make painting the borders of the design easier.

2 Paint the Pear in Sections

Using the full-spectrum triad, mix different colors for each of the four pear sections and paint each one. While the paint is still shiny wet, sprinkle it with salt to create a textured, naturalistic pear surface. Be sure to let each section dry before going onto the next one.

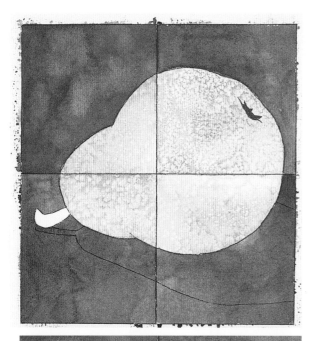

3 Paint the Four Background Sections

Using the full-spectrum triad, mix four different purple colors for each of the four background shapes. Your background painting will be untextured, while the pear shapes are by contrast textured with salt. This is the opposite of my examples, *The Escape Artist* and *Istanbul Sunrise* (see pages 48 and 49). There are many ways to go with windowpane painting.

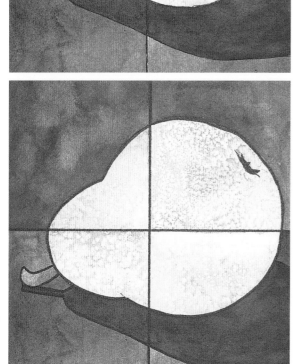

4 Paint the Stem

Paint the stem using a mixture of dark brown paint. When dry, darken the shadow areas in the two bottom sections. You may want to review the section on color mixing grays and darks with triads on page 31.

5 Outline All Shapes and Lines

Once you are sure everything is dry, remove the drafting tape. Go over all the lines of the pear, shadow, windowpanes and outside edges with waterproof felt-tip pen or black ink pen.

Room With a View

I love to look at landscapes framed by a window. When I lived in China, one of my special pleasures was riding on trains and viewing the passing landscape enclosed by the window and the ubiquitous white embroidered curtains. Hotel rooms, restaurants, portholes, my own home, friend's homes, they all provide unexpected opportunities for the landscape painter. For a new twist on the theme, draw everything inside the room with pen, adding watercolor only to the scenery outside the window. This fresh technique gives the viewer a sense of being in the room with the artist, while letting the landscape outside the window take center stage.

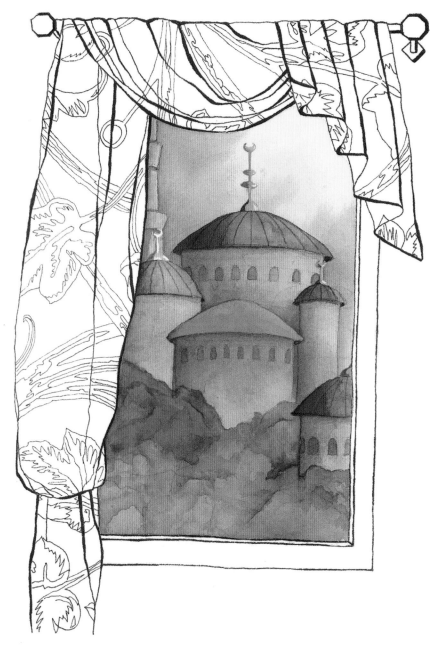

Ink the Interior, Paint the Exterior

I love to make room-with-a-view paintings of each of my hotel rooms when I'm traveling. I am always intrigued with the view, no matter what it is. In this case, my Istanbul hotel room offered an architectural and atmospheric treasure. I used pen to draw in the outlines of the window and the elaborate drapery. I went over some of the pen lines to emphasize the folds and edges of the fabric. Before painting the towers and domes of the Blue Mosque, I underpainted the entire area of the exterior landscape with soft pastel colors suggesting the golden glow of the rising sun. I wet the whole window area first with clean water, then dropped diluted mixtures of the full-spectrum triad onto the damp paper. After this soft underpainting dried, I completed the painting by adding architectural details of the mosque and the trees in the foreground.

Capture Simplicity and Sophistication

MATERIALS

Arches 140-lb. (300gsm) cold-pressed
 paper
Full-spectrum triad pigments *Permanent*
 Rose, Winsor Blue (Red Shade), Winsor
 Lemon
No. 2 round
Pencil
Pigma Micron .50mm black pen or water-
 proof felt-tip pen

I spent a peaceful weekend at a friend's home in the country. The lovely view out the window summed up my feelings for their warm and cheerful home. The combination of ink for the window and watercolor for the landscape outside, helped contrast the sophisticated interior of the room with the rustic landscape. I painted the scene outside the window with a childlike primitive quality to convey the simple pleasures of their country life.

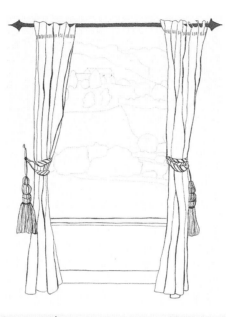

1 Draw the Window and Curtains
On a piece of watercolor paper sized to fit your sketchbook, draw the window ledge, window frame, curtains and other features of the room using a black felt-tip pen. Draw the scene outside the window lightly in pencil. The great part is that your composition is already framed for you by the boundaries of the window.

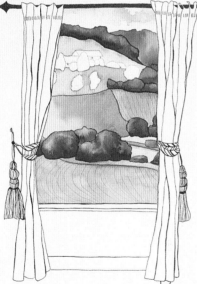

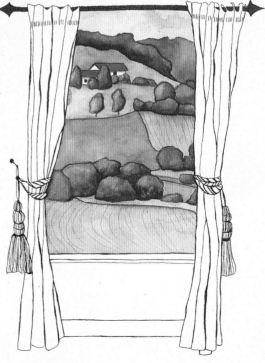

2 Bring Color to the Landscape
With the full-spectrum triad, paint the landscape framed by your inked window. I made a rich variety of greens using my method for mixing brights and shades with the full-spectrum triad (see pages 30 and 31).

3 Add Details
Add a few details and the painting is complete.

Travel Art Tips

The Collection

One of the joys of travel is becoming aware of the differences between cultures. Gather a group of items spiced with the local color—objects delightfully different from home or special in some singularly foreign way. The subjects of your journal collections are direct reflections of what you uniquely observe and love about the country, state or city you visit.

I think it's obvious—I love to keep artistic journals when I travel. Café art, the creative matrix, watercolor mosaics, one minute drawings—so many of the projects in this book were born while pursuing my practice of journaling when I travel. My children keep travel journals, too. They especially love suggestions for new, freeing formats. It's also fun to collaborate on journal pages with your travel partners. But, perhaps my favorite travel moments are those quiet, private ones, sitting in a shady café, drawing and painting. Here are a couple of my favorites for you to try on your next journey.

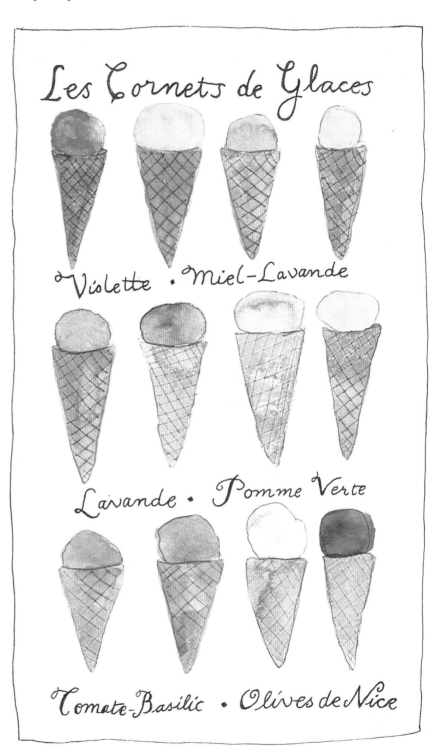

Les Cornets de Glaces

Violette • Miel-Lavande

Lavande • Pomme Verte

Tomate-Basilic • Olives de Nice

A Collection of the Ice Creams of France

I never could have predicted the fabulous flavors of ice cream in southern France. I realized on my first day in Nice that I had to make an exhaustive, personal study of the subject. My husband was happy to offer his assistance as we sampled an array of ice-cream cones during my journal "research." First, I put empty ice cream cone paintings on my page, then filled in the names of the flavors and colors of the ice-cream scoops as I went along. It took me two weeks to finish this travel journal page. I patiently waited for the most amazing flavors to appear before including them in my collection. Here are the flavors I discovered: Violet, Honey-Lavender, Lavender, Green Apple, Tomato-Basil, Olives of Nice.

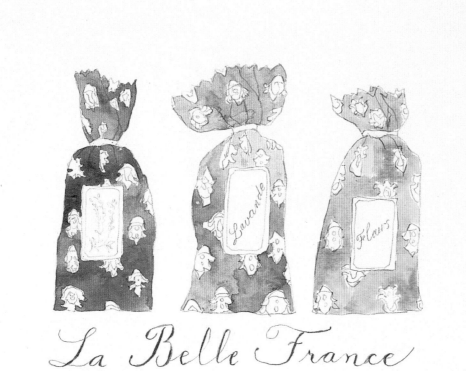

La Belle France

September 2000

Sachets Adorn My Title Page

This is the *frontispiece*, or title page, of one of my travel journals. I always begin with a page indicating the destination and the date. On the day we arrived, I fell in love with these little lavender sachets sewn with colorful provençal fabrics. This page is a collection, first drawn in pencil, then painted in watercolor. A simple idea can create a beautiful travel memory page.

Observation Icons

Isolate small aspects of your travel experience into delicious visual treats. Observation icons are painted symbols of the beauty of the natural world, edged with silver or gold, displayed on your journal page with raised mounting tabs. One approach is to choose a single theme for a group of icons on a page. Another is to devote a whole page to one special image. We all seem to appreciate the natural world more when we travel, when we see with refreshed eyes. Perhaps it is because we take the time to really look that makes the difference.

The Sea

Bodrum May 12

Gümüsklük May 13

Knidos May 14

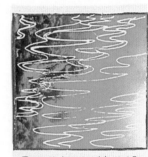

Bozukkale May 15

Ekincik May 16

Agliman May 17

Six Views of the Sea

I made this page of observation icons while sailing on the Aegean off the southern coast of Turkey. The sea was so beautiful—tinged and altered by the time of day, the light, wave patterns and weather. I wanted to record daily views of this fascinating phenomenon. Each day for six days, I painted one of the watercolor paper squares with the colors, textures and patterns I saw in the sea. I colored the edges of each sea icon with my Krylon gold leaf pen. I attached each icon to my journal page with four double stick mounting tabs, one on each corner. Each sea image is labeled with the place and the date.

Create an Observation Icon

MATERIALS

Arches 140-lb. (300gsm) cold-pressed paper cut into small squares

Full-spectrum triad pigments *Permanent Rose, Winsor Blue (Red Shade), Winsor Lemon*

Double stick mounting tabs, available at most office and craft stores

Gold Krylon pen

No. 4 round or medium Niji waterbrush

Pencil and pens

These geraniums were one of many that graced the courtyard of my hotel in Bodrum, Turkey. They are the perfect example to demonstrate how to make an observation icon. I love to use a medium sized Niji waterbrush when I travel. It holds water inside the handle. All you do is squeeze and clean water comes out.

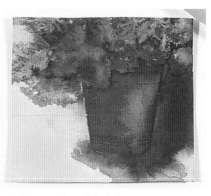

1 Create a Small Painting

Cut a small piece of watercolor paper, and paint the pot of geraniums. Use the full-spectrum triad, which is perfect for the bright, primary colors of this vibrant environment.

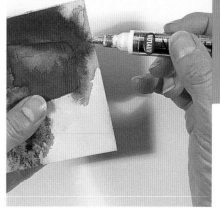

2 Gold Leaf the Edges

Color the edges of the finished painting with a Krylon gold leaf pen, creating the effect of a gold frame. Be sure to go over the edges two times with the gold pen to ensure an even metallic coating.

3 Press on Mounting Tabs

When the gold ink is dry, attach four double stick mounting tabs to each corner of the back of your painted observation icon and place it in the center of your sketchbook page.

Flower Pot at SuOtel Bodrum Turkey May 12 · 2001

4 Place Your Creation

Add a title and caption, including the place and date. This example shows just one observation icon. The painted image is highlighted with the raised mounting and the gold leaf edging.

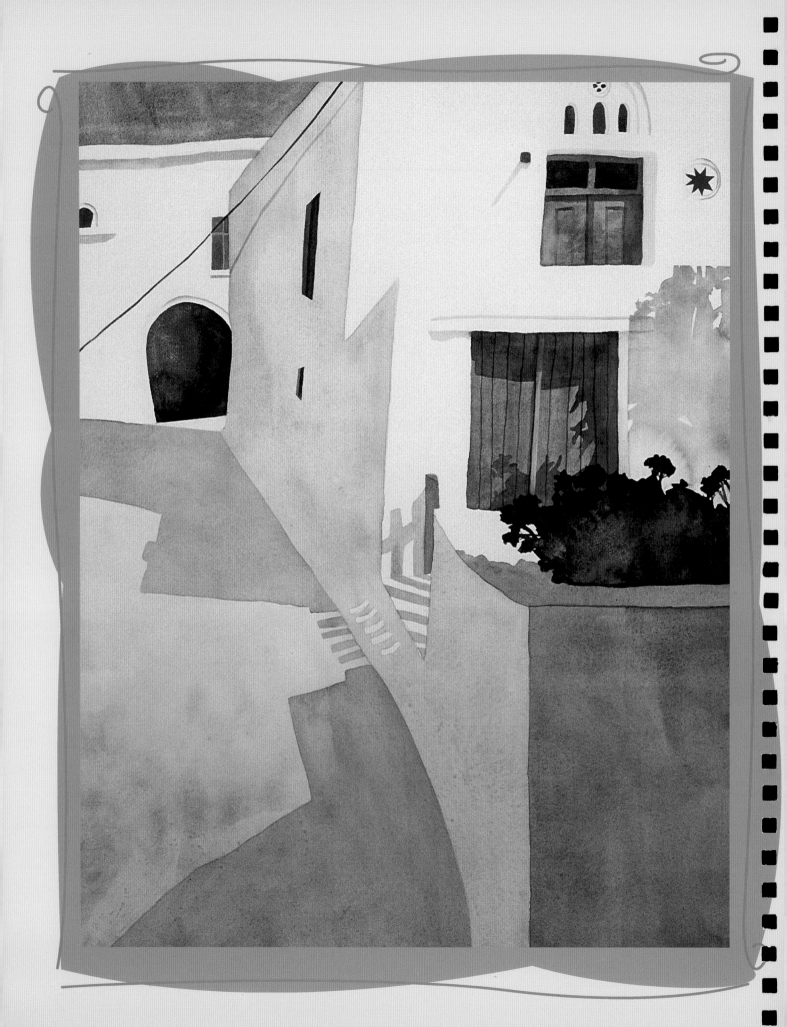

4

Putting It All Into Perspective

Painting is just another way of keeping a diary.

~ Pablo Picasso

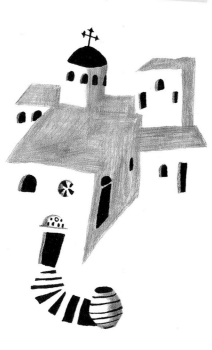

Your perspective is what makes you, you. You can bring more of yourself to your paintings and drawings with the art of perspective.

The traditional way to use perspective is to create the illusion of depth and dimension on a flat surface. Another way to use perspective is what I like to call creative framing. Creative framing is using an out-of-the ordinary vantage point to translate your inner impressions. The creative exercises in this chapter will show you how to use both of these approaches. Get ready for some new perspectives on perspective!

A comfortable understanding of perspective drawing—the traditional method—allows the viewer to see a landscape or interior from the artist's point of view. In the watercolor painting on the opposite page, I made use of one-point perspective to beckon the viewer to cross the threshold and step into this Greek island lane. As you look at this watercolor, it is as if you are standing in my shoes while I was creating it. Step a little to the left or right and you would see a different view.

Now, take a look at the sketchbook drawing on this page. It is a mixture of perspectives and conflicting planes. I drew it as if seeing the buildings from many different vantage points all at once. I wanted to suggest the quality of a hand-built environment—houses all cobbled together, no square corners or right angles in sight. Manipulating traditional ideas of perspective produces a very personal and playful vision of this same Greek village.

Keeping an artistic journal as a daily reference point helps me put my life into perspective, too. Some days, life is a jumble. As I sit down with my journal, I wonder what to capture. Shall I concentrate on just one narrow slice of my day? Or, embrace the larger constellation of my life? I use my artistic journal to reflect on my surroundings and sensations. Journaling is a wonderful way to discover your point of view and find a natural focus. The act of keeping art in my everyday life helps me truly acknowledge the present, appreciate the past and anticipate the future.

BLUE AND WHITE, SANTORINI
Watercolor on Arches 140-lb. (300gsm) cold-pressed paper
26" × 20" (66cm × 51cm)
Collection of Jan Stewart and Gordon Allen

Bird's-Eye View

One of my favorite art escapes is imagining a landscape from an aerial perspective. There is something dreamlike about visualizing flying above a garden and seeing it from a bird's-eye view. I love the play of shadow patterns against the blueprint of strong garden elements. Painting from a bird's-eye view puts fundamentals of one-point perspective effortlessly into your hands.

You will quite naturally discover rules of one-point perspective while doing this creative exercise.

I learned to use perspective only when I felt the need to show depth more convincingly in my paintings. So, I had a quick consultation with my friend, Bill, an architect. He simplified the basics for me quickly over coffee, drawing on the back of an envelope. Off to the studio I went to experiment. My advice is to avoid getting hung up on the rules and mathematics. Instead, dive into this exercise and learn to play with perspective—don't stress about it.

Escape from the ordinary by envisioning a garden in your mind's eye from the sky.

Imagine a Garden From Above

There are many drawings in my journal of imaginary gardens as seen from above. My own garden at home is a tiny, shady courtyard. Perhaps that's why I love to imagine landscapes with big expansive lawns, pools, tall trees and blazing sunlight. This watercolor painting came from one of these imagined garden sketches. One-point perspective helped me bring dimension and depth to the painting, inviting the viewer to look down into the garden from a point directly above. Seeing the garden from above allows me to highlight the shadow patterns of the trees and bushes, as well as show a footprint of the whole garden plan. I included a pathway at the right and left to suggest that the garden continues into the distance.

Vanishing point

Use One-Point Perspective for Depth

This invented landscape allowed me to decide exactly where the bird in my bird's-eye view is suspended over the garden. I decided that the bird is flying directly above the center of the garden. Think of a bird flying with a camera and taking a picture while hovering directly above the middle of the pool. That point is the vanishing point. That's the point of view of this painting and all the lines of the tree trunks refer to that point. That is one-point perspective in a nutshell (or eggshell). All you have to do is slant all the tree trunks so that they line up pointing to the vanishing point. Use a straightedge to connect the dots of the tree trunks to the vanishing point. That's all there is to figuring out the angles of the trees.

Make a Garden

MATERIALS

Arches 140-lb. (300gsm) cold-pressed
 paper
Drafting tape
Full-spectrum triad pigments *Permanent
 Rose, Winsor Blue (Red Shade), Winsor
 Lemon*
Nos. 2 and 4 rounds
Pencil
Salt
Straightedge or ruler

Paint Your Home From a Bird's-Eye View

Pretend you are a bird flying above your own home and garden. All you can see is the design of the garden, not all the branches and leaves and certainly not any garden debris. Concentrate on the overall blueprint, not the details. You may want to invent what you would like your garden to look like. This can be a wonderful wintertime journal activity. If you don't have a garden where you live, invent one. In fact, don't stop there, invent a house or cottage to put beside it. Use one-point perspective to create a sense of depth as you look deep into your garden space.

Follow along with me as I paint an invented garden landscape as seen from a bird's-eye view. I discovered this style of painting several years ago when I stood at the top of a tall Venetian tower and looked at the garden directly below. I loved seeing the design the trees and their shadow patterns made from this unusual vantage point.

1 Draw the Garden Elements

Enlarge my painting on a photocopier and trace it onto a piece of watercolor paper. (Or create your own bird's-eye design.) An easy way to trace is to place your drawing or photocopy behind your piece of watercolor paper and set them up against a bright windowpane. You will be able to see the drawing right through the 140-lb. (300gsm) watercolor paper. Tape the edges of the drawing with drafting tape. Be sure to draw in the shadow patterns made by the trees. Notice that all the shadows of the trees are parallel with one another. This is always true of shadows emanating from the sun.

2 Paint the Grass Areas

Mix an ample amount of green for the grass by combining Winsor Lemon with Winsor Blue. With a no. 4 round, paint all the lawn areas an even yellow-green. Continue with the no. 4 round to paint the pool an evenly applied blue shade, using Winsor Blue with a touch of Permanent Rose.

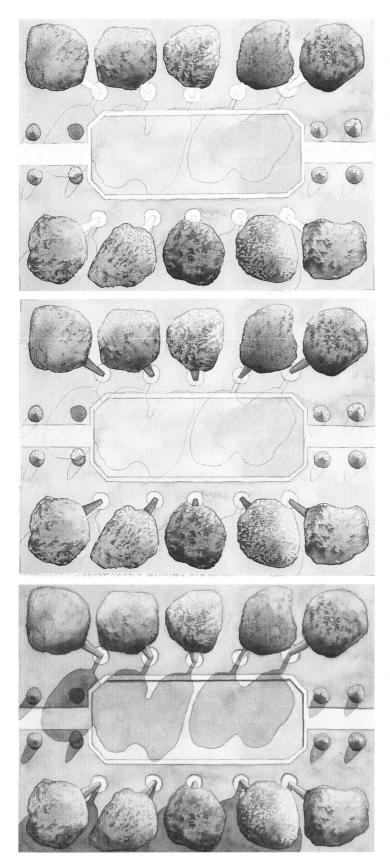

3 Paint the Trees and Bushes

Use the no. 4 round to paint the foliage of the trees a light yellow-green mixed with predominantly Winsor Lemon and a small touch of Winsor Blue for the sunlit areas, and dark green for the shadow side. I mixed a dark green hue by first creating a bright green of Winsor Blue and Winsor Lemon. To that mixture I added a small bit of Permanent Rose to gray the color to a deep, dark green. While the paint is still shiny wet, drop in salt for a textured appearance (see page 83). It helps to draw an arrow or symbol on the taped edge to remind you of the direction of the sun.

4 Paint the Pathways and Tree Trunks

With a no. 2 round, paint the pathways a light yellow-tan made by mixing Winsor Lemon with a bit of Permanent Rose. Paint the trunks of the trees a brown shade using the no. 2 round, keeping the sunlit side lighter, and darkening the shadow side. My trick for mixing rich browns is to make a bright orange with approximately equal amounts of Winsor Lemon and Permanent Rose. Then add little bits of Winsor Blue to gray it to just the right brown color.

5 Paint the Shadows

The trees and bushes cast deep shadows from the sunlight. With the no. 2 round, darken the lawn, pool and pathways in the shadow areas. Use a more concentrated mixture of the same pool blue you used originally. Mix the grass shadow color from Winsor Blue and Winsor Lemon. Remember to pay attention to the angle of your shadows; they should be parallel to one another to replicate how shadows from the sun appear. Remove the tape and take a visual walk in your imagined landscape.

Piazza Perspective

Invite some friends or family members to Italy! Along the way, you will discover two-point perspective as you paint your loved ones into a Renaissance town square.

Perspective drawing teases the eye into seeing and believing an illusion of depth. The best way to learn perspective drawing is by having some fun with it. With this creative exercise you will gain a comfortable intuitive understanding of how two-point perspective works, all by putting your hands to work building a piazza. Come along and I'll show you the tricks and techniques you'll need for the construction of this painting.

I know it's easy to get stumped and confused by the rules of perspective drawing. Trust me on this one—your painting will be dramatic and realistic after completing this creative itinerary.

Use Two Eyes to Create Three Dimensions

Here is a trick about perspective drawing. Figures of the same height, on the same plane, all have their eyes at the same level, no matter how close or far away they are. This is a useful thing for the artist to know.

Let's look at our Italian piazza. I drew all three figures as if they were all basically the same height. The eye level, my vantage point, is the reference point for everything in the drawing. My son, standing closest to me, is the young man at the left. (I can almost hear him say, "Hurry up and finish drawing, Mom!") My daughter, in the middle, is standing further back. My husband, at the right, is walking even further back in the piazza.

Notice that all eyes are at the same horizontal level—the eye level—even though the figures are in different places on the town square. That's the interesting thing about this particular perspective situation. Keep the eye levels of the figures constant (assuming everyone is about the same height) and the feet will end up in the right spot. If you want to put a shorter person or child in the picture, you simply have to lower the eye level a little bit below the standard reference point.

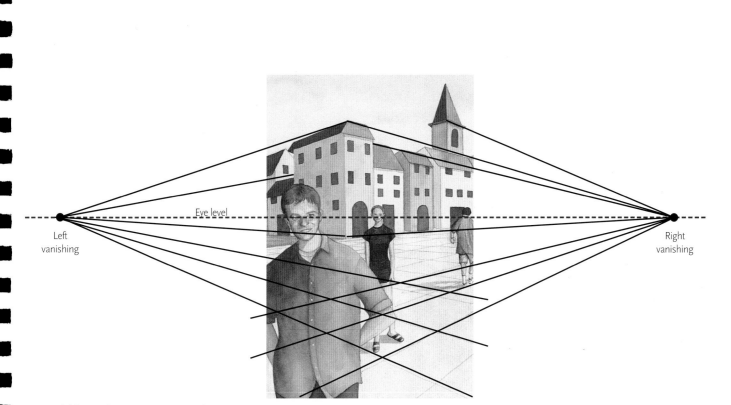

Vanishing Points Create Perspective

Take a look at the rooflines and tops and bottoms of the windows. They all slope downwards, meeting at two vanishing points, one at the right and one at the left. Now look at the base of the buildings. They slope upwards, meeting at the same two vanishing points. Above the eye level, lines slope down; below the eye level, lines slope up. Two-point perspective comes into play when you look at a building from an angle. Basically, when you can see two sides of a building, then you'll have two vanishing points, which means two-point perspective. Simple enough! To simplify further, note that all the vertical lines of our buildings stay parallel to each other.

Let's look at the paving stones of the piazza. See how the lines of the pavement also meet at the two vanishing points. Use perspective to make a tile floor or paving blocks look realistic.

Paint With Perspective

MATERIALS

Arches 140-lb. (300gsm) cold-pressed
 paper cut into small squares
Drafting tape
Full-spectrum triad pigments *Permanent
 Rose, Winsor Blue (Red Shade), Winsor
 Lemon*
Nos. 2, 4 and 6 rounds
Pencil
Salt
Straightedge or ruler

Look through your photo references for people you would like to include in your painting. I added the figures by tracing them from photographs. The drawing of my son was taken from a small photo, which I enlarged on a photocopier and then traced onto the watercolor paper. I traced both my daughter and husband directly from the photos. I knew that no matter how large or small they were, if I placed their eyes at the same level, they would end up being in the right spot for correct perspective. I fudged a little bit because all three people are not exactly the same height, but it still works well enough to be convincing. That's what I mean about not getting too hung up on the math. I use perspective as a tool and technique to support, rather than stymie, my creativity. Just remember to keep the eye level constant, that's the trick.

Reference Photographs

1 Draw Your Figures in the Piazza

Enlarge the piazza painting on a photocopier, and trace just the buildings and pavement onto a piece of watercolor paper. Leave the figures out. Draw in the vanishing points and eye level in pencil (they will be well past your drawing so use a large enough piece of paper).

Trace your figures into the drawing, placing them wherever you want them. Make sure the eyes are placed at the eye level. Erase the eye level line once you have all the figures in place. Make adjustments to accommodate large height differences between your figures. Put the eyes of a very tall person above the eye level, and the eyes of a very small child below the eye level.

Tape the edges of the drawing with drafting tape. With the no. 6 round, underpaint by covering the whole paper with a very light, muted yellow shade. The yellow underpainting will infuse the painting with a golden, old-world accent.

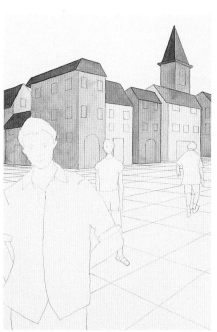

2 Paint the Buildings and Roofs

Check with a straightedge to insure that the angles of the roofs lead to their vanishing points. Use the no. 4 round to paint the buildings with different shades of yellows, oranges, pinks and warm grays. Paint the roofs a terra-cotta orange color.

3 Paint the Pavement and Windows

Use the straightedge to check the tops and bottoms of the windows; be sure they lead to their vanishing points. Paint the windows dark blue.

Paint a light tan mixture all over the pavement of the square using the no. 6 round. While the paint is still wet, use the corner of a credit card or a bamboo pen to scratch along the lines of the pavement blocks. Inscribing into the wet paint produces darker lines when it dries. With a no. 2 round, paint a natural looking shade on the faces, and other areas on the figures where skin is showing.

4 Paint the Faces and Figures

With a no. 2 round, paint the faces of the figures by referring to the photographs. Add the shadows cast by the figures on the pavement. Darken the shadow side of the roofs and the buildings. Take off the tape and admire your painting. Congratulations! You have just painted using two-point perspective.

Leave Out a Ground

My students laugh when I tell them that what I leave out of a landscape painting is more important than what I put in. I say that to remind all of us that we don't have to include every tree, branch and leaf we see. In fact, the more you refine your vision, the more successful you are at revealing the essence of your personal experience. Artist Raoul Dufy said, "My eyes were made to efface what is ugly." By that I think he meant "Go ahead and take out that clutter if you want so we can see what you really, truly love about this landscape."

Before composing a landscape painting, take a good look at your subject, and identify the foreground, middle ground and background. Isolate each of these areas in your mind, seeing each one distinct from the other two. Practice this reframing process when painting outdoors or when working from a photograph. Then, give yourself license to simply eliminate one, or even two, of these grounds. What's left is the passionate distillation of your unique vision.

Eliminate the Background and Preserve the White of the Paper
This watercolor painting was inspired by a photograph taken by my friend, Robert Cantor, while on vacation in Corsica. After a mental reframing process, I decided to concentrate on the two elements most significant to me, the sea and sailboat of the foreground, and the citadel of the middle ground. I eliminated the background mountains, sky and clouds. Leaving the background area unpainted focuses attention on the stunning play of light and shadow on the walls, rocks and houses of the citadel, and the graceful sailboat skimming the brilliant blue sea. It also made it faster to paint!

Make Seven Paintings From One Landscape

Leaving out a ground is a liberating form of creative framing. You can easily paint the same scene several times, leaving out and including different grounds as you change your frame of mind. In fact, you can frame one subject at least seven different ways.

Background
Mountains and sky

Middle ground
Citadel and rocks

Foreground
Water and boat

Foreground, Middle Ground and Background

PHOTOGRAPH BY ROBERT CANTOR

Foreground Only

Middle Ground Only

Background Only

Foreground and Middle Ground

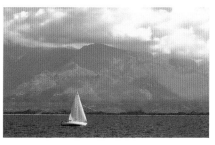

Foreground and Background

Middle Ground and Background

Panoramic Perspective

Another fun art escape exercise is the painted panorama. Practice creative framing by isolating a narrow slice of a photograph into a panoramic perspective. Use this technique to salvage a poor photograph or make a good picture even better. There are no rules about how long or how narrow the image should be. Whatever gives you the most exciting visual information should be your rule of thumb for determining the borders. You can also make what I call keyhole paintings by framing a narrow vertical slice of a photograph, in addition to the horizontal framing shown here.

PHOTOGRAPH BY ROBERT CANTOR

Isolate a Narrow Band

Robert Cantor took this photograph of the fourth 1998 Yankees-Padres World Series game. I isolated the action of the pitcher and batter, eliminating most of the photograph. The panoramic framework allows me to cut out the least interesting elements—the tops of the heads of the press in the front and much of the stadium stands. The charged energy of the game is heightened by paring down the photograph and reframing it to highlight what's most essential—the players and the closest fans.

Watercolor With a Wide-Angle Lens

I like to fade the edges of my panoramas to create painted vignettes. This technique subtly suggests to the viewer that there is more to this scene, but I'm showing you the best parts. I painted this image on a piece of 9" × 12" (23cm × 30cm) Arches 90-lb. (190gsm) cold-pressed watercolor paper. I used 90-lb. paper because I planned to display this painting in a folded frame format. The 90-lb. paper is best for this purpose because it folds crisply.

Get Involved in the Action

Sports are perfect for panoramic paintings because the interest is often spread over a wide field. Make paintings from quickly drawn sketches completed on site at ballgames. Or use the VCR to freeze-frame a highlight of a recorded sports event. Take your journal along with you to your children and grandchildren's sports practices and events. I loved making panoramic drawings during my daughter's ballet classes, and while sitting on the bleachers at my son's baseball games. Here is a trick to capture the action. Freeze just one moment with a quick drawing. Use your one-minute drawing skills from chapter two to capture the basic gesture of the figures. Use your memory to add definition. Since the background isn't in constant motion, you can take your time filling in the surrounding details.

PAGE-A-DAY IDEA

Make a Panoramic Viewfinder

Reframe your photographs by looking at them through a panoramic viewfinder that you can easily make. See your photographs in a new light by cutting out distracting elements and focusing in on the visual action.

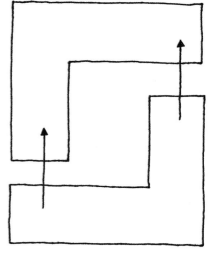

1 Cut the Paper in Half
Cut an 8½" × 11" (22cm × 28cm) piece of white cover stock (or other sturdy white paper) in half, ending up with two identical 5½" × 8½" (13cm × 22cm) pieces.

2 Cut The Viewfinder
With a ruler, mark a 2-inch (5cm) border along the top edge and the left side edge. Cut along the lines, creating a 2-inch (5cm) wide right-angled corner. Cut the other piece of paper the same way.

3 Overlap the Pieces
Overlap the two right angle corners to create a panoramic viewfinder. You can adjust the height and length of the opening to frame the visual action of your photograph to its best advantage.

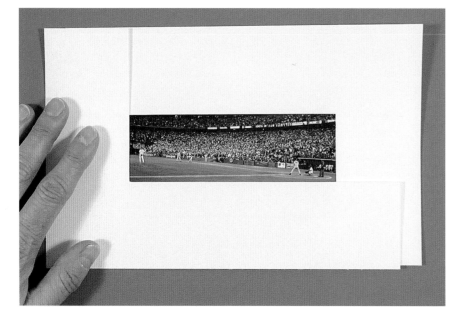

Frame Your Panorama
I moved and adjusted the two pieces of the viewfinder until I found just the right image to frame. I found precisely the elements in the photograph that I wanted to include in the painting.

Create a Folded Frame for Your Panoramas

MATERIALS

Arches 90-lb. (190gsm) cold-pressed
 paper, cut 9" x 12" (23cm x 30cm)
Bone folder or table knife
Craft knife
Double stick tape
Full-spectrum triad pigments *Permanent
 Rose, Winsor Blue (Red Shade), Winsor
 Lemon*
No. 2 round
Pencil
Straightedge or ruler

Bring your art out of the studio and into your life! Display your painted panoramas in a handmade folded frame on your desk, table or shelf.

I like being able to artfully display my watercolors without having to go to the bother and expense of a traditional mat and frame. This handmade folded frame is a wonderful way to present art to your friends. Slip it into an envelope and fill someone's letter box with an artistic surprise.

For this exercise you will need a bone folder or a table knife. A bone folder is a book art tool used to fold paper by hand. The typical folder is made of white bone, about 6 inches (15cm) long and 1 inch (25mm) wide, with a tapered point.

FOLD

CUT

2 Fold and Cut the Display Frame
When your painting is dry, make the folds as indicated. Always fold through one single layer of paper at a time for cleaner and more accurate folds. Slit the center of the paper with a straightedge and craft knife as indicated by the dotted line in the diagram.

1 Paint the Panorama
Fold a 9" × 12" (23cm × 30cm) piece of 90-lb. (190gsm) cold-pressed Arches watercolor paper in half. Score the line of the fold with a bone folder or the dull edge of a table knife blade before folding to get a crisp fold. Paint your panoramic composition on the bottom half of the folded paper. As you paint, the fold should be facing upward in a *mountain* position, rather than a *valley* position.

Paint the inside panels
of the display "box."

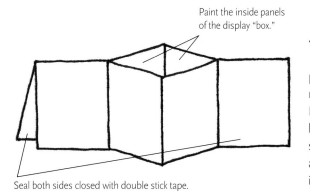

Seal both sides closed with double stick tape.

3 Display Your Painting
Paint the two inside panels with a color complimentary to your painting. Fold as shown and seal both ends with double stick tape. Give your creation to a friend or display it on your desk at work. This folded frame format makes a wonderful painted display card.

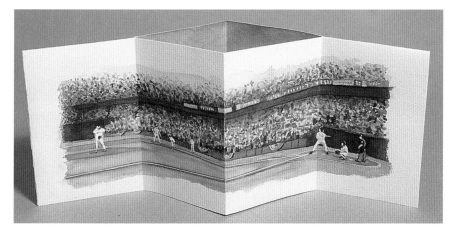

Panorama Folded Frame

The Sensory Perspective

Each of our five senses is a precious gift. Create a shrine of appreciation to each of them by painting abstract watercolors inspired by sensory mindfulness. The five-senses exercise invites you to be attentive to each of your senses, one at a time. What story is your sense of hearing telling you? What scents does your nose detect in the air right now? What taste sensations are lingering on your tongue? Where do your eyes pause and focus? How does your skin feel?

Discover a place of sanctuary. Is it a favorite park? A room in your home? A city street? A garden? Wherever that place is for you, take a few moments for what I call a sensory walk. Gently shut down the rest of your mind, and as you walk, simply listen, smell, see, taste and feel. Hold onto each impression for a moment. Heighten the awareness of your body and mind in space and time.

Become a vessel for a sensory engagement with the natural world.

Normally, we blend all our sensations together into one overall impression. The differnece with this exercise is that you isolate each of your senses, and reflect on each one separately. This is a great way to creatively frame your personal perspective.

Sense of Hearing

I made this watercolor painting while I was sitting in a café by the yacht harbor in a small Mediterranean town in France. I was sitting peacefully, sipping a fresh-squeezed lemonade, listening to the gentle sounds of water lapping against the ancient seawall and splashing against the yachts anchored in the harbor. All of a sudden, an ambulance arrived, with a screaming siren. The red stripes in my painting represent the sound of the blaring horn, in contrast to the soft purples and greens representing the sound of the waves and water, and tinkle of cups and glasses in the café. After completing the painting, I cut it into four strips to create a collage. You can see that some sounds appear louder than others!

Sense of Taste

I like to make five-senses paintings on blank watercolor postcards. These are very handy, especially when traveling. This painting represents my sense of taste while in Turkey. I savored the fresh vegetables, the rich Turkish coffee, delicious black olives, tangy goat cheese...all that and more is in this watercolor! To create texture I scratched into the wet paint with the edge of a credit card, sprinkled salt onto the wet paint, and spattered red paint from my paint brush.

Sense of Touch

As I sat in the sun on the rooftop of my Istanbul hotel, I thought about all the sensations of touch I remembered from the previous two weeks in Turkey. Soft warm breezes and sharper, cooler winds, brisk dives into the sea, the smoothness of hand-polished woodwork on our boat, the relaxed feeling throughout my whole body as I lay on the deck as we sailed. It was a pleasure to recall all these sensory memories, and great fun to bundle them up into an abstract painting.

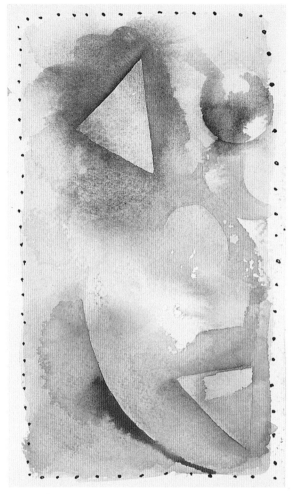

Sense of Smell

This little painting on a watercolor postcard represents what I perceived through my sense of smell as I took a sensory walk in a seaside town. The restaurants must have been preparing for lunch. My nose picked up the marine air of the sea and the pungent scents of the fisherman's fresh catch, as well as very tangible notes of garlic, olive oil and eggplant sautéing. All the scents were distinct, but they melded together into a beautiful sensory concoction.

Sense of Sight

I feel as if I'm back in the Italian seaside town of Portovenere when I see this watercolor. After a sensory walk, I settled into a fine café and encapsulated my impressions of sight into this abstract painting. As I look at it now, I recall the warm tan tones of the ever-present stone building blocks and the brilliantly colorful umbrellas of all the cafés lining the harbor. Sunshine and bright Italian fabric colors round out my impression. It's amazing how many memories these watercolors bring back. The act of creating from the treasury of your sensory storehouse is a powerful spiritual experience.

The Scents of Turkey

Turkish coffee brewing · flowers at the Su Otel · flowers from Bill for Andrea · musty odor of old carpets · white goat cheese pungent goat scent · pine trees at Agliman inlet · sun screen · salty sea breezes · fragrant spices wafting up to the Rustem Pasha Camii from the Egyptian Spice Market · cigarette smoke at restaurants · sweet lily scent from my birthday flowers · diesel exhaust on the boat · lamb grilling on spits at kebab shops · braziers selling corn on the cob · fish at markets · surprisingly fresh air at covered market ·

List Your Impressions

After you complete a five-senses painting, make a list of all the impressions that flood your mind. Just list them, don't bother with sentences. You will be surprised by how much awareness you carry, and how many feelings you can remember as you start listing them. This is a page in my artistic journal from a trip to Turkey. This watercolor is dedicated to the sense of smell. My friend, Andrea, gave me some Turkish stamps. I loved the colors and designs, so I added them to the image. I attached my painting to a page in my journal with some double stick mounting tabs. I enjoyed the process of remembering and reliving all the wonderful scents of Turkey. The listing format freed me from worrying about grammar or sentence structure. I just kept listing and listing until I ran out of room.

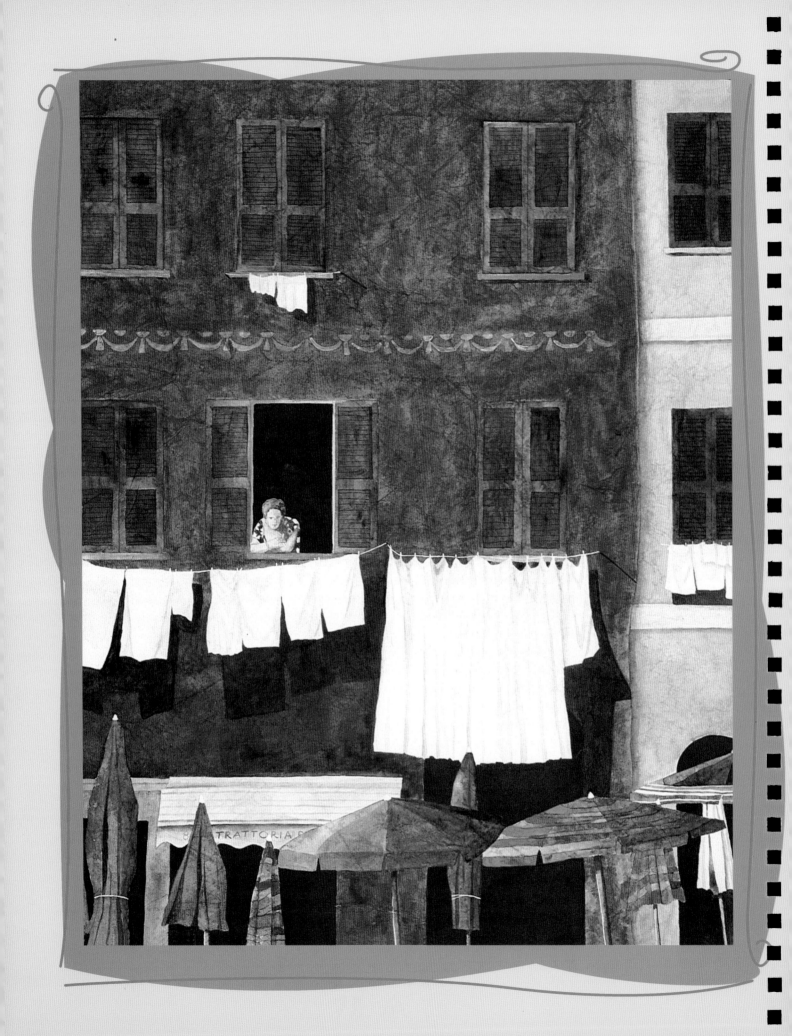

5
Art Assemblage, Collage & Other Inspiring Ideas

I am my sketchbook.

~ Pablo Picasso

Making collages is exciting. I love the spontaneity of cutting and pasting. The best part is that I don't need a plan to begin. Collage is a dynamic tool for spontaneous design. Transform the ephemera of daily life—candy wrappers, ticket stubs, bottle labels, postcards and stamps—into enduring images. My spirit of invention soars when I construct abstract assemblages, and paint on unique collaged surfaces.

This chapter is a resource manual of my favorite collage techniques, time-tested and shared with many friends, students and colleagues. All you need is your collage tool kit to get going on new, energizing page-a-day creations. You will learn how to make watercolor mosaics, painted paper cutouts, paper weavings, crinkled paper collages, and found-object collages.

Each project is an open door to a fresh approach in your artistic journal. There are many page-a-day ideas and creative prompts to trigger your imagination. I hope you enjoy the experimentation of art assemblage, and the invitation to celebrate the day in new invigorating ways.

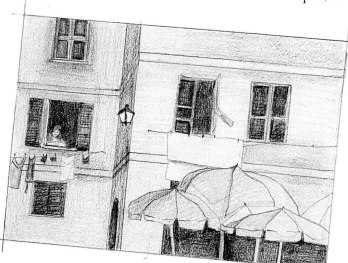

WASH DAY, VERNAZZA
Watercolor on crinkled Masa paper collage, mounted on
Arches 140-lb. (300gsm) cold-pressed paper
26" × 20" (66cm × 51cm)
Collection of Randall Vemer

Watercolor Mosaics

I think of watercolor mosaics as inventions of the soul. Make a mosaic-of-the-moment in your journal and see what springs forth from your brush, your hands and your spirit.

There is infinite diversity to this simple format. Expand your visual vocabulary with abstract collage art. Some artists have become positively addicted to this art habit.

Cut Pieces in Random Sizes
I had fun assembling this design to commemorate a day spent with friends. I tried to recreate the blues and greens of the river and sky on my painted paper. I cut the rectangles and strips in random sizes for variety, some large, some small and some medium. The composition came together quickly after I cut the pieces. I included both the sailboat and boathouse in the finished design. It all started with rectangles and strips.

Free Your Spirit With Mosaic Art

A few years ago, my family had just begun a very special yearlong sojourn in Europe. I was so excited to begin our adventure, and so full of ideas and dreams of the artwork I would produce. There was one problem; I was paralyzed with the limitless potential. The French countryside where we started our sabbatical was so heartbreakingly beautiful. How was I going to paint it? How could I do it justice? I broke through my painter's block by creating watercolor mosaics. I started painting paper, simply replicating the colors of the French hills, vineyards, farmhouses and flowers. Then I cut my French-inspired watercolor papers into rectangles and strips. I designed them into abstract collages and glued them into my brand new journal. I broke through the barrier of "what to do?" with a liberating artistic invention.

Express Yourself in Colorful Abstractions

I created this watercolor mosaic in response to the tragic events of September 11, 2001. I used color and design, rather than a direct depiction, to reveal my emotions. I painted a piece of paper with the colors of intense fire and smoke, then cut it into strips before gluing the collage into my journal.

9.11 NYC
Watercolor and collage on Arches 140-lb. (300gsm) cold-pressed paper
5" x 6" (13cm x 15cm)

Use Black or Colored Backgrounds

Let the Subject Emerge

Take a piece of watercolor paper and simply enjoy painting on the paper, without giving any thought to your subject matter. The subject, at this moment, is you. Remember, the muse comes to the moving brush. You may want to paint more than one piece of paper, as you loosen up. If you like, play some music while you paint.

Pick one of your painted papers and cut it into rectangles and strips. Create a watercolor mosaic, allowing the subject to surface unbidden. Give your mosaic a title only after you finish composing your design. Perhaps you will discover something about yourself in the process. Sometimes I don't know what the inspiration for an artwork is until it is done. This is part of the magic of art.

Take a look at the watercolor mosaic, *Friday Night Chopsticks*. You can see it in its original form on top, and recreated against a background of black cardstock below. It's surprising to see the brilliant mosaic pieces as they appear against different backgrounds. Experiment by varying background colors for your mosaics—it all adds to the spirit of innovation. You can create your own version of *Friday Night Chopsticks* using the step-by-step demonstration on pages 84-85.

FRIDAY NIGHT CHOPSTICKS
Watercolor, gold leaf and collage on Arches 140-lb. (300gsm) cold-pressed watercolor paper
5" × 6" (13cm × 15cm)

Add Texture Using Special Effects

One of the wonderful attributes of watercolor is the ability to add fascinating texture to the painted surface. Here are four of my favorite techniques. Have fun and experiment with all four as you create painted papers for your watercolor mosaics. Use one or combine two or more of these techniques for added surface richness.

Scratch

Scratch a pointed object into wet paint and you will produce a dark line on your paper. The paint puddles into the valleys created by the impressions made with the pointed tool. On the right, I inscribed lines with the tip of a bamboo pen; the dark marks in the middle were made from the point of my scissors. Scratching into dry paint creates white marks as you reveal the paper. The white marks on the left were made by scratching with a craft knife.

Sprinkle Salt

Scatter salt from a shaker over your painting while the paint is still shiny wet. As the wet paint dries, the salt absorbs the pigment, leaving white, starlike shapes. Experiment with different kinds of salts—kosher, margarita, table—for different versions of the same natural phenomena.

Spatter Paint

I spattered yellow paint on top of wet red paint. When the red background was dry, I filled a toothbrush with blue paint and ran my finger across the bristles to produce a fine blue paint spray. The best way to spatter with a paintbrush is to knock your loaded brush against your other hand, which is resting securely on the table for support—not up in the air. Spraying clean water onto wet paint with a sprayer will produce light spatter marks.

Add Metallics

I include Krylon leafing pens in my drawing tool kit. They come in gold, silver or copper. I love the shimmering metallic accents stroked over dry watercolor paintings. The Krylon pens are great because of the richness of their metallic coverage.

MATERIALS LIST

Acid-free rubber cement

Arches 140-lb. (300gsm) cold-pressed
paper, cut to fit inside sketchbook

Full-spectrum triad pigments *Permanent
Rose, Winsor Blue (Red Shade), Winsor
Lemon*

Krylon leafing pen: gold, silver or copper

No. 6 round

Pen tips and pointed tools for texturing
Rubber cement pick-up tool, or
gummed eraser

Salt

Scissors

Scratch paper for gluing

The best way to adhere all your mosaic pieces to a paper surface is with the dry mount glue technique. The great advantage of this method is that you don't have to glue each mosaic piece individually.

Here is how it works: Cover the back of your uncut, painted watercolor paper with rubber cement. Let it dry. Cover the paper where you want to mount your mosaic with rubber cement and let it dry. Now, cut your collage pieces out of the painted paper. Simply press each collage piece onto the paper substrate, and the two dry glued surfaces will bond together. Follow the step-by-step instructions below. You will save lots of time and make gluing a breeze with the dry mount gluing technique. Be sure to buy acid-free rubber cement (Elmer's makes one) to preserve your artwork.

1 Create Color and Texture on Watercolor Paper

Use the full-spectrum triad to paint rich colors onto Arches 140-lb. (300gsm) cold-pressed paper. Inscribe into the wet surface with the bamboo pen. Sprinkle salt and spray clean water onto the semiwet paint. When dry, add some calligraphic marks with the Krylon 18 Kt gold leaf pen. At this point in the process the subject is still unknown. Simply enjoy playing with the paint and have fun layering textures and colors. The subject will reveal itself as you continue.

2 Apply Glue to Your Painting

Lay your dry painting face down on a piece of scratch paper. Spread an ample amount of acid-free rubber cement over the back and past the edges of your painting. Let it dry until it is no longer sticky to the touch.

3 Apply Glue to Your Journal Page

Spread acid-free rubber cement over the page in your journal where you want to adhere the mosaic. Be sure to apply rubber cement over a larger area than you imagine your finished design will be so that you have freedom when placing the pieces. Let the glue dry until it is no longer sticky to the touch.

4 Cut Rectangles and Thin Strips

When the rubber cement on your painting is thoroughly dry and no longer sticky, cut your painting into strips about 1-inch (25mm) wide. Now cut most of the strips into squares. Cut freely—don't bother measuring the strips and squares with a ruler. It is not important to produce rigidly uniform shapes. Cut some of the wide strips into thinner strips for accent pieces. Create a large pile of painted mosaic rectangles.

5 Design Your Mosaic

Lay all your cutouts on a separate piece of paper and pick the ones that attract you. Play with the pieces until you find a pattern that appeals to you. You won't use all the pieces. If you want to cut the pieces again, go ahead and trim. Turn your composition upside down and sideways to see if it is balanced. You'll see your mosaic with new eyes simply by viewing it from a different angle. You might even like it better upside down.

6 Transfer Your Design Onto the Glued Surface

Replicate the pattern you created by picking up each mosaic piece and setting it onto the glued paper surface. Each piece will bond to the glued paper because of the contact of dry rubber cement on both surfaces. After you have placed all the pieces, use a rubber cement pick-up tool or a gummed eraser to rub away the excess rubber cement. The subject of your mosaic will emerge as you create your design. Finish your mosaic with a title and your signature.

85

Painted Paper Cutouts

Henri Matisse created vibrant collages by "drawing with scissors." Inspired by the freedom of his method, I create my own version of painted paper cutouts in my artistic journals. Design without drawing—let your scissors describe the shapes for you. Don't like the shape? Just cut again!

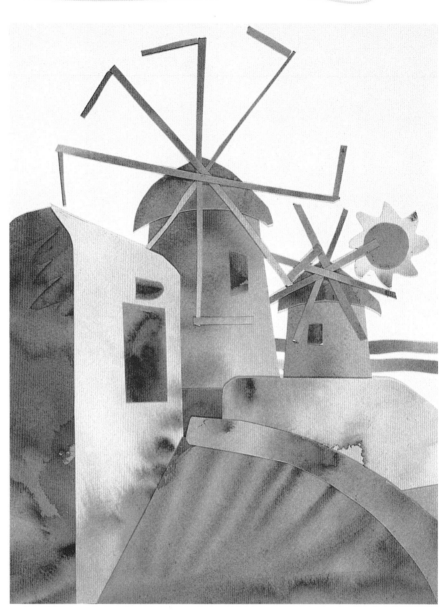

Contrast Brilliant Colors Against a White Background
Monica Wheeler interpreted her love of the island of Mykonos in this bold magenta watercolor cutout. You can almost feel the warm sunset glow over the windmills so typical of this Greek island. Against the white paper of her journal page, the monochromatic color is brilliant in its simplicity.

WHY MYKONOS?
Monica Wheeler
Watercolor on Arches 140-lb. (300gsm) cold-pressed watercolor paper
10" × 8" (25cm × 20cm)

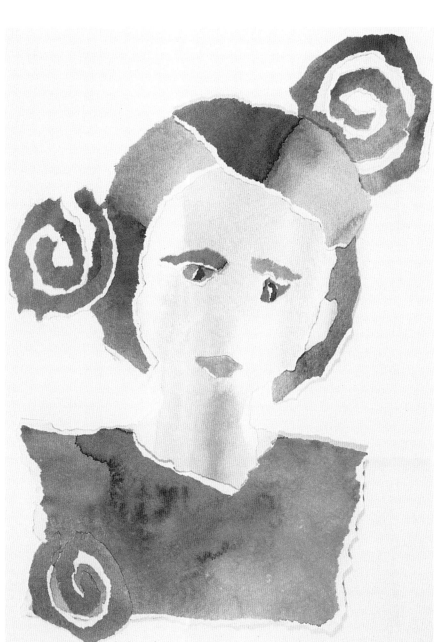

Cutout Collaborations

Ask a friend or family member to collaborate on a portrait. Ask them to loosely paint a piece of watercolor paper, covering it from edge to edge. Have them select colors they are particularly drawn to. The colors should represent something about that person. If your friend or family member gets stuck with that concept, ask them to think about the colors they love to wear. This usually represents a person's favorite colors.

Use the painted paper to make a cutout portrait of your subject. Try the torn paper technique for a very personal and uncomplicated image. Give the original collage to your friend or family member as a gift, and make a color copy to insert into your journal.

Tearing Painted Paper

Tearing paper for collages is a freeing way to create shapes. It's hard to get too fussy when you are tearing paper. I love the raw white deckled edge of torn painted paper. The white outline allows you to draw attention to shapes in your composition. The torn spiral patterns added to this self-portrait are ancient Greek symbols for chaos and energy. On some busy days, that motif seems like the right symbol for my life! It was restorative to take some time for myself out of a day full of activity to create this sketchbook self-portrait.

SELF-PORTRAIT
Watercolor on Arches 140-lb. (300gsm) cold-pressed watercolor paper
8" x 11" (20cm x 28cm)

Create a Colorful Background Blanket

MATERIALS

Acid-free glue stick

Arches 140-lb. (300gsm) cold-pressed paper, 10" x 14" (25cm x 36cm) piece and one cut to fit inside your sketchbook

Full-spectrum triad pigments *Permanent Rose, Winsor Blue (Red Shade), Winsor Lemon*

No. 6 round

Scissors

Scratch paper for gluing

This painted paper assemblage recalls the fish, sailboats and sea of the island of Corsica. The background blanket is painted in turquoises and blues—brilliant Mediterranean colors. My full-spectrum triad eased the blending of these exuberant hues. I made this painted paper collage while on a ferry ride from Corsica to Nice. Out came my scissors, glue stick and a lot of memories of a week in Corsica. What a wonderful way to while away an hour or two.

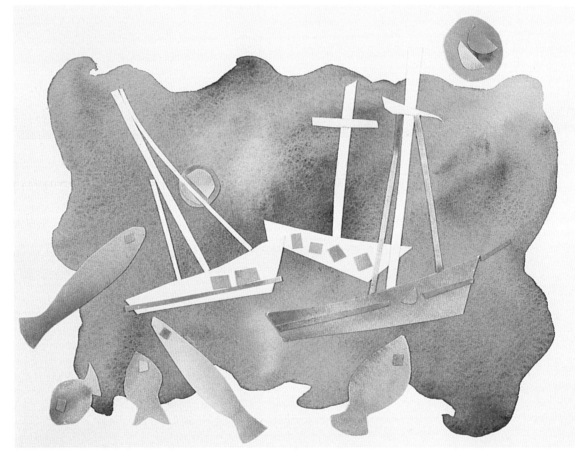

CORSICAN MEMORIES
Painted paper on Arches 140-lb. (300gsm) cold-pressed watercolor paper
8" x 10" (20cm x 25cm)

1 Paint a Colorful Wash

Paint an entire piece of cold-pressed watercolor paper with loose splashes of colors derived from your subject. You don't need to describe the subject as you paint—just record the colors of the landscape, objects or figures in your theme. Have fun and paint freely to cover the paper with unself-conscious broad color washes.

2 Create a Background Shape

On another piece of cold-pressed watercolor paper, paint a colorful background shape—a large rectangle, ellipse, circle or other shape. Think of the painted background shape as a blanket to hold your cutout shapes. Vary the blanket shape to indicate the atmosphere of your theme. This painting suggests the waves and colors of the sea. Some other possibilities are a starry dark blanket for a night scene or a field of green grass for a pastoral subject.

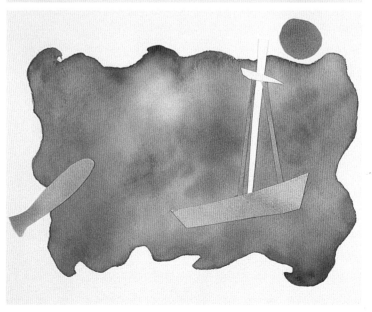

3 Glue Your Shapes on Top of the Background

Take your painted paper from step 1, and cut shapes that will float on top of your painted background blanket. Cut out fish, boats and sun shapes with your scissors. Move the pieces around to decide where to glue them. Use an acid-free glue stick. It's surprising how pleasurable painting, cutting and gluing can be.

Paper Weaving

Weave a Garden View

This page is from a journal I made a few years back. Its a very uncomplicated paper weaving—that only took a few minutes. I used two blank watercolor postcards to make the paintings. On one, I quickly painted the greens of the foliage in my garden on a June day. On the other, I painted the colors of the late spring flowers, budding and blossoming in my little garden patch. I casually cut the paintings into strips and wove them together. You can see that I didn't bother cutting the strips evenly or in perfectly straight lines. I like this informal look—especially in my journal. I picked one of the flowers and tucked it underneath the paper weaving. It's pleasing to look through my sketchbook and be reminded of a garden that grew several years ago.

"June Garden". woven Collage

Create unique paper weavings in your artistic journal. Merge two paintings or photographs together into a construction that combines both in a fascinating way. The end result is greater than the sum of its parts. It's exciting to see how your woven image turns out. There is always a happy surprise when you are done.

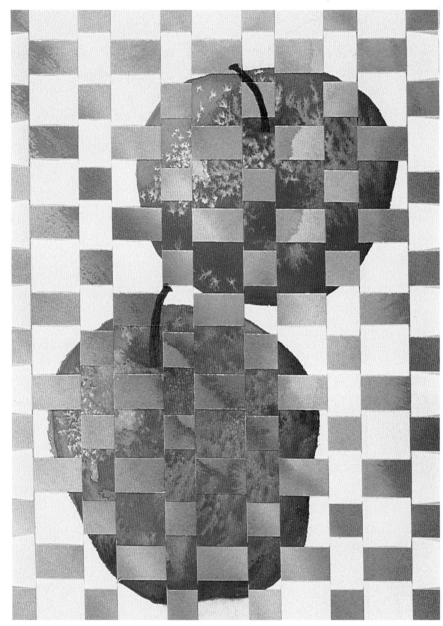

The White Background Makes the Subject Stand Out
One way to create a dramatic paper weaving is to leave the background white. I painted two apples onto a piece of Arches 140-lb. (300gsm) cold-pressed paper, leaving the background unpainted. The second painting is a wash of red and green apple colors. I like the way the apples stand out strongly after weaving the two images together.

BELLE MELE PER FRANCO
Watercolor on Arches 140-lb. (300gsm) cold-pressed paper
7" x 10" (18cm x 25cm)

Weave a Wavy Memory

My daughter, Laura, made a collage for her college dormitory room out of two identical photocopies of a favorite photograph of our cat, Hercules. She cut each one into vertical strips, without a ruler—just cutting with scissors freehand. Using the dry mount glue technique, she adhered each strip to her page with rubber cement. She made an original, spirited image from two matching photocopies, just by cutting and pasting twin strips next to each other.

Your finished collage will be twice the width of your original photo because of doubling the identical strips. Crop both photos on the sides to focus attention on your subject. In this way you can temper the width of your finished artwork.

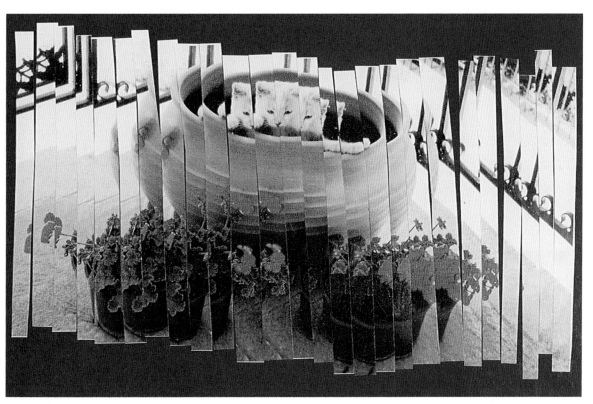

Double the Impact

The dry mount gluing system is perfect for this project. Follow the same procedure described on page 84. Before you cut the two identical photos, photocopies or postcards, spread rubber cement over the back of each one and a page in your artistic journal.

When the rubber cement is no longer tacky, cut each image into vertical strips, about ¼-inch (6mm) wide. Be sure to keep all the pieces in order. Lay the strips down onto the dried rubber cement on your journal page. In this case, Laura used a piece of black mat board as her background, rather than her journal. Place each twin strip next to its mate. You can offset the strips a bit to create an animated uneven edge.

HERCULES
Laura Kanter
Paper weaving from photocopies, glued onto black mat board
5" x 8" (13cm x 20cm)

Demonstration

Weave two paintings together to combine two observations of one theme, in an extraordinary way. One painting depicts the sky, clouds and watery waves of the seashore. The other describes the beach grasses and flowers growing near the dunes.

1 Paint Two Different Ways
Identify two aspects of the subject and paint each of them on a 4" × 6" (10cm × 15cm) piece of watercolor paper or a postcard. Paint one image depicting the sky, clouds and sea. Paint the second one showing the colors and textures of the beach grasses and flowers.

2 Cut Vertical Strips
Set the sky/clouds/sea painting on a cutting board, stretch drafting tape across the top ¼-inch (6mm) edge of the painting and secure it. Use a craft knife and ruler to cut the painting into vertical strips, cutting them alternately ½-inch (12mm) and ¼-inch (6mm) wide. Cut the strips only up to the lower edge of the tape, leaving the painting uncut underneath the tape.

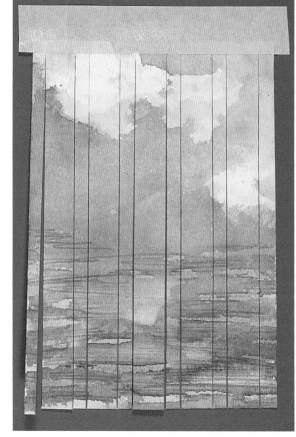

3 Cut Horizontal Strips

Use a craft knife and cutting board to cut the beach grass/flower painting into horizontal strips, again alternating between ½-inch (12mm) and ¼-inch (6mm) widths. This time cut all the way across, keeping the strips in order.

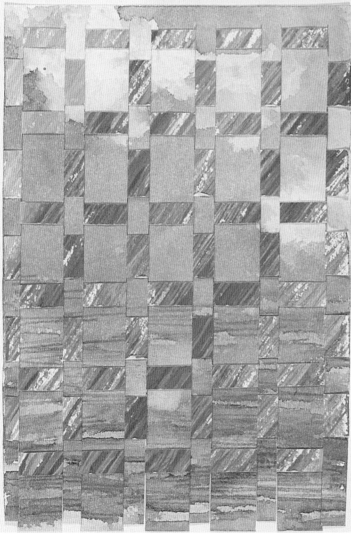

4 Weave the Strips Together

Take each horizontal strip and weave it into the vertically cut sea painting. Alternate rows beginning over and under, then under and over. Alternate between the ¼-inch (6mm) and ½-inch (12mm) strips to create an attractive pattern. When you finish weaving, tape the back of the collage along the edges to keep the strips from unraveling.

SEA WEAVE
Watercolor on Arches 140-lb. (300gsm) cold-pressed watercolor paper
4" x 6" (10cm x 15cm)

Crinkled Paper Collage

Mingle the traditional and the innovative by painting on crinkled paper collage. Crunch up a piece of paper and unfold it—you have just created a strikingly textured surface for watercolor. Paint directly on the crinkled paper or glue it onto a piece of watercolor paper before painting. In both cases, a fantastic veined surface will appear as you apply watercolor. This wholly unique effect is a wonderful tool to add to your artistic repertoire.

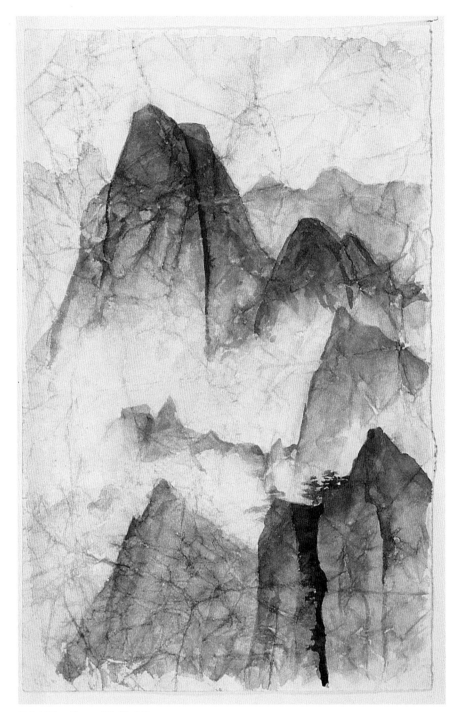

Paint Directly on Crinkled Paper

Japanese Masa paper is similar in appearance to white butcher paper, but it is much stronger when wet. I crunched up a piece of unwaxed Masa paper. Then I unfolded the paper and started painting with watercolor. When finished, I lightly tacked this watercolor sketch onto my journal page with a dab of glue at each of the four corners. I love the instant texture that developed on the painted mountains. As the wet watercolor soaks into the grooves of the crinkles, batik-like lines and veins appear on the surface. This quick sketch was in preparation for *Yellow Mountains, China* on page 10. I often use my artistic journal for experimentation before beginning larger works.

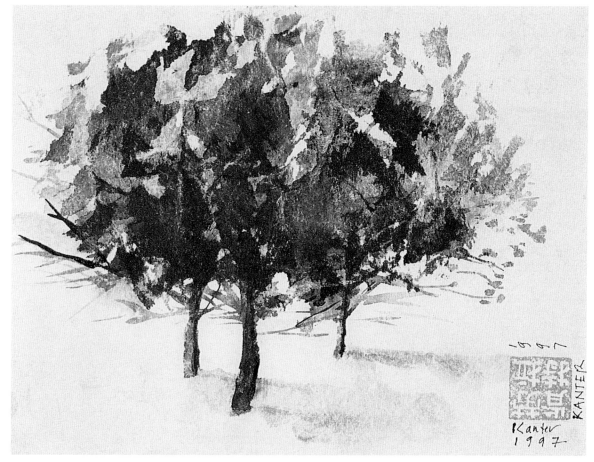

Paint on Crinkled Masa Paper With Ink

This is another example of painting directly onto crinkled Masa paper. I let the creases and bumps in the paper help make the tree shapes. I loaded a no. 6 round with black sumi ink. Holding the brush on its side, I stroked it over the bumps and folds of the crinkled paper, which I did not stretch out completely flat. The brush hit the raised paper folds and missed the areas inside the creases. When the large tree mass was established, I added a few lower branches and leaves to the edges using a no. 2 brush held upright in the customary fashion. Next I painted the trunks of the trees. When done painting, I completely unfolded the paper and glued it onto the stiff surface of my sketchbook cover using white PVA glue. When glued flat, I used a carved stone chop to stamp my name in Chinese characters. Ink paintings on crinkled paper convey a distinctively Eastern simplicity and elegance.

Make Botanical Studies With Crinkled Papers

Lines and veins appear quite naturally in crinkled paper collages painted with watercolor. This distinctive textural effect makes a beautiful surface for botanical subjects. You can create amazingly lifelike leaves and petals. This painting was made with crinkled Masa paper, glued onto 140-lb. (300gsm) watercolor paper. I stained the whole sheet of crinkled paper with light tones of blues and violets after it was glued onto the watercolor paper.

FEBRUARY BULBS
Watercolor on crinkled Masa
paper mounted on Arches 140-lb.
(300gsm) cold-pressed paper
13" × 20" (33cm × 51cm)

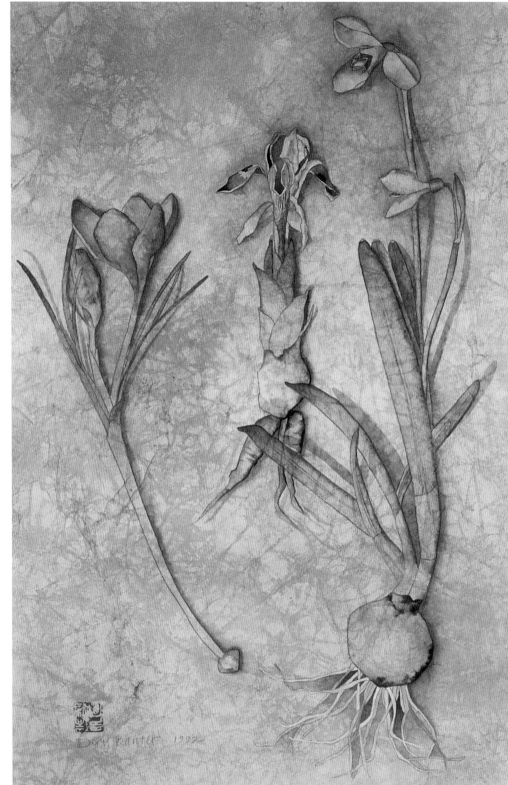

Rich Color and Texture

MATERIALS

Arches 140-lb. (300gsm) cold-pressed paper

Brayer

Clothes iron, set on the lowest temperature

Elmer's white glue or acid-free PVA glue

Glue brush

Nos. 2, 4 and 6 rounds

Sun triad pigments: *Holbein Marine Blue, New Gamboge, Permanent Magenta*

Spray bottle filled with water

Plastic wrap

Unwaxed Masa paper or white butcher paper (not as strong when wet)

2B pencil

Create a naturalistic texture for your floral paintings with this special collage technique. The creases of the crinkled paper collage make lifelike veins and tonal variations in the painted flower petals and leaves. Follow the step-by-step instructions to make a crinkled paper floral painting.

1 Draw the Image

One side of the Masa paper is smooth and shiny, the other side is rough. With a 2B pencil, draw a floral design on the shiny side of the paper. After drawing, crush the Masa paper into a tight ball. Don't be afraid of crumpling the paper too much, the creases create the textural effect. Unfold and gently press the paper flat with your fingers.

2 Add Color

Spray the Masa paper with clean water. With a no. 6 round, loosely paint on top of your drawing. Veins will appear where the paper is creased. Use pure New Gamboge and Permanent Magenta, and a purple mixed from Permanent Magenta and Marine Blue for the flowers. Mix a bright green using New Gamboge and Marine Blue for the leaves, and light Marine Blue for the vase.

When dry, flatten by lightly ironing on the back side of the painted Masa paper. Glue the painting onto a slightly larger piece of 140-lb. (300gsm) cold-pressed watercolor paper with white or acid-free PVA glue. Cover with plastic wrap to protect the Masa paper, and roll with a brayer to press flat. Remove the plastic wrap, and let dry.

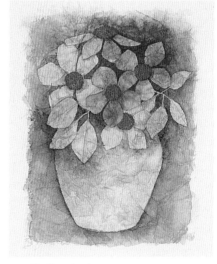

3 Define the Image

Make the subject appear by painting the negative shapes behind it. Use a no. 2 round to paint darker values of the same color mixtures as in step two, to darken the shapes behind the flowers, leaves and vase. Leave the subject untouched to preserve the freshness of the underpainting. The creases in the Masa paper emerge as you apply wet paint to the surface. The more you paint, the more the creases appear. Finish by adding red centers to each of the flowers with a no. 2 round using a mixture of New Gamboge and Permanent Magenta.

Found Object Collage

The Weekend Collage

This week, keep a resealable bag with you to collect all the labels, ticket stubs, menus, newspaper clippings and attractive papers you find. Then, over the weekend, cut, tear and arrange the papers into a collaged composition. Look for variety in color and shape, layering translucent papers on top of others for a subtle effect. Center the eye on a dominant area or focal point that is supported by all the other design elements. Lightly paste the collage pieces in place temporarily so you can make changes if you wish. When you have settled on your composition, apply glue from a glue stick over the back of each piece. Press down so that all the shapes lay flat when dry. Don't forget to take a moment to admire the new pages in your artistic journal.

Thomas Edison said, "To invent, you need a good imagination and a pile of junk." What some call junk, I call treasure. Recycling is an art form. What normally is lost, instead, can be turned into found object collages. Gather a collection of attractive scraps—newspaper clippings, tickets, bits of wrapping papers, handwritten letters and notes, leaves, flowers, printed E-mail messages—all these bits and pieces have personal meaning and memories. Transform these everyday artifacts into page-a-day artistic journal creations.

Reclaim Old Sheet Music and Candy Wrappers
Recently I found some tattered sheet music, yellowed with age, at a secondhand store. I love incorporating bits of sheet music into my collages. I also included a stamp I peeled off of a postcard from China. The transparency of the white rice paper on top of the black torn rectangle creates a subtle layered effect. It was fun combing through my scrap paper collection and combining bits and pieces into this collage.

Labels Inspire Art

A label from a bottle of mineral water found its way onto a page in my journal. The bright sunset image caught my eye. It became the inspiration for my journal watercolor painting. I'm glad I tore the label off the bottle and saved it. Sometimes inspiration for artwork comes from the most unexpected places. The first step is collecting fabulous scraps, and gluing them into your sketchbook—the best place to experiment with new ideas, images and approaches.

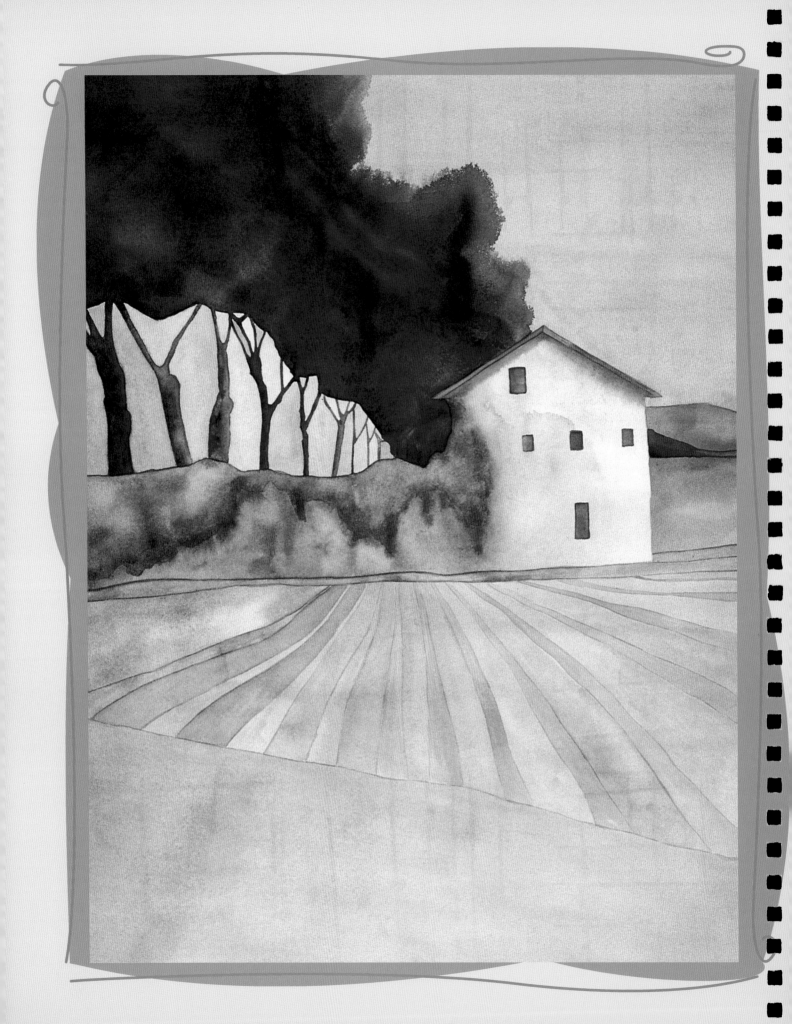

6 Let's Go Outside and Paint!

I love to paint outdoors. In this chapter, I'd like to share with you my joy of landscape painting. My best work comes when I am relaxed and enjoying myself. My four-step strategy to *plein air* painting helps me to "paint the way a bird sings"—freely, intuitively and passionately.

How do you get from seeing to painting? What are the steps to get you there? Over the years, I discovered four key steps to painting a landscape. Each step leads you quite naturally to the next one—from *inspiration* to *shapes* to *values* to *color*.

An essential element is painting with passionate color, rather than photographic color. In this chapter, you will learn how to convey the mood of the landscape with my four color triads. It's time to get acquainted with the dynamic personalities of what I call the full-spectrum, earth, water and sun triads!

No two artists will capture a scene in the same way. Your impressions reveal what only you distill from a moment and place in time. It is a delightful truth that everyone experiences the kaleidoscope of life uniquely. I hope the projects and suggestions in this chapter will persuade you to go outside and paint your world!

> I would like to paint the way a bird sings.
>
> ~Monet

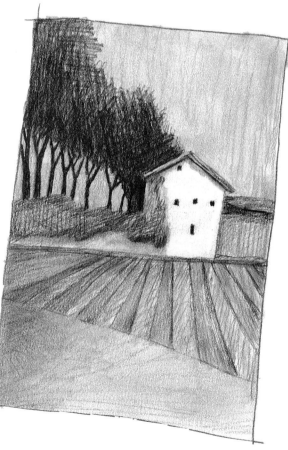

PROVENCE: SUMMER ABUNDANCE
Watercolor on Arches 140-lb. (300gsm) cold-pressed paper
28" x 20" (71cm x 51cm)
Collection of Susan Monti

Inspiration: The First Step

The first step allows you to absorb the beauty of nature. You can be inspired by any number of aspects in a natural setting. The important thing is that you recognize what stirs you. Let that spiritual force propel your painting. Although this is the single most significant step to painting with expression, strangely, it is often overlooked. Get in touch with your emotional response to the landscape, otherwise you will have nothing to communicate to the viewer.

Take advantage of all your senses: sight, sound, touch, smell and taste. Look this way and that, until you find one view that attracts your attention more than others. Take a moment to ask yourself, "What is it about this place that I want to take home with me? What do I want to remember?" That is the element you need to emphasize in your painting.

Always refer back to your original source of inspiration. My quest is to produce paintings of beauty, originality and meaning. This initial step reminds me to put first things first, to reflect on what inspires my sight and my soul, and incorporate that essence in my artwork. As Paul Cézanne said, "Painting from nature is not copying the object; it is realizing one's sensations."

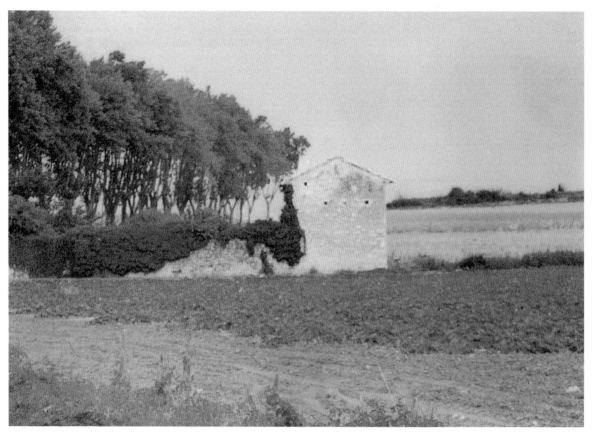

Record Your Inspiration
Painting landscapes *en plein air* has deepened my experience as an observer and traveler. I always take photos to include in my artistic journal. But a photo can never substitute for the on-site, in-the-moment acknowledgment of your sensations. This photograph was taken of a landscape in the south of France, and is the inspiration for *Provence: Summer Abundance* on page 100. I wanted to encompass all my passion for this countryside in my watercolor painting.

Aureillac • France • 2:30 p.m. • August 10 • I'm sitting on the sunny patio of our rustic rented house ••• my feet on the warm paving stones ••• crickets & locusts chirp & buzz all around, then suddenly stop until the bug chorus starts up again ••• the vineyard bursts with fresh green shoots & heavy leaves ••• everywhere I look I see & feel & touch life ••• even the earth is alive with a robust red-amber hue ••• the sky too is lit with life ••• is it the heat that makes it shimmer? ••• a light breeze whispers at my neck & hugs my legs ••• the breeze brought the scent of lavender, rosemary & thyme ••• I can almost taste the tang of the herbs on my tongue ••• I want to stitch together the abundance, fertility, fruitfulness, & vitality of this radiant & vibrant landscape into my painting.

Possible title • Summer Abundance

Brainstorm Your Emotional Response

After taking some moments to drink in the landscape, I like to record my sensations by writing in my artistic journal. I always make note of the time of day and the date. In the process of brainstorming my sensory reactions, I find it easy to distinguish vivid sources of artistic inspiration.

Write It Down

Start by recording your impressions of a landscape in your sketchbook journal. Write for ten minutes continuously, without stopping. Chronicle your primary reactions and responses, without editing. A variation on this method is to write without lifting your pencil off the paper, one word flowing right into the next. I find this practice quite liberating.

Here are some questions to get you going:

- How does the air feel on your skin?
- Which colors attract your eye?
- What fragrances or odors does your nose detect?
- What sounds do you hear?
- What does your sense of taste detect?
- Does the light or shadow in one area particularly attract you?

After your ten-minute free-write, give your painting-to-be a working title, even before you begin painting. This working title will gently remind you to always refer back to your original inspiration, directing your attention to what you most want to communicate in your painting. The title can be descriptive, *The Red Door*, or metaphoric, *Wild and Free*. Remember: this is your own unique experience. Celebrate it!

Shape Plan: The Second Step

Step two is simple; less is more! This is especially true when composing a land-scape. Artists talk about learning to *see*. For me, that magic moment occurred when I learned to shift my vision from all the leaves on a tree and instead, saw a tree as one large shape.

Convey the essence of your inspiration by stretching beyond detailed represen-tation. Simplify all you see in the landscape into ten to twelve abstract shapes. Focus on the big picture and eliminate detail. See shapes, rather than individual objects. Create unity by linking and interlocking shapes like pieces in a jigsaw puzzle. The underlying structure to your painting comes from seeing the landscape in as few shapes as possible.

Create a Strong Composition With Shape Plans

Take out your sketchbook and make thumbnail shape plans of your subject. Vary the format from horizontal to vertical. Draw the outline of the shapes with no detail at all. The more you experi-ment with different ways to frame your subject, the more original your composition will be. Crop the scene in different ways until you come up with a design that reflects your inspiration from step one. Draw from a variety of angles; come in close on the subject, and view it from far away. Give yourself the time to discover an inspired composition, expressing your response to the landscape. Experiment with a variety of shape plans. If you have drawn more than twelve shapes, take anoth-er look. Combine shapes. Take out unnecessary detail. Remember, less is more.

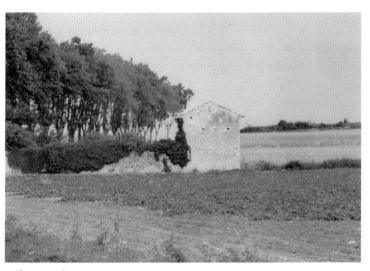

Reference Photo

Walk on the Wild Side

I know a wonderful landscape photographer. He can make a familiar scene appear totally fresh by showing the viewer a completely new perspective. His secret is to assume that for the first fifteen minutes all his shots will be the usual, trite responses. After he gets the obvious out of his system, he begins to discover unusual angles. I've seen him crouch down on his hands and knees to shoot up at a sharp angle and jump on top of a stone wall to shoot his subject from above. I follow his advice when *plein air* painting and assume that my first drawings are going to be the most ordinary ones. I allow myself the time to work past conventional compositions. After my first attempts, I start seeing from a more unique perspective. Give yourself permission to get warmed up and go a little wild. Walk around and explore the landscape for fifteen minutes to allow unexpected viewpoints to arise. Discover the hidden beauty.

Look for an Underlying Design

Select one shape plan from your thumbnails to develop into a painting. Count your shapes—remember no more than twelve. All shapes fit into each other in jigsaw puzzle fashion. Can you find an underlying structural design to your composition? Do all the shapes fit into a larger pattern that ties the whole image together? Look at the dotted lines to see the Z structure that underlies this entire composition. Think about the design as a whole and how all the elements work together.

Value Plan: The Third Step

A well-composed painting is half-done.
~ Pierre Bonnard

In step three you turn your shape plan into a value plan. Values are the relative lightness and darkness of a color. They range from the pure white of the paper to the blackest black, and all shades of gray in between.

In music, there are soft, lyrical passages. There are also places where the dynamics are loud and the cymbals crash. The same is true in painting. The value choices you make can create areas of intensity. They can also create passages that sing with a softer, gentler voice.

The eye is attracted to contrast. Wherever you place the lightest light next to the darkest dark, you create a point of interest. In essence, you are crashing the cymbals and banging the drums! Likewise, you create serene sustaining passages when you stay within a narrower range of values.

Build a Value Chart

It's a good idea to make your own value chart to add to your artistic journal for reference. I find it's best to use Winsor Blue, a pigment that can go from very, very light to very, very dark. Draw five squares on a piece of watercolor paper, labeled from 1 to 5 as shown. Start by filling in the square for value 5 with as dark a blue as you can, using Winsor Blue. The darker you can make it, the better. Next, fill in value 3, the middle square. Take your time to match the value in my chart. Next fill in the square for value 4. Your shade should be halfway between value 3 and value 5. Lastly, complete the value chart by filling in the square for value 2. It is halfway between value 1 (white of the paper) and value 3.

Shape Plan　　　　　　　　　　**Value Plan**

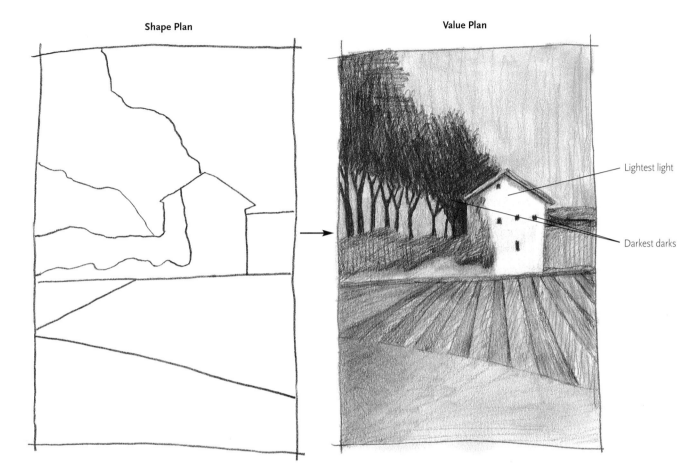

Lightest light

Darkest darks

Go From the Shape Plan to the Value Plan

Add shading in pencil to indicate your value choices on top of your shape plan. Put in your darkest values first. Next, add the lightest values. Where they meet is your painting's center of interest. Now add midtones everywhere else. Where there is no shading, you are indicating white of the paper, or value 1. Are you sure that is what you want in that area? Refer back to the brainstorming you did in step one. Does your value plan reflect your original inspiration and working title? Are you bringing the viewer's attention where you most want it? Refer back to your value chart to remind yourself of the full range of values possible.

Using a Red Filter to See Values

Being able to see the highlights, shadows and everything in between is a skill worth learning. A trick I learned from a photographer friend is to use a red filter to view the landscape. Photographers find it useful to previsualize the landscape, obscuring color to mimic the contrast in black and white film. As you look at the landscape through a red filter, all the value contrasts are heightened. You'll find it easier to see the lightest lights, the darkest darks and all the midtones in between because most of the color information is filtered out. I buy inexpensive clear red acetate at the art supply store and cut a piece into a 6" × 4" (15cm × 10cm) rectangle. Tape the acetate onto the back of an inexpensive 5" × 7" (13cm × 15cm) mat with a 3" × 4½" (8cm × 11cm) pre-cut window. I tuck it into my sketchbook so I have it handy while I'm composing my landscapes. Use what you learn by looking through the red filter when making your value plan.

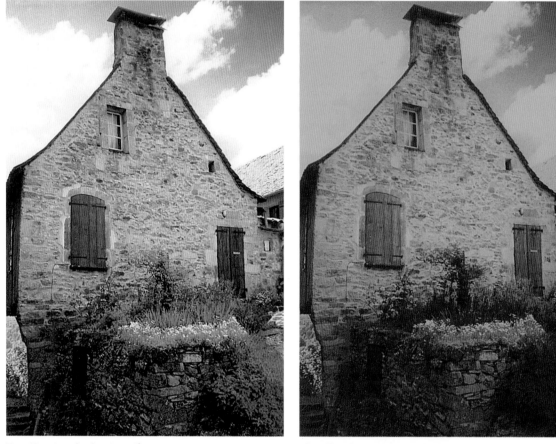

Turn Your Inspiration Into Shapes

This is a photograph I took while on a painting vacation in the Dordogne region of France. I was attracted to the irises growing like purple flags in the pocket garden in front of the house. I had a little bit of time to draw and paint, so I pulled out my sketchbook. I spent a few minutes brainstorming what appealed to me about this village house. I realized I loved the contrast between the rugged stone construction and the brilliant, fresh, dewy iris garden tucked into the front of the house. Next, I got started making thumbnail shape plans. I chose one to develop further into a painting.

Identify Values With a Red Filter

I was ready to make my value plan. I pulled my red acetate filter out of a pocket in my sketchbook to see the values in this scene more clearly. I'm glad I had my red filter with me while I was on location because it helped me make a value sketch. I was able to see how the light flowers in front of the irises stand out from the darker foliage behind them. Also, it helped me notice the dark value of the wooden shutters and door set against the stones of the house.

Moving From Landscape to Painting

The landscape artist has the ability to transform reality to better communicate an emotional response. I often elect to make my own value choices when painting a landscape. You can bring the viewer's attention to any aspect of your painting by simply pumping up the value contrast.

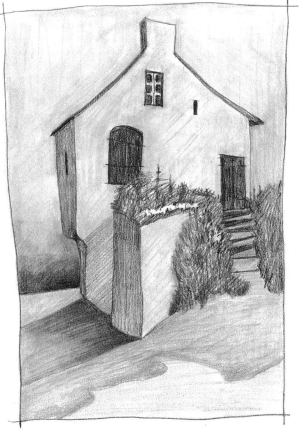

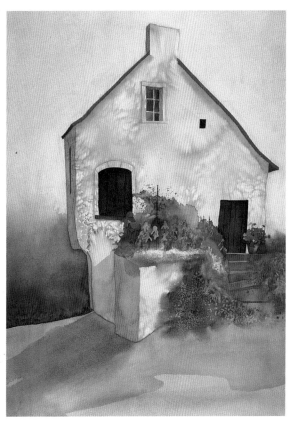

Add Values on Top of Shapes in Your Artistic Journal

Here's my on-location value plan, which I drew on top of my shape plan. I wanted to be sure to get the shapes of the shadows as they danced across the lane and in front of the house. On reflection, I see that I didn't include the clouds in my drawing. If I paint this scene again, I think I will include the dramatic cloud formations in the photograph. You can always paint the same scene more than once.

Put Inspiration Into Your Painting

This is my finished watercolor, *Village House With Irises*. Everything came together because of creative planning. I feel relaxed when it comes to painting, and simply enjoy myself, because I have a plan and know how I am going to proceed. The success of a painting very often has little to do with the actual time spent painting. Rather it has more to do with the time taken to plan your painting so you know how to go forward without anxiety. No plans are rigid, however, and adjustments happen as you dive into the creative process.

Color: The Fourth Step

Make a Triad Sampler

Start with a quick landscape sketch on a journal page with a .50mm or wider felt-tip pen. Make four photocopies of your drawing on white cover stock. Paint each photocopied sketch with a different triad. Apply the paint loosely on top of the drawing. Splash on color mixtures to reveal the personality, temperament and possibilities of each color triad. Don't forget to make note of the triad you used for each painting. When dry, add your triad samplers to your journal. Use the slit method described on page 115 and you will be able to remove your four triad paintings for future color reference. You may need to trim the cover stock to fit your journal page. See if you feel the same way about the personality of the four triads as I do. Do my descriptions of each triad hold true for you? If other labels work better for you, use them.

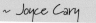

It is not pure fantasy to say that the color red is like the sound of a trumpet.

~ Joyce Cary

Painting on-location is an art form of the moment—best done quickly before the light changes or you get uncomfortable. I always paint with triads when out-of-doors. Triads are a creative shortcut to vibrant color blends. With just three well-chosen pigments, I am confident of eye-catching and harmonious color mixes. The best part about painting with triads is that each of them conveys a different mood. Becoming familiar with the characteristics of each triad gives you a powerful catalyst for color expression. Each trio of pigments is a connoisseur's recipe for creating atmospheric colors and an eloquent way to convey your original inspiration.

Triads Have Attitude

I painted the watercolor, *Village House With Irises*, using my sun triad. I knew before I started painting that this trio of pigments would create sun-drenched color blends—luminous violets, yellow-oranges and greens. It gave me confidence to know that all my mixes would be well balanced and communicate the mood of this summery scene.

Capture the Mood With Color Triads

Each triad interprets the landscape in a unique way. Marry the color mood of your watercolor with the emotional message you want to send to the viewer through your choice of triad. Painting with the three limited colors of a triad has the advantage of keeping the whole painting harmonious. Indeed, in some cases, you won't be able to mix a match for the local color you see from the pigments in your triad. This is not a limitation! It is an invitation to paint passionately, rather than photographically. Put your personality into your painting, and let the viewer know what you feel about your subject, rather than merely reproducing it.

Full-Spectrum Triad

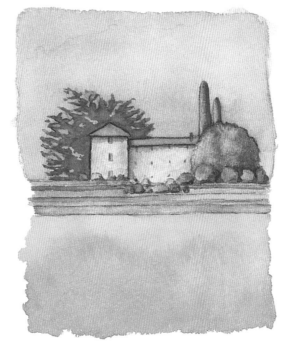

Sun Triad

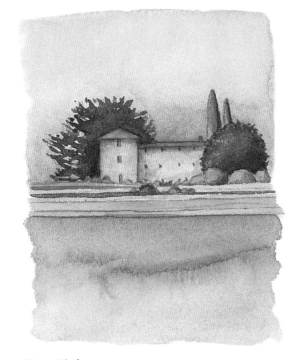

Water Triad

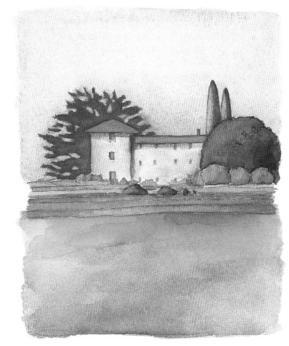

Earth Triad

Triads Have Personality!

My palette is made up of twelve colors that form four different triads. I call them the full-spectrum, earth, water and sun triads. As I got to know each triad, it became clear to me that each one possesses an essentially unique personality. The way the pigments blend, mix and marry within each trio of colors creates an unmistakable atmosphere and mood. I realized I had unlocked a marvelous tool for self-expression. I gave the triads names corresponding to their color personalities.

Later I realized that these names echo the ancient world's understanding of the four elements of the universe—air, earth, water and fire. However, don't take these labels too literally. The sun triad is a lot more than yellows and oranges. The water triad is a lot more than blues and grays. And, the earth triad is a lot more than greens and browns.

Full-Spectrum Triad

✳ Winsor & Newton Winsor Lemon or Holbein Permanent Yellow Lemon

✳ Winsor & Newton Winsor Blue (Red Shade)

✳ Holbein Permanent Rose or Winsor & Newton Permanent Rose

Characteristics: Multihued, fullness, airy, wind, abundance, potential, promise, horn of plenty, cornucopia, rich, profusion, treasure, fruitfulness, vigor, transparency, clear light, optimism, clarity, luscious, succulence, wholeness, fulfillment, well-being...

Earth Triad

✳ Holbein Permanent Green #2

✳ Schmincke Ultramarine Violet

✳ Holbein Cadmium Red Light or Winsor & Newton Cadmium Scarlet

Characteristics: Minerals, stones, tile, bricks, cliffs, soil, mountains, weathered texture, dusty, sandy, fields, farms, plant life, orchards, weeds, natural elements, wood, texture, grasses, strength, groundedness, calm, terra firma...

Water Triad

✤ Holbein Viridian

✤ Winsor & Newton Ultramarine Violet

✤ Holbein Cadmium Red Orange

Characteristics: Watery, moist, misty, foggy, coolness, drizzly, hazy, vaporous, cloudy, dewy, low light, waterways, forests, dawn and dusk, less focused, underwater, subterranean, mysterious, secretive, deep, silent, moonlit...

Construct a Color Library
One good way to get to know the triads is by making a color library of each one in your sketchbook. Open to a new page and paint each pure pigment at the three points of a triangle. Fill in the triangle with blends and mixes in between the pure pigments. Discover for yourself the temperament and spirit rooted in each one. Identify some characteristics of your own. Does one triad speak to you more than the others? For more ideas on color libraries, see page 30.

Page-a-Day Idea

Sun Triad

✤ Holbein Marine Blue or Holbein Cerulean Blue

✤ Winsor & Newton Permanent Magenta or Holbein Permanent Magenta

✤ Winsor & Newton New Gamboge or Holbein Gamboge Nova

Characteristics: Warmth, floral, sun-drenched, foliage, blooming, meadows, deserts, wildflowers, sun and shadow patterns, bright sunlight, fire, comfort, luminous light, joyful, pleasure, active, lush, velvety, burnished, radiant, flame-like, aglow, candlelit, golden, vivid...

The Full-Spectrum Triad

※ Winsor & Newton Winsor Lemon or Holbein Permanent Yellow Lemon

※ Winsor & Newton Winsor Blue (Red Shade)

※ Holbein Permanent Rose or Winsor & Newton Permanent Rose

Using the Full-Spectrum Triad and the Four-Step Plan

This is a page from my one of my travel journals to Greece. You can see how I made visual notes as I progressed through my four steps.

Step 1 Inspiration

The flowers and pots stood out in exuberant contrast to the stark white walls of this village house. After a few pleasant moments' reflection, I gave my painting the working title of *Dancing Pots*. I took a photograph for reference and later added it to my journal page.

Steps 2 and 3 Shape and Value Plans

My composition took form as I sketched a small shape plan in pencil. When my shape plan was complete, I shaded my sketch to make my value plan.

Step 4 Color Triad

I made color notes to help choose the best triad to express my feelings about this scene. The full-spectrum triad had all the characteristics I needed to express the profusion of energy in this lively doorway.

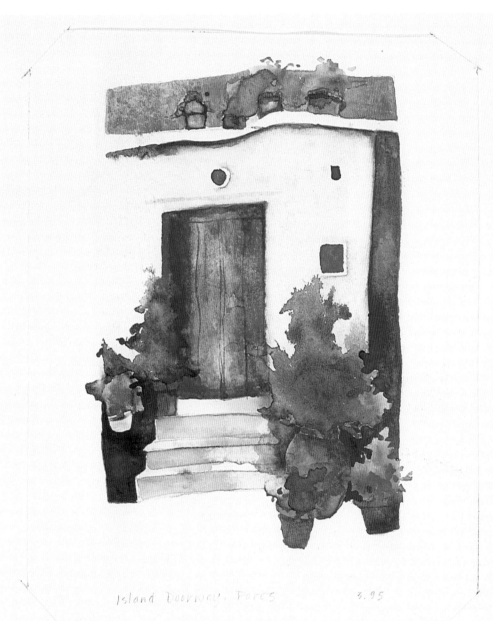

Island Doorway, Poros 3.95

Four Steps and the Full-Spectrum Triad Makes *Plein Air* Painting Fun

My journals are filled with small, playful watercolor paintings, which are often the inspiration for larger works completed back home in the studio. I cherish my travel journals as a resource book of ideas. My four steps help make painting outdoors a carefree and satisfying experience. Here is my painting *Dancing Pots* from my Greek travel journal.

Note how slits cut in the journal page with a craft knife support the painting done on a separate sheet of watercolor paper. This simple technique allows you to safely insert paintings into your artistic journal without degrading them with adhesive.

The Earth Triad

✻ Holbein Permanent Green #2

✻ Schmincke Ultramarine Violet

✻ Holbein Cadmium Red Light or Winsor & Newton Cadmium Scarlet

PAGE-A-DAY IDEA

Turn a New Leaf

Take an artistic ramble to collect leaves, twigs, flowers, weeds and other natural treasures. Every season offers its own special bounty. When you are back in the studio, sort through your collection and select a few to paint. Place each object directly on top of a new page in your journal. Play with the position of your botanical finds until you find an arrangement you like. When you are satisfied with your composition, simply hold each object in place and trace around the outside edges with a no. 2 pencil. Remove the objects after tracing them. Add watercolor to your drawing by using the earth triad to mix the rich colors of your nature study.

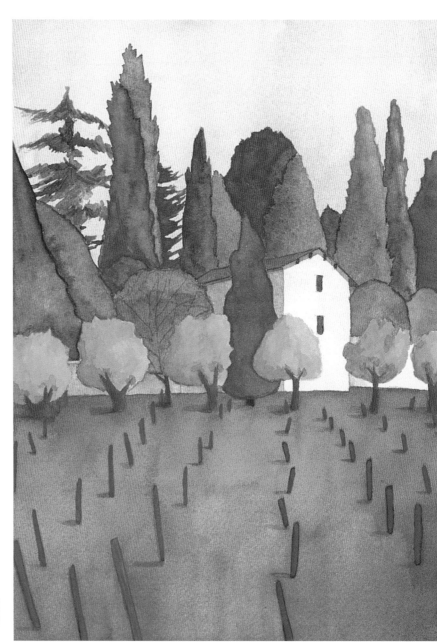

Express the Essence of the Scene With the Earth Triad

I love the way painting with a limited palette encourages color choices that aren't a photographic match for the landscape, but instead lead me to make more personal, emotional choices. I gave myself permission to play with color in this watercolor, and use nonlocal colors for the trees, the vineyard stakes and the soil in the foreground. I knew that by using the earth triad, I would end up with a harmonious combination of colors, all conveying the richness of this vineyard scene.

WILLAMETTE VALLEY VINEYARD
Watercolor on Arches 140-lb. (300gsm) cold-pressed paper
7" x 11" (18cm x 28cm)

Use the Earth Triad

MATERIALS

Bamboo pen

Arches 140-lb. (300gsm) cold-pressed paper, cut to fit inside sketchbook

Earth triad pigments *Cadmium Scarlet, Permanent Green #2, Ultramarine Violet*

Facial tissues

Nos. 4 and 6 rounds

Salt

The earth triad helped me to create beautiful colors—all summoning up this robust, natural environment. Paint this landscape yourself to learn how painting with triads helps you understand color by painting with a limited palette. When painting a landscape, a rule of thumb is to paint the most distant areas first.

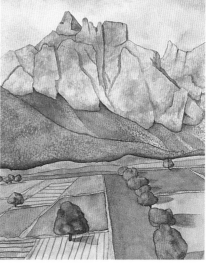

1 Paint What Is Furthest Away

Wet the whole sky area with clean water. Then brush on diluted Schmincke Ultramarine Violet with a no. 6 round. Use a clean, dry tissue to lift some of the wet paint to suggest clouds.

Dilute a mixture of Winsor & Newton Cadmium Scarlet with Schmincke Ultramarine Violet and brush it over the entire mountain area with a no. 6 round. Suggest grassy areas by dropping in diluted Holbein Permanent Green #2 tinted with Winsor & Newton Cadmium Scarlet on some of the mountains while they are still wet. When dry, add shadows to the mountains with a darker shade mixed from Ultramarine Violet and Cadmium Scarlet.

2 Texture the Foothills With Salt

Paint the green foothills with a mixture of Holbein Permanent Green #2 and Winsor & Newton Cadmium Scarlet with a no. 6 round. Sprinkle each area with salt while it's still shiny wet to create a textured surface to suggest forests and shrubbery.

3 Paint the Fields and Trees

Paint the farmland in the valley. Use unmixed Holbein Permanent Green #2 in the bright yellow-green fields. Create red-browns by mixing Winsor & Newton Cadmium Scarlet and Schmincke Ultramarine Violet, touched with just enough Holbein Permanent Green #2 to brown it. Scratch a pen nib into the surface of the wet paint to create dark lines for rows and furrows. Paint the trees green, created with Holbein Permanent Green #2 and a bit of Schmincke Ultramarine Violet to cool it down. Use pure Schmincke Ultramarine Violet for the shadows of the trees.

The Water Triad

✯ Holbein Viridian

✯ Winsor & Newton Ultramarine Violet

✯ Holbein Cadmium Red Orange

Studio on Wheels

Inclement weather does not have to be an obstacle to the *plein air* painter. Fog and rain are commonplace where I live, but even during the wet months, I can still satisfy my urge to paint on site. My secret is to get in my car and drive to a scenic spot. All I do is point my car in front of an inspiring landscape and set up my studio on wheels. Fill your car's cup holders with a cup of water for painting and a cup to hold your brushes. Lay out your drawing and watercolor tool kits on the passenger seat. Bring along some CDs or tapes to play while you explore the four seasons, good weather or not. Try out the water triad as you paint during a rainstorm, cozy and warm in your portable studio. It's fun to be a foul weather painter.

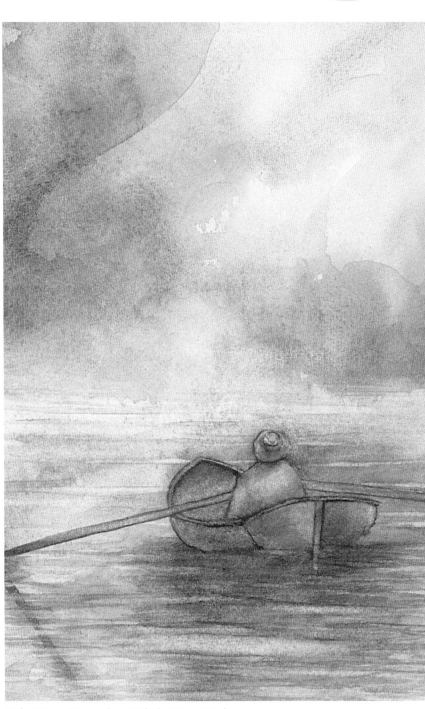

Make Watery Watercolors With the Water Triad

One of the great things about triad painting is that when you become familiar with the personality of each one, it takes no time to make color choices. This is a page from one of my artistic journals. I wanted to make a watercolor sketch of a lone fisherman at a nearby lake on a brisk fall day, but I didn't want to spend a long time outside getting cold. I knew that the water triad would help me convey this misty scene. In essence, I let the watercolor pigments do some of the interpretive work for me. I painted the whole piece of watercolor paper with a soft, loose wash of the three water triad colors. After it dried, I sketched the fisherman in his canoe in pencil and then painted in the shapes.

Paint the Foggy, Foggy Dew

This watercolor explores the silvery, hazy quality of sunrise in an Oregon forest. The water triad conveys the soft, unfocused light of early morning, peeking between dense old-growth fir trees. The feeling of coolness and wetness in this palette lends itself to expressing water and reflections in a dewy way. The fir tree at the left was painted with a mixture of Holbein Viridian and Winsor & Newton Ultramarine Violet. I sprinkled salt on the wet paint to give the tree shape some texture and an illusion of depth. The water was painted all in one try. When dry, I added reflections of the tree trunks in the water. I then ran a clean no. 4 round horizontally across the reflections in the water, and gently lifted off some of the pigment to suggest ripples.

Get to Know the Sun Triad

The Sun Triad

✒ Holbein Marine Blue or Holbein Cerulean Blue

✒ Winsor & Newton Permanent Magenta or Holbein Permanent Magenta

✒ Winsor & Newton New Gamboge or Holbein Gamboge Nova

Great Expectations

Fuse expectation with experience in a two-part journal exercise. Before going to an artistic event, open to a new page in your journal, and draw in pencil for just five minutes. Briefly record something about the upcoming event. There are no rules. Just draw whatever comes to your mind about the movie, concert, art exhibition, dance performance, lecture or museum you are going to see. After it is over, embellish and modify your preconception drawing. Erase, or go on top of your original pencil drawing, adding new or revised images. Use felt-tip pens to highlight the final drawing. Then choose a triad to add color. This exercise reveals the evolution of perception. Experience a heightened focus of attention during an event as you anticipate further reflection in your journal afterward. It helps me hold onto the beauty of a dance, the lilt of a song and the creativity of the artist.

Paint Sun and Shadows With the Sun Triad

This is a little watercolor sketch made in the south of France, painted on a page in my travel journal. The color mixing was easy for me. I knew that the sun triad would help me convey the warmth of this sunlit scene. I could depend upon the harmony of the color mixes to fashion an atmosphere corresponding to what I most enjoy in the south of France—the strong light, olive trees, cypress trees and houses with tile roofs kissed by the sun on one side and bathed in warm shadows on the other.

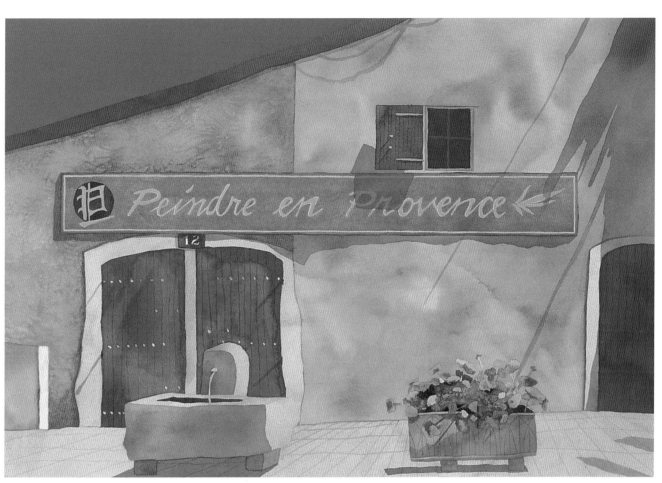

The Landscape Is Aglow With the Sun Triad

Triadic painting means that you can quickly match the mood you want to convey in your paintings with specific color combinations. I wanted to capture the strong afternoon light and shadows of Provence, therefore I used the sun triad in this watercolor. Permanent Magenta and New Gamboge combine brilliantly for the rich orange of the painted stucco walls of the building. I sprinkled a little salt onto the wet paint for a textured look. It was a breeze to create the blues of the sky and the sign, using Marine Blue with a touch of Permanent Magenta. The dark green of the doors and shutters was created by mixing Marine Blue and New Gamboge to make a blue green, then adding a touch of the third pigment in the triad (Permanent Magenta) to gray it. The sign on the building says it all—"Paint in Provence" (with the sun triad).

My Color Palette

My palette is made up of just twelve pigments, one for each of the hues of the traditional color wheel. Each of the triads is balanced evenly around the color wheel. The idea is to keep it simple with twelve versatile and well-chosen pigments. From these twelve pigments, you can literally mix any color.

Each of these pigments has excellent lightfastness for color durability and longevity. I'm reminded of what J.S.

Bach said of his son, C.P.E. Bach, "His music is Prussian Blue: it fades." In those days, apparently Prussian Blue was not lightfast.

Another important quality of my palette is that each of these pigments is a pure color. Painting with pure pigments is essential to mixing vibrant colors. When you mix two colors together, you want to know that you

are mixing just those two colors. For example, to get a brilliant violet, you mix together red and blue. With pre-mixed pigments, there are colors other than pure red in your red pigment, and colors other than pure blue in your blue. You are actually mixing more than just red and blue together, you are mixing trace amounts of other colors that dull the brilliance of your violet.

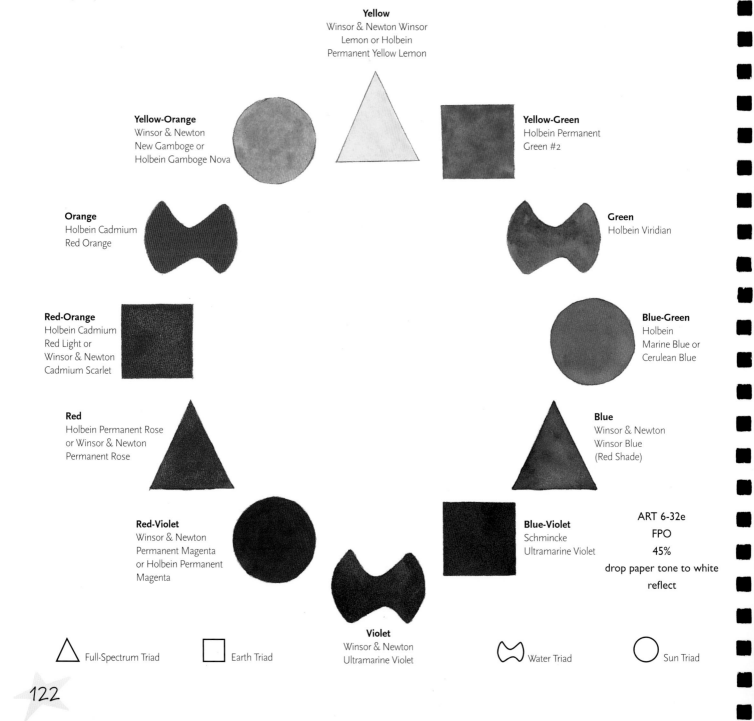

Yellow
Winsor & Newton Winsor
Lemon or Holbein
Permanent Yellow Lemon

Yellow-Orange
Winsor & Newton
New Gamboge or
Holbein Gamboge Nova

Yellow-Green
Holbein Permanent
Green #2

Orange
Holbein Cadmium
Red Orange

Green
Holbein Viridian

Red-Orange
Holbein Cadmium
Red Light or
Winsor & Newton
Cadmium Scarlet

Blue-Green
Holbein
Marine Blue or
Cerulean Blue

Red
Holbein Permanent Rose
or Winsor & Newton
Permanent Rose

Blue
Winsor & Newton
Winsor Blue
(Red Shade)

Red-Violet
Winsor & Newton
Permanent Magenta
or Holbein Permanent
Magenta

Blue-Violet
Schmincke
Ultramarine Violet

ART 6-32e
FPO
45%
drop paper tone to white
reflect

Violet
Winsor & Newton
Ultramarine Violet

△ Full-Spectrum Triad ☐ Earth Triad ⧖ Water Triad ○ Sun Triad

Perfect Complements Create Perfect Blacks

Color theory tells us that any complementary pairs mixed together create black. Complements are those pigments that are directly opposite each other on the color wheel.

Over the years, friends, students, friendly art supply stores and paint manufacturers have all offered me dabs and tubes of paint to try. When I eventually found just the right twelve pigments, I shouted "Eureka! I've got it!" Each pair of complements makes a perfect black.

You may want to replace a tube of paint for one that is close in color to one in my palette. There is an easy litmus test to see if your pigment is an accurate color substitute. Mix your pigment with its complement, and see if you, too, get black. If so, you have found a substitute.

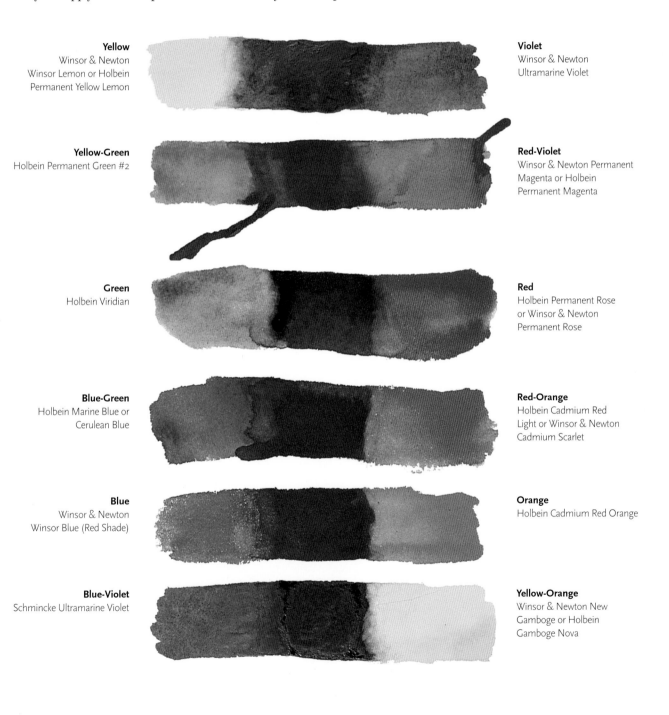

Yellow
Winsor & Newton
Winsor Lemon or Holbein
Permanent Yellow Lemon

Violet
Winsor & Newton
Ultramarine Violet

Yellow-Green
Holbein Permanent Green #2

Red-Violet
Winsor & Newton Permanent
Magenta or Holbein
Permanent Magenta

Green
Holbein Viridian

Red
Holbein Permanent Rose
or Winsor & Newton
Permanent Rose

Blue-Green
Holbein Marine Blue or
Cerulean Blue

Red-Orange
Holbein Cadmium Red
Light or Winsor & Newton
Cadmium Scarlet

Blue
Winsor & Newton
Winsor Blue (Red Shade)

Orange
Holbein Cadmium Red Orange

Blue-Violet
Schmincke Ultramarine Violet

Yellow-Orange
Winsor & Newton New
Gamboge or Holbein
Gamboge Nova

The Palette Layout

My palette is like a good friend. It has been with me all over the world, and is the same one I rely on in my studio. I always use the Jones Color Round watercolor palette. It is specifically designed for the twelve pigments of the color wheel. This feature is a big help to the watercolor painter. You can purchase this palette at most fine art supply resources.

Make Your Own Template

If you are using the palette I use, the Jones Color Round palette, you will want the template to be 7" (18cm) in diameter. If you are using a different palette, measure the diameter of that palette to determine how large to make your template. When your template is made, have it laminated for extra durability. Cut out the large outside circle of the template and the three small pigment circles with scissors. Use the black lines as a guide. Place the template over the palette. Now you are ready to pick a triad and experience the freedom of triadic painting.

Organize Your Pigments in a Circle

I've used this palette for years and love its color wheel organization, size and portability. To make it totally portable, fill each well with the correct pigment and let the paint dry until hard. Be patient, this thorough drying process can take a few days. When completely hardened, there are no dripping paint messes to worry about. When I'm ready to use a pigment, I spray it lightly with water to soften the paint.

Isolate the Triads With a Template

I designed my triad template to fit on top of my palette. As you rotate the template, you expose just the three pigments of each triad.

I love to visually isolate the colors of each triad. This prevents me from accidentally sticking my brush in the wrong well when in the whirl of painting. The less I have to think in a logical and linear way, the more I am free to be creative. All my planning comes before I start painting. My triad template is the secret to painting without working to remember which pigments are included in the triad.

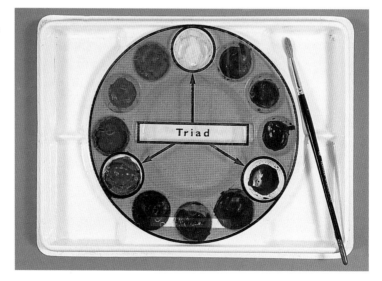

Conclusion: Be an Art Explorer

The artist is an explorer—both of things you can see, and things you can't see. Explorers make fantastic discoveries, but they also sometimes reach a dead end. This is a natural part of the process. As an art explorer, I give myself permission to take risks, reach dead ends and try new things that don't always work out. That is the special privilege of the private experience in the artistic journal. Think of your journal work as exploration, rather than accomplishment, and discovery, rather than achievement. You never know what new worlds you will find when you embark on an uncharted art journey. Use your artistic journal to make private, personal art. You don't need to share it with the public unless you choose. Explore your creativity wholeheartedy, and most importantly, relax. Open your journal, fill a page every day, and allow the magic to happen.

PAGE-A-DAY IDEA

Final Thoughts

✷ Break the rules and take artistic liberties. Paint the sky yellow, the trees purple, the grass orange and the water red!

✷ The art critic is on vacation—toss judgement out the window. Nothing squelches creativity more than the daunting expectation of perfection.

✷ Have fun! Experiment with what you already know, and extend it into the unknown. Liberate yourself from predictability. Open up to the exhilaration of discovery.

Dive In, the Water's Fine!

Take the plunge and explore your creativity from the inside out. Pay attention to what captures your interest on a daily basis. Use your journal to make artistic gestures reflecting the pulse of your life. This is the rhythm and music of what is meaningful to you, and it contains the symbols of personal imagery. These two watercolor paintings are a good example. They came about after reading recent newspaper articles about the plight of salmon in the Northwest United States. I made some visual notations in my artistic journal, and from that a series of paintings evolved.

BLUE FISH, BLUE WATER
Watercolor on crinkled Masa paper collage on Arches 140-lb. (300gsm) cold-pressed watercolor paper
7" × 10" (18cm × 25cm)

BLUE FISH, RED WATER
Watercolor on crinkled Masa paper collage on Arches 140-lb. (300gsm) cold-pressed paper
7" × 10" (18cm × 25cm)
Collection of Teri Wadsworth and John Paul

Index

The best art instruction comes from North Light Books!

THE ONE-HOUR WATERCOLORIST

Timesaving tips and exercises to make the most of your painting sessions

PATRICK SESLAR

No matter how little free time you have, this book gives you the confidence and skills to make the most of every second. Learn how to create simple finished paintings within 60 minutes, then attack more complex images by breaking them down into a series of "bite-sized" one-hour sessions. 12 step-by-step demonstrations make learning easy and fun.

ISBN 1-58180-035-5, paperback, 128 pages, #31800-K

Paint Happy!

Cristina Acosta

Celebrate your Creative Self

more than 25 exercises to unleash the artist within

Mary Todd Beam

This book shows you how to develop the skills you need to express yourself no matter what unique approach your creations call for! Experiment with and explore your favorite medium through dozens of step-by-step mini-demos. No matter what your level of skill, *Celebrate Your Creative Self* can help make your artistic dreams a reality!

ISBN 1-58180-102-5, hardcover, 144 pages, #31790-K

Cristina Acosta shows you how to re-connect with the imagination, creativity and energy of your childhood to create amazing works of art! She'll help you re-think color mixing and design, while developing your own personal style in acrylic or any other medium. Every lesson is designed to make your painting easier, more satisfying and, most importantly, more fun!

ISBN 1-58180-118-1, paperback, 112 pages, #31814-K

Keys to Drawing

BERT DODSON

- 55 specific keys to improving your drawings
- 48 mini-lessons that help you master techniques
- 8 self-evaluation checklists to help you gauge your progress

NORTH LIGHT 15th Anniversary CLASSIC EDITIONS

Bert Dodson's successful method of "teaching anyone who can hold a pencil" how to draw has made this tome one of the most popular, best-selling art books in history-an essential reference for every artist's library. Inside you'll find a complete system for developing drawing skills, including 48 practice exercises, reviews, and self-evaluations.

ISBN 0-89134-337-7, paperback, 224 pages, #30220-K

14.95

How to Register a United States Copyright

SECOND EDITION

WITH FORMS

By Mark Warda
Attorney at Law

1990

*3 internal cross
since 92*

— curr ed 5/05

Sphinx® Publishing

Note: The law changes constantly and is sub-
ject to different interpretations. It is up to you
to check it thoroughly before relying on it.
Neither the author nor the publisher guaran-
tees the outcome of the uses to which this
material is put.

Second Edition, March, 1990

ISBN 0-913825-26-3
Library of Congress Catalog Number: 90-60841

Manufactured in the United States of America.

This publication is designed to provide accurate and authoritative information in regard to the
subject matter covered. It is sold with the understanding that the publisher is not engaged in
rendering legal, accounting or other professional services. If legal advice or other expert
assistance is required, the service of a competent professional person should be sought.

-From a Declaration of Principles jointly
adopted by a Committee of the Amerocan Bar
Association and a Committee of Publishers.

Published by Sphinx Publishing, a division of Sphinx International, Inc., Post Office Box 2005,
Clearwater, Florida 34617-2005. This publication is available by mail for $14.95 plus Florida sales
tax if applicable, postpaid($15.85 or $16.00 in counties with local option 1% tax).

TABLE OF CONTENTS

Introduction

While nearly everyone has created some work which deserves copyright protection, few people know the process for registering and protecting a copyright. It is the purpose of this book to explain the law of copyrights in simple language and provide step-by-step instructions for registration of a copyright.

This book answers most basic questions about copyright protection. In the event that your case is in some way complicated or does not fit within the explanations in this book you should seek further information from the Copyright Office or from an attorney specializing in copyright law. The address and phone numbers of the Copyright Office are contained on page 34 of this book.

Copyright law offers protections to a wide range of works. Although written works are well known to be copyrightable due to their obvious copyright notice, copyright protection is also available for such things as photographs, sculptures, musical compositions and other sounds and choreographic works.

Unlike some types of protection such as patents which can only be awarded to the first producer of the work, copyright is available to anyone who creats an original work. If two persons create identical works independently and without copying each other, both are entitled to protection. However, the one who registered first would be in a much better position should a legal battle result.

A recent change in rules by the copyright office allows us to provide master forms which may be photocopied and used for filing registrations. Previously they required the registrations to be on original forms which had to be obtained from their office. In using these forms the instructions in Chapter VI should be followed carefully.

This second edition was made necessary when the United States joined the Berne Convention, making certain statements in the first edition obsolete.

Congratulations in becoming an author and best wishes in your career!

I What is a Copyright?

A. **Legal Rights.** A copyright is a legal monopoly. It is a grant of exclusive rights, guaranteed by the federal government, to a work of authorship. The law concerning copyrights is the Copyright Act of 1976 (Title 17 of the United States Code). The exclusive rights granted by a copyright are as follows:

1. The exclusive right to reproduce the work.

2. The exclusive right to prepare derivative works such as translations and abridged versions.

3. The exclusive right to distribute copies of the work to the public by sale, or rental.

4. The exclusive right to perform the work publicly such as for music, plays, dances, pantomimes and motion pictures.

5. The exclusive right to display the work publicly such as for paintings, sculptures or photographs.

There are some limitations to these exclusive rights, such as the rights of others to "fair use" of the work. Fair use includes such things as copying small excerpts, quoting parts in reviews and critiques, making parodies and use by educators.

B. **Creation.** A copyright, that is, the exclusive right to a work, is automatic upon the creation of a work. Nothing need be done at the creation of a work to create the copyright. A work is considered "created" when it is "fixed in a medium," such as written down or recorded. No copyright can be had for a work that is just a thought and not yet fixed in a medium. (To avoid confusion with information you may have heard, the law prior to passage of the 1976 law was that there was no copyright until the work was published with a copyright notice.)

C. **Protection.** Until March 1, 1989 it was required that a copyright notice appear on a published work before it could be protected. If a work was published without such notice the copyright was lost and the work was in the public domain for anyone to use. However, in 1989 the United States joined the Berne Convention, an international agreement that allows a work to be protected even if it has no notice on it. Therefor, works originally published in the United States after March 1, 1989 are protected even if no copyright notice appears on them.

It must be noted that in copyright law the word "publish" means to distrubute copies to the public. Making several photocopies of your manuscript and loaning, selling or giving them out is considered publishing your work.

D. **Works Published Prior to March 1, 1989.** If a work was published (see above definition) prior to March 1, 1989 it should have been with the copyright notice if you are to obtain protection. However, there is a way to rescue a work from the public domain, even if some copies have been distributed without notice. If the work is registered within five years of publication (the time copies were distributed) and if a reasonable effort is made to add the notice to all copies that have been distributed to the public in the United States, the copyright protection may be preserved.

E. **Works published After March 1, 1989.** As stated in C. above, no notice is required by law to obtain copyright of a work, whether or not it has been published. However, as a practical matter it is best to put a copyright notice on all copies of a work. Believe it or not, some people do not read self-help law books and these people may not be aware that the law changed in 1989. Therefor theymay believe that any work without a copyright notice is in the public domain. Rather than pay your lawyer tens of thousands of dollars to convince them otherwise, you should always put the notice on your work.

F. **Notice.** The notice which was required to be used on all works published prior to March 1, 1989 and which it is adviseable to use now is as follows:

 1. The symbol ©, the word "copyright", or the abbreviation "copr."

 a. To protect international rights it was necessary to use the symbol © rather than the word. **Note:** Some people use (c) but the law does not recognize this as a copyright symbol and it is not known if a court would accept it as valid.

 b. For phonorecords the symbol P in a circle is used instead of the word copyright or the ©.

 2. The year of <u>first</u> publication of the work. Where a pictorial, graphic or sculptural work is reproduced on postcards, greeting cards, stationery, jewelry, toys or other useful articles, the year may be omitted.

 3. The name of the copyright owner or a recognizable abbreviation of the owner's name.

Thus, a correct notice would be as follows:

© Copyright 1991 John Doe

or

© 1991 John Doe

The notice should be affixed to the copies in such a way as to give reasonable notice of the claim of copyright. In **motion pictures** or other audiovisual works the notice should be with or near the title, cast, credits or similar information or at the beginning or end of the work. On **machine readable works** the notice should be with or near the title, user's terminal, continuous display, printouts, containers for the work or at the end of the work. For works on which it is impractical to affix a notice, it is acceptable to use a tag attached to the goods which will stay with them while they pass through commerce.

G. **Mandatory Deposit of Copies.** The copyright law also requires that within three months of publication of a work two copies of the best edition of the work must be deposited in the Copyright Office.

H. **Comparison to Trademarks & Patents.** A **trademark** is a name or symbol used to identify goods or services. It can last indefinitely if registered in the United States Patent and Trademark Office, used continuously and renewed properly. A **patent** is protection given to new inventions, discoveries and designs. The term for a patent for inventions is 17 years and for designs is 3-1/2, 7 or 14 years. Patents cannot be renewed.

II What Can Be Copyrighted?

Only original works of authorship may be copyrighted. This means that the original creator of the work (or his agent) is the only one who may obtain a copyright. You cannot take someone else's work and obtain a copyright. The following types of works are allowed protection under the copyright law:

A. **Literary Works.** These include novels, non-fictional works, poems, articles, essays, directories, advertising, catalogs, speeches, computer programs and data bases.

B. **Musical Works.** This includes both the musical notation and the accompanying words.

C. **Dramatic Works.** Plays, operas, scripts, screenplays and any accompanying music.

D. **Pantomimes and Choreographic Works.**

E. **Pictorial, Graphic and Sculptural Works.** These include sketches, drawings, cartoons, paintings, photographs, slides, greeting cards, architectural and engineering drawings, maps, charts, globes, sculptures, jewelry, glassware, models, tapestries, fabric designs and wallpapers.

F. **Motion Pictures and Other Audiovisual works.** These include movies, videos and film strips.

G. **Sound Recordings.** This includes music, voice and sound effects.

H. **Compilations.** You can put together a collection of existing materials and the collection as a whole can be copyrighted. Some examples would be a book of poems written about trees or a list of all doctors in the U. S.

 1. In the collection of poems example, you couldn't use poems that were copyrighted by someone else without their permission. You could use old poems where the copyright expired. Your copyright on the collection would not give you exclusive right to each individual poem, only to the collection as a whole. But if someone else collected the same poems independently, they could also copyright their work.

 2. In the list of doctors example, you couldn't stop someone else from also putting together a similar list. How would you know if they copied yours or did their own research? There would probably be some errors or typographical differences in the lists if they were

put together separately. If they were exact in every detail, one was probably copied. Some compilers add a fake name or two so that if it appears in another's list it proves copying.

I. **Derivative Works.** Works such as the Mona Lisa or the Venus de Milo are in the public domain and may be copied by anyone. However, if someone takes the time and money to fly to Paris take a photograph of one of them, that photograph is copyrightable. Another person may take the same photograph, but no one may make a copy of someone else's copyrighted photograph.

III What Can't Be Copyrighted?

A. **Works that have not been fixed in a Tangible Form.** Until a work has been written down on paper or made into some other form which can be seen and held it is not copyrightable. Some examples are stories which have not been written down, dances which have not been notated or recorded or speeches or lectures which have not been written down or recorded.

B. **Titles, Names, Mottos or Slogans.** Book titles, company names, group names, product names, phrases , mottos, slogans and the like may not be copyrighted. Some of these may be registered as trademarks. For information on registering a trademark, please see our book, *How to Register a United States Trademark*.

C. **Ideas, Methods, Procedures and Systems.** Copyright only protects the form of expression of an idea, not the idea itself. If you come up with a great way to make a million dollars, a process for tripling corn yield or a system for eliminating paying income tax you can write and copyright a book and no one can copy your book, but others can use your ideas or write their own books about your ideas.

D. **Common Information.** No one may copyright the basic information for calendars, height and weight charts, rulers, or other such lists of information. If you design a creative form of calendar or ruler you can copyright your design but not the information.

E. **Lists of Ingredients.** A recipe may be copyrighted, but not a mere list of ingredients.

F. **Blank Forms and Record Books.** Any form which is relatively blank such as a check, diary, address book or columnar pad may not be copyrighted. Where there is some creativity in a form, such as a lengthy legal form the text may be copyrighted.

G. **Government Publications.** Works of the United States Government may not be copyrighted, and anyone may copy them freely. Some people reprint government publications and sell them. Copyrighted works may contain works of the government.

IV Why Should You Register a Copyright?

A copyright automatically exists from the moment of creation of a work (fixed in a tangible medium) but registration of the work with the United States Copyright Office is important. The cost of the process is low and the procedure is simple. The benefits are as follows:

A. **Damages and Attorney's Fees.** If your work is registered before someone infringes it (or within three months of publication) you can receive monetary damages set by the copyright law and payment of your attorney's fees. If you don't register and you must pay your own attorney's fees for a federal lawsuit, it might not be worth suing.

B. **Evidence.** Your registration certificate is *prima facie* evidence of the validity of your copyright. This means that the burden is on the person infringing to prove that he has some right to the work.

C. **Record.** The registration provides a permanent record of your claim to the work.

D. **Correction of Errors.** Your application will be reviewed by the copyright office which may bring to your attention errors which may be corrected.

E. **Overcome Omissions.** If you released copies of your work without the proper copyright notice or if the name is listed incorrectly the registration will help overcome these problems.

F. **Royalties.** For recorded musical works you may collect compulsory royalty payments from persons who make recordings of your works.

G. **Marketing Opportunities.** Your work may be discovered by someone searching the copyright registration and may result in a business opportunity.

V Who Can Claim and Register a Copyright?

A. **Authors.** Immediately upon the creation of a work in a fixed form a copyright exists for the author.

B. **Employees.** Where a work is created by an employee in the scope of his employment the employer is considered to be the author and owner of the copyright.

C. **Contributors.** In a collective work, each author usually retains the copyright to his own contribution, while the person doing the compiling may have a copyright in the collection as a whole.

D. **Assignees.** An author may assign his rights to a work to another person and that person, the assignee of the author, may claim and register the work.

E. **Minors.** Minors may claim a copyright in works they create. However, state laws usually restrict their business dealings and require a guardian to handle their business affairs.

F. **Owners.** The owner of a work (e.g. a book, letter, painting) usually does not have any right to the copyright unless he has a specific grant from the author.

VI How to Register a Copyright

A. **Application.** To register a copyright, a simple application form must be filed with the copyright office along with the filing fee and one or two copies of the work. The first step is to decide which application form to use. The following are the different forms available:

1. **Form TX. Nondramatic literary works.** For written works which are not plays or other "performing arts." This includes most works which consist of text.

2. **Form PA. Performing arts.** For musical and dramatic works, pantomimes, choreographic works, motion pictures and other audiovisual works.

3. **Form VA.** Visual arts. For pictorial, graphic and sculptural works.

4. **Form SE. Serials.** For works such as newspapers, magazines, annuals and newsletters which are intended to continue indefinitely.

5. **Form SR. Sound recordings.** For recordings of sounds on records, tapes, discs or other medium. Form SR differs from Form PA in that form PA is for registration of the notation on paper of a work and Form SR is for the performance. One person can own the rights to a musical composition and another can own the copyright to his or her performance of the work.

Until recently the Copyright Office has required that applications for copyright be submitted only on forms provided by their office. To save expenses they now allow applications to be submitted on photocopies of their forms. However the forms should be photocopied on both sides of the paper, head to head, and should be legible and on a good grade of paper.

Blank forms for photocopying are included with this book along with instructions and sample filled-in forms. If you prefer to obtain ready-made forms from the copyright office, you can call then at (202) 707-9100 or write to:

Register of Copyrights
Copyright Office
Library of Congress
Washington, DC 20559

B. **Filing Fee.** The filing fee for each application is $10.00. The fee is considered a filing fee and not a registration fee so if the application is rejected for any reason the fee is not refundable. For additional certificates the fee is $4.00.

C. **Copies of the work.** If the work has not yet been published one complete copy or phonorecord must be submitted. If the work was first published in the United States on or after January 1, 1978, then two copies of the best edition of the work must be submitted. If the work was first published in the United States before January 1, 1978, then one copy of the work as first published must be submitted. If the work was first published outside of the United States then one copy of the work as first published must be submitted.

An explanation of what is the "best edition" of a literary work is included as Appendix A of this book.

D. **Special Exceptions.** The copyright office has made some exceptions to the basic rules for deposits.

 1. **Large Works.** For works which exceed 96 inches in any dimension, you must deposit a drawing, transparency or photograph (preferably 8 x 10 inches).

 2. **Limited Audience Works.** For nondramatic literary works of speeches, sermons, lectures and tests and answers published individually only one copy is necessary.

 3. **Computer Programs.** For computer programs it is possible to send in only "identifying portions" of the work. This is usually the first 25 pages and last 25 pages of the program printed out on paper along with the page containing the copyright notice. For special rules regarding computer programs, see Appendix B of this book

 4. **Visual and three-dimensional works.** For works such as sculptures, "identifying material" such as a photograph of the work must be submitted instead of physical copies. An explanation of what must be deposited for a work of the visual arts is included as Appendix C of this book.

 5. **Performing Arts Works.** For motion pictures which are published, musical compositions which are rented and not sold and published instructional multi-media kits, only one copy need be deposited. For unpublished motion pictures, identifying material can be sent instead of a complete copy. The identifying material

can be a description of the motion picture and a copy of the sound track or an enlargement of one frame from each ten-minute portion of the work.

6. **Sound Recordings.** For sound recordings the visual or written material included with the recording must also be included with the deposit.

 It must be remembered that a sound recording includes two separate works, the underlying composition and the actual rendition of the sounds. Each of these can be copyrighted separately or they can be copyrighted together. To copyright them together, use Form SR. To copyright them separately, use Form SR for the sound and either Form TX or Form PA for the underlying work.

E. **Sending It In.** The application, filing fee and copies must be enclosed in the same envelope and sent to:

 Register of Copyrights
 Copyright Office
 Library of Congress
 Washington, DC 20559

VII How long does a Copyright Last?

A. **Works Created After January 1, 1978.** As of January 1, 1978 the term of the copyright is for the life of the author plus fifty years. For works prepared by two or more authors, the term is the life of the last surviving author plus fifty years. For works made for hire and for anonymous works and pseudonymous works (unless the identity is disclosed in Copyright Office records) the term is for 75 years from publication or 100 years from creation, whichever is shorter.

B. **Works Created Before January 1, 1978.** Prior to passage of the 1976 law (which took effect in 1978) the term was for 28 years with the ability to renew for an additional 28 years. Works that were in their first term on January 1, 1978 can now be renewed for a 47 year term and works that were in their second term on that date are automatically extended to a total term of 75 years. This should be kept in mind if you plan to use material from older works.

Once the term of a copyright expires the work is considered to be in the public domain. That means that anyone may reproduce, copy, distribute, perform or display the work freely.

VIII How to Protect Your Copyright

Your rights to your creative work are automatic upon creation of the work in a tangible form. You do not have to do anything to secure these rights. However, there are things you can do to protect your rights.

Prior to March 1, 1989 it was required that a copyright notice be placed on all copies of a work which were distributed to the public. If you work was distributed before that date without a notice you can save your work from the public domain by registering it within five years of publication and by making a reasonable effort to add a copyright notice to all copies which were distributed without the notice.

For works published after March 1, 1989, the copyright notice is not legally necessary, but as a practical matter it is best to use the notice. It will be many years before the general public learns that copyright notices are no longer necessary and that all works have copyright protection whether or not there is a notice. Many authors and editors have learned that they can freely use anything that does not have a copyright notice on it. It will be a long time before this habit is unlearned.

IX How to Transfer a Copyright

A. **Non-exclusive licenses.** The sale of a copyrighted work such as a book or videocassette involves a transfer of some rights to use the work. But this does not involve any transfer of rights to the copyright itself. The copyright owner retains all other rights unless these are granted in writing.

B. **Exclusive Licenses.** A copyright owner may sell all or some of his rights to a copyright. He or she may sell translation rights for one language, marketing rights for one state or area, all rights for a limited period of time or any other portion of the rights included in the copyright. These rights can be transferred in any of several ways:

1. **Written contract.** An agreement transferring a copyright must be in writing to be valid.

2. **Will.** A person may dispose of a copyright in a will.

3. **Bankruptcy.** A copyright can be taken in a bankruptcy proceeding.

4. **Divorce.** A copyright can be considered marital property and distributed in a divorce proceeding. In community property states each spouse owns half of any work created during a marriage.

C. **Recordation.** Whenever a copyright is transferred the transfer should be registered with the copyright office. This is done by sending a copy of the written instrument (with original signatures or a certified copy) and the filing fee to the following address:
Renewals and Documents Section, LM-444
U. S. Copyright Office/Examining Division
Library of Congress
Washington, D.C. 20559

D. **Revocation.** Even if a copy has been sold and all rights transferred to another party, the author or his heirs can legally rescind the deal and get the copyright back. After 35 years from the date of publication or 40 years from the date of transfer, whichever occurs first, the transfer may be revoked if proper notice is sent to the copyright owner. However, it is necessary that the notice be sent during the final five years of this time period.

X International Copyrights

A. **Countries Offering Automatic Protection.** A work which is created by a United States citizen or permanent resident which is first published in the United States is protected in some other countries by the Universal Copyright Convention and the Berne Convention of which the United States is a signatory and by some individual treaties with certain countries. However, not all countries are signatories of these conventions.

The countries which are signatories of the Universal Copyright Convention other than the United States are as follows:

Algeria	Japan
Andorra	Kanpuchea
Australia	Kenya
Austria	Laos
Bahamas	Lebanon
Bangladesh	Liberia
Barbados	Liechtenstein
Belgium	Luxembourg
Belize	Malawi
Bulgaria	Malta
Cameroon	Mauritius
Canada	Mexico
Chile	Monaco
Columbia	Morocco
Costa Rica	Netherlands
Cuba	New Zealand
Czechoslovakia	Nicaragua
Denmark	Nigeria
Dominican Republic	Norway
Ecuador	Pakistan
El Salvador	Panama
Fiji	Paraguay
Finland	Peru
France	Philippines
West Germany	Poland
East Germany	Portugal
Ghana	Senegal
Greece	Spain
Guatemala	Sweden
Guinea	Switzerland
Haiti	Tunisia
Hungary	USSR
Iceland	United Kingdom
India	Vatican City
Ireland	Venezuela
Israel	Yugoslavia
Italy	Zambia

The countries which are signatories of the Berne Convention other than the United States are as follows:

Argentina	Libya
Australia	Liechenstein
Austria	Luxembourg
Bahamas	Madagascar
Barbados	Mali
Belgium	Malta
Benin	Mauritania
Brazil	Mexico
Birkina faso	Monaco
Bulgaria	Morocco
Cameroon	Netherlands
Canada	New Zealand
Central African Republic	Niger
Chad	Norway
Chile	Pakistan
Colombia	Philippines
Congo	Poland
Costa Rica	Portugal
Cote D'Ivoire	Rumania
Cyprus	Rwanda
Czechoslovakia	Senegal
Denmark	South Africa
Egypt	Spain
Fiji	Sri Lanka
Finland	Surinam
France	Sweden
Gabon	Switzerland
Germany (East)	Thailand
Germany(West)	Togo
Greece	Tunisia
Guinea	Turkey
Hungary	United Kingdom
Iceland	Uruguay
India	Vatican City
Ireland	Venezuela
Israel	Yugoslavia
Italy	Zaire
Japan	Zimbabwe
Lebanon	

If you are concerned about protection of your work in these countries your rights are protected merely by complying with United States law. Even if you complete your work in a country which is not listed, if you are a United States citizen your work is protected in all of these countries.

B. **Protections Offered.** The protection offered in countries which have signed the Universal Copyright Convention is for at least the life of the author plus 25 years. For the Berne Convention it is the life of the author plus 50 years. This protection includes the exclusive right to translate the work except that if a work has been imported into one of these countries but not translated within seven years of the first publication of the work,

then the government of the country has the right to make translations of the work. However, the government entity making the translation must pay royalties to the copyright owner.

C. **Other countries.** Some countries have not signed either of the copyright conventions. These fall into three categories:

1. **Buenos Aires Convention.** The countries of Bolivia and Honduras have not signed either the Universal Copyright Convention or the Berne Convention but have signed the Buenos Aires Convention. Therefore, to obtain protection in these countries one must follow the requirement that the statement "All rights reserved." follow the copyright notice.

2. **Bilateral Treaties.** In some cases the United States has signed copyright treaties with other nations. Where these countries are signatories to the major conventions, the treaties do not add many rights. But in some cases, such China which has not signed the conventions, the treaty gives protection to American's works.

2. **No Agreements.** Where a country has not signed any convention and does not have a treaty with the United States there is still a chance for protection. Some newly independent countries have been honoring conventions signed before their independence. To check on an individual country, you should contact their trade representative at that country's embassy. Another possibility for protection is the fact that some countries which are not signatories to the conventions will give copyright protection to authors if the author's country gives protection their citizens.

D. **Local law.** Some countries have different laws regarding some aspects of copyright law. For example, for computer programs, the artwork, text and source code is generally considered copyrightable but object code, ROM and other aspects of a program may not be in some countries.

This section is intended to answer the most basic questions about international copyright protection. If you seriously plan to market overseas or see a likelihood of infringement from overseas you should consult an attorney specializing in international copyright law. The best way to select a competent attorney is upon the advise of a friend, but if you do not know anyone who has used a copyright specialist you should consult the yellow pages. Sometimes copyright specialists are listed under "Attorneys–Patent, Trademark & Copyright Law." Because such specialists are not in every town you may have to travel to a large city to find one.

FORM TX

FORM TX
UNITED STATES COPYRIGHT OFFICE

REGISTRATION NUMBER

IX TXU

EFFECTIVE DATE OF REGISTRATION

Month Day Year

DO NOT WRITE ABOVE THIS LINE. IF YOU NEED MORE SPACE, USE A SEPARATE CONTINUATION SHEET.

1 TITLE OF THIS WORK ▼

THE JOY OF SLEEPING

PREVIOUS OR ALTERNATIVE TITLES ▼

PUBLICATION AS A CONTRIBUTION If this work was published as a contribution to a periodical, serial, or collection, give information about the collective work in which the contribution appeared. Title of Collective Work ▼

If published in a periodical or serial give: Volume ▼ Number ▼ Issue Date ▼ On Pages ▼

2 NAME OF AUTHOR ▼
a RIP VAN WINKLE

DATES OF BIRTH AND DEATH
Year Born ▼ Year Died ▼
1899

Was this contribution to the work a "work made for hire"?
☐ Yes
☒ No

AUTHOR'S NATIONALITY OR DOMICILE
Name of Country
OR { Citizen of ▶ U.S.A.
 Domiciled in ▶

WAS THIS AUTHOR'S CONTRIBUTION TO THE WORK
Anonymous? ☐ Yes ☒ No
Pseudonymous? ☐ Yes ☒ No

NATURE OF AUTHORSHIP Briefly describe nature of the material created by this author in which copyright is claimed. ▼
entire work

NOTE
Under the law, the "author" of a "work made for hire" is generally the employer, not the employee (see instructions). For any part of this work that was "made for hire" check "Yes" in the space provided, give the employer (or other person for whom the work was prepared) as "Author" of that part, and leave the space for dates blank.

b NAME OF AUTHOR ▼

DATES OF BIRTH AND DEATH
Year Born ▼ Year Died ▼

Was this contribution to the work a "work made for hire"?
☐ Yes
☐ No

AUTHOR'S NATIONALITY OR DOMICILE
Name of Country
OR { Citizen of ▶
 Domiciled in ▶

WAS THIS AUTHOR'S CONTRIBUTION TO THE WORK
Anonymous? ☐ Yes ☐ No
Pseudonymous? ☐ Yes ☐ No

NATURE OF AUTHORSHIP Briefly describe nature of the material created by this author in which copyright is claimed. ▼

c NAME OF AUTHOR ▼

DATES OF BIRTH AND DEATH
Year Born ▼ Year Died ▼

Was this contribution to the work a "work made for hire"?
☐ Yes
☐ No

AUTHOR'S NATIONALITY OR DOMICILE
Name of Country
OR { Citizen of ▶
 Domiciled in ▶

WAS THIS AUTHOR'S CONTRIBUTION TO THE WORK
Anonymous? ☐ Yes ☐ No
Pseudonymous? ☐ Yes ☐ No

NATURE OF AUTHORSHIP Briefly describe nature of the material created by this author in which copyright is claimed. ▼

3 YEAR IN WHICH CREATION OF THIS WORK WAS COMPLETED This information must be given
1989 ◀ Year in all cases.

DATE AND NATION OF FIRST PUBLICATION OF THIS PARTICULAR WORK
Complete this information Month ▶ June Day ▶ 5 Year ▶ 1989
ONLY if this work has been published. U.S.A. ◀ Nation

4 COPYRIGHT CLAIMANT(S) Name and address must be given even if the claimant is the same as the author given in space 2. ▼

RIP VAN WINKLE
P. O. Box 57, Clearwater, FL 34617

TRANSFER If the claimant(s) named here in space 4 are different from the author(s) named in space 2, give a brief statement of how the claimant(s) obtained ownership of the copyright. ▼

APPLICATION RECEIVED

ONE DEPOSIT RECEIVED

TWO DEPOSITS RECEIVED

REMITTANCE NUMBER AND DATE

DO NOT WRITE HERE
OFFICE USE ONLY

MORE ON BACK ▶ • Complete all applicable spaces (numbers 5-11) on the reverse side of this page. DO NOT WRITE HERE
• See detailed instructions. • Sign the form at line 10. Page 1 of ___ pages

5 (FOR COPYRIGHT OFFICE USE ONLY)

EXAMINED BY FORM TX

CHECKED BY

☐ CORRESPONDENCE
 ☐ Yes

☐ DEPOSIT ACCOUNT
 ☐ FUNDS USED

FOR COPYRIGHT OFFICE USE ONLY

DO NOT WRITE ABOVE THIS LINE. IF YOU NEED MORE SPACE, USE A SEPARATE CONTINUATION SHEET.

5 PREVIOUS REGISTRATION Has registration for this work, or for an earlier version of this work, already been made in the Copyright Office?
☐ Yes ☒ No If your answer is "Yes," why is another registration being sought? (Check appropriate box) ▼
☐ This is the first published edition of a work previously registered in unpublished form.
☐ This is the first application submitted by this author as copyright claimant.
☐ This is a changed version of the work, as shown by space 6 on this application.
If your answer is "Yes," give: Previous Registration Number ▼ Year of Registration ▼

6 DERIVATIVE WORK OR COMPILATION Complete both space 6a & 6b for a derivative work; complete only 6b for a compilation.
a. Preexisting Material Identify any preexisting work or works that this work is based on or incorporates. ▼

b. Material Added to This Work Give a brief, general statement of the material that has been added to this work and in which copyright is claimed. ▼

7 MANUFACTURERS AND LOCATIONS If this is a published work consisting preponderantly of nondramatic literary material in English, the law may require that the copies be manufactured in the United States or Canada for full protection. If so, the names of the manufacturers who performed certain processes, and the places where these processes were performed must be given. See instructions for details.
Names of Manufacturers ▼ Places of Manufacture ▼
Snooze Press New York, NY

8 REPRODUCTION FOR USE OF BLIND OR PHYSICALLY HANDICAPPED INDIVIDUALS A signature on this form at space 10, and a check in one of the boxes here in space 8, constitutes a non-exclusive grant of permission to the Library of Congress to reproduce and distribute solely for the blind and physically handicapped and under the conditions and limitations prescribed by the regulations of the Copyright Office: (1) copies of the work identified in space 1 of this application in Braille (or similar tactile symbols); or (2) phonorecords embodying a fixation of a reading of that work; or (3) both.
☒ a ☐ Copies and Phonorecords b ☐ Copies Only c ☐ Phonorecords Only

9 DEPOSIT ACCOUNT If the registration fee is to be charged to a Deposit Account established in the Copyright Office, give name and number of Account.
Name ▼ Account Number ▼

CORRESPONDENCE Give name and address to which correspondence about this application should be sent. Name/Address/Apt/City/State/Zip ▼
Rip Van Winkle
P. O. Box 57
Clearwater, FL 34617
Area Code & Telephone Number ▶ (813) 555-1212

10 CERTIFICATION* I, the undersigned, hereby certify that I am the
Check one ▶
☐ author
☐ other copyright claimant
☐ owner of exclusive right(s)
☒ authorized agent of
Name of author or other copyright claimant, or owner of exclusive right(s) ▲

of the work identified in this application and that the statements made by me in this application are correct to the best of my knowledge.

Typed or printed name and date ▼ If this is a published work, this date must be the same as or later than the date of publication given in space 3.
Rip Van Winkle date ▶ June 25, 1989

Handwritten signature (X) ▼
Rip Van Winkle

11 MAIL CERTIFICATE TO
Name ▼
RIP VAN WINKLE
Number/Street/Apartment Number ▼
P. O. BOX 57
City/State/ZIP ▼
CLEARWATER, FL 34617

Have you:
• Completed all necessary spaces?
• Signed your application in space 10?
• Enclosed check or money order for $10 payable to Register of Copyrights?
• Enclosed your deposit material with the application and fee?
MAIL TO: Register of Copyrights, Library of Congress, Washington, D.C. 20559

*17 U.S.C. § 506(e): Any person who knowingly makes a false representation of a material fact in the application for copyright registration provided for by section 409, or in any written statement filed in connection with the application, shall be fined not more than $2,500.

☆U.S. GOVERNMENT PRINTING OFFICE: 1985: 491-560/20,001

December 1985—200,000

FORM VA
UNITED STATES COPYRIGHT OFFICE

REGISTRATION NUMBER

VA VAU

EFFECTIVE DATE OF REGISTRATION

Month Day Year

DO NOT WRITE ABOVE THIS LINE. IF YOU NEED MORE SPACE, USE A SEPARATE CONTINUATION SHEET.

1 TITLE OF THIS WORK ▼
TRUTH

NATURE OF THIS WORK ▼ See Instructions
SCULPTURE

PREVIOUS OR ALTERNATIVE TITLES ▼

PUBLICATION AS A CONTRIBUTION If this work was published as a contribution to a periodical, serial, or collection, give information about the collective work in which the contribution appeared. Title of Collective Work ▼

If published in a periodical or serial give: Volume ▼ Number ▼ Issue Date ▼ On Pages ▼

2 NAME OF AUTHOR ▼
a JOSE SANTIAGO

DATES OF BIRTH AND DEATH
Year Born ▼ 1930 Year Died ▼

Was this contribution to the work a
"work made for hire"?
☐ Yes
☒ No

AUTHOR'S NATIONALITY OR DOMICILE
Name of Country
OR { Citizen of ▶ _____
 Domiciled in ▶ Miami, FL

WAS THIS AUTHOR'S CONTRIBUTION TO
THE WORK
Anonymous? ☐ Yes ☒ No
Pseudonymous? ☐ Yes ☒ No
If the answer to either
of these questions is
"Yes," see detailed
instructions.

NATURE OF AUTHORSHIP Briefly describe nature of the material created by this author in which copyright is claimed. ▼
Entire work.

NAME OF AUTHOR ▼
b

DATES OF BIRTH AND DEATH
Year Born ▼ Year Died ▼

Was this contribution to the work a
"work made for hire"?
☐ Yes
☐ No

AUTHOR'S NATIONALITY OR DOMICILE
Name of Country
OR { Citizen of ▶ _____
 Domiciled in ▶ _____

WAS THIS AUTHOR'S CONTRIBUTION TO
THE WORK
Anonymous? ☐ Yes ☐ No
Pseudonymous? ☐ Yes ☐ No
If the answer to either
of these questions is
"Yes," see detailed
instructions.

NATURE OF AUTHORSHIP Briefly describe nature of the material created by this author in which copyright is claimed. ▼

NAME OF AUTHOR ▼
c

DATES OF BIRTH AND DEATH
Year Born ▼ Year Died ▼

Was this contribution to the work a
"work made for hire"?
☐ Yes
☐ No

AUTHOR'S NATIONALITY OR DOMICILE
Name of Country
OR { Citizen of ▶ _____
 Domiciled in ▶ _____

WAS THIS AUTHOR'S CONTRIBUTION TO
THE WORK
Anonymous? ☐ Yes ☐ No
Pseudonymous? ☐ Yes ☐ No
If the answer to either
of these questions is
"Yes," see detailed
instructions.

NATURE OF AUTHORSHIP Briefly describe nature of the material created by this author in which copyright is claimed. ▼

NOTE
Under the law, the "author" of a "work made for hire" is generally the employer, not the employee (see instructions). For any part of this work that was "made for hire" check "Yes" in the space provided, give the employer (or other person for whom the work was prepared) as "Author" of that part, and leave the space for dates of birth and death blank.

3 YEAR IN WHICH CREATION OF THIS
WORK WAS COMPLETED This information
1989 ◀ Year must be given
 in all cases.

DATE AND NATION OF FIRST PUBLICATION OF THIS PARTICULAR WORK
Complete this information Month ▶ April Day ▶ 12 Year ▶ 1989
ONLY if this work
has been published. U.S.A. ◀ Nation

4 COPYRIGHT CLAIMANT(S) Name and address must be given even if the claimant is the
same as the author given in space 2. ▼
JOSE SANTIAGO
311 - 24th Ave.
Miami, FL 33010

APPLICATION RECEIVED

ONE DEPOSIT RECEIVED

TWO DEPOSITS RECEIVED

REMITTANCE NUMBER AND DATE

DO NOT WRITE HERE
OFFICE USE ONLY

TRANSFER If the claimant(s) named here in space 4 are different from the author(s) named
in space 2, give a brief statement of how the claimant(s) obtained ownership of the copyright. ▼

MORE ON BACK ▶ • Complete all applicable spaces (numbers 5-9) on the reverse side of this page. • See detailed instructions. • Sign the form at line 8.

DO NOT WRITE HERE

Page 1 of _____ pages

FORM VA

EXAMINED BY

CHECKED BY

CORRESPONDENCE
☐ Yes

DEPOSIT ACCOUNT
FUNDS USED

FOR
COPYRIGHT
OFFICE
USE
ONLY

DO NOT WRITE ABOVE THIS LINE. IF YOU NEED MORE SPACE, USE A SEPARATE CONTINUATION SHEET.

5 PREVIOUS REGISTRATION Has registration for this work, or for an earlier version of this work, already been made in the Copyright Office?
☐ Yes ☒ No If your answer is "Yes," why is another registration being sought? (Check appropriate box.) ▼
a. ☐ This is the first published edition of a work previously registered in unpublished form.
b. ☐ This is the first application submitted by this author as copyright claimant.
c. ☐ This is a changed version of the work, as shown by space 6 on this application.
If your answer is "Yes," give: Previous Registration Number ▼ Year of Registration ▼

6 DERIVATIVE WORK OR COMPILATION Complete both space 6a & 6b for a derivative work; complete only 6b for a compilation.
a. Preexisting Material Identify any preexisting work or works that this work is based on or incorporates. ▼

See instructions
before completing
this space.

b. Material Added to This Work Give a brief, general statement of the material that has been added to this work and in which copyright is claimed. ▼

7 DEPOSIT ACCOUNT If the registration fee is to be charged to a Deposit Account established in the Copyright Office, give name and number of Account.
Name ▼ Account Number ▼

CORRESPONDENCE Give name and address to which correspondence about this application should be sent. Name/Address/Apt/City/State/Zip ▼
Jose Santiago
311 - 24th Ave.
Miami, FL 33010

Area Code & Telephone Number ▶ (305) 555-1212

Be sure to
give your
daytime phone
number

8 CERTIFICATION* I, the undersigned, hereby certify that I am the
Check only one ▼
☒ author
☐ other copyright claimant
☐ owner of exclusive right(s)
☐ authorized agent of _____
 Name of author or other copyright claimant, or owner of exclusive right(s) ▲

of the work identified in this application and that the statements made
by me in this application are correct to the best of my knowledge.

Typed or printed name and date ▼ If this is a published work, this date must be the same as or later than the date of publication given in space 3.
JOSE SANTIAGO date ▶ May 1, 1989

Handwritten signature (X) ▼
Jose Santiago

MAIL
CERTIFI-
CATE TO

Name ▼
JOSE SANTIAGO

Number/Street/Apartment Number ▼
311 - 24th Ave.

City/State/ZIP ▼
MIAMI, FL 33010

Certificate
will be
mailed in
window
envelope

Have you:
• Completed all necessary spaces?
• Signed your application in space 8?
• Enclosed check or money order
 for $10 payable to Register of
 Copyrights?
• Enclosed your deposit material
 with the application and fee?
MAIL TO: Register of Copyrights,
Library of Congress, Washington,
D.C. 20559

*17 U.S.C. § 506(e): Any person who knowingly makes a false representation of a material fact in the application for copyright registration provided for by section 409, or in any written statement filed in connection with the application, shall be fined not more than $2,500.

FORM PA
UNITED STATES COPYRIGHT OFFICE

REGISTRATION NUMBER

PA ___ PAU

EFFECTIVE DATE OF REGISTRATION

Month ___ Day ___ Year ___

DO NOT WRITE ABOVE THIS LINE. IF YOU NEED MORE SPACE, USE A SEPARATE CONTINUATION SHEET.

1
TITLE OF THIS WORK ▼
SINGING IN THE SNOW

PREVIOUS OR ALTERNATIVE TITLES ▼
RHAPSODY IN WHITE

NATURE OF THIS WORK ▼ See Instructions
SONG LYRICS

2
NAME OF AUTHOR ▼

a CHARLES "SLOW MAN" WHITE

DATES OF BIRTH AND DEATH
Year Born ▼ 1948 Year Died ▼

Was this contribution to the work a "work made for hire"?
☐ Yes ☐ No

AUTHOR'S NATIONALITY OR DOMICILE
Name of Country
OR { Citizen of ▶
Domiciled in ▶ New York, NY

WAS THIS AUTHOR'S CONTRIBUTION TO THE WORK
Anonymous? ☐ Yes ☒ No
Pseudonymous? ☐ Yes ☒ No
If the answer to either of these questions is "Yes," see detailed instructions.

NATURE OF AUTHORSHIP Briefly describe nature of the material created by this author in which copyright is claimed. ▼
Entire work.

NOTE

b NAME OF AUTHOR ▼

DATES OF BIRTH AND DEATH
Year Born ▼ Year Died ▼

Was this contribution to the work a "work made for hire"?
☐ Yes ☐ No

AUTHOR'S NATIONALITY OR DOMICILE
OR { Citizen of ▶
Domiciled in ▶

WAS THIS AUTHOR'S CONTRIBUTION TO THE WORK
Anonymous? ☐ Yes ☐ No
Pseudonymous? ☐ Yes ☐ No

NATURE OF AUTHORSHIP Briefly describe nature of the material created by this author in which copyright is claimed. ▼

c NAME OF AUTHOR ▼

DATES OF BIRTH AND DEATH
Year Born ▼ Year Died ▼

Was this contribution to the work a "work made for hire"?
☐ Yes ☐ No

AUTHOR'S NATIONALITY OR DOMICILE
OR { Citizen of ▶
Domiciled in ▶

WAS THIS AUTHOR'S CONTRIBUTION TO THE WORK
Anonymous? ☐ Yes ☐ No
Pseudonymous? ☐ Yes ☐ No

NATURE OF AUTHORSHIP Briefly describe nature of the material created by this author in which copyright is claimed. ▼

3
YEAR IN WHICH CREATION OF THIS WORK WAS COMPLETED This information must be given
1969 ◄ Year in all cases.

DATE AND NATION OF FIRST PUBLICATION OF THIS PARTICULAR WORK
Complete this information Month ▶ Jan. Day ▶ 29 Year ▶ 1989
ONLY if this work has been published.
U.S.A. ◄ Nation

4
COPYRIGHT CLAIMANT(S) Name and address must be given even if the claimant is the same as the author given in space 2 ▼
CHARLES WHITE
2120 W. MADISON AVE.
CHICAGO, IL 60612

TRANSFER If the claimant(s) named here in space 4 are different from the author(s) named in space 2, give a brief statement of how the claimant(s) obtained ownership of the copyright. ▼

APPLICATION RECEIVED
ONE DEPOSIT RECEIVED
TWO DEPOSITS RECEIVED
REMITTANCE NUMBER AND DATE
DO NOT WRITE HERE
OFFICE USE ONLY

MORE ON BACK ▶ • Complete all applicable spaces (numbers 5-9) on the reverse side of this page.
• See detailed instructions. • Sign the form at line 8.

Page 1 of ___ pages

FORM PA
FOR COPYRIGHT OFFICE USE ONLY

REGISTRATION NUMBER

EXAMINED BY

CHECKED BY

CORRESPONDENCE ☐ Yes

DEPOSIT ACCOUNT FUNDS USED

DO NOT WRITE ABOVE THIS LINE. IF YOU NEED MORE SPACE, USE A SEPARATE CONTINUATION SHEET.

5
PREVIOUS REGISTRATION Has registration for this work, or for an earlier version of this work, already been made in the Copyright Office?
☒ Yes ☐ No If your answer is "Yes," why is another registration being sought? (Check appropriate box) ▼
☒ This is the first published edition of a work previously registered in unpublished form.
☐ This is the first application submitted by this author as copyright claimant.
☐ This is a changed version of the work, as shown by space 6 on this application.
If your answer is "Yes," give: Previous Registration Number ▼ 2152809 Year of Registration ▼ 1970

6
DERIVATIVE WORK OR COMPILATION Complete both space 6a & 6b for a derivative work; complete only 6b for a compilation.
a. Preexisting Material Identify any preexisting work or works that this work is based on or incorporates. ▼

b. Material Added to This Work Give a brief, general statement of the material that has been added to this work and in which copyright is claimed. ▼

7
DEPOSIT ACCOUNT If the registration fee is to be charged to a Deposit Account established in the Copyright Office, give name and number of Account.
Name ▼ Account Number ▼

CORRESPONDENCE Give name and address to which correspondence about this application should be sent. Name/Address/Apt/City/State/Zip ▼
CHARLES WHITE
2120 W. MADISON AVE.
CHICAGO, IL 60612

Area Code & Telephone Number ▶ (312) 555-1212

8
CERTIFICATION* I, the undersigned, hereby certify that I am the
Check only one ▼
☐ author
☒ other copyright claimant
☐ owner of exclusive right(s)
☐ authorized agent of ___
Name of author or other copyright claimant, or owner of exclusive right(s) ▲

of the work identified in this application and that the statements made by me in this application are correct to the best of my knowledge.

Typed or printed name and date ▼ If this is a published work, this date must be the same as or later than the date of publication given in space 3.
CHARLES WHITE date ▶ April 20, 1989

Handwritten signature (X) ▼
[signature]

9
MAIL CERTIFICATE TO
Name ▼
CHARLES WHITE
Number/Street/Apt Number ▼
2120 W. MADISON AVE.
City/State/Zip ▼
CHICAGO, IL 60612

Certificate will be mailed in window envelope

Have you:
• Completed all necessary spaces?
• Signed your application in space 8?
• Enclosed check or money order for $10 payable to Register of Copyrights?
• Enclosed your deposit material with the application and fee?
MAIL TO: Register of Copyrights, Library of Congress, Washington, D.C. 20559

*17 U.S.C. § 506(e): Any person who knowingly makes a false representation of a material fact in the application for copyright registration provided for by section 409, or in any written statement filed in connection with the application, shall be fined not more than $2,500.

☆ U.S. GOVERNMENT PRINTING OFFICE: 1987 181-556/40,004

July 1987—200,000

26

"Best Edition" of Published Copyrighted Works for the Collections of the Library of Congress*

The copyright law (title 17, United States Code) requires that copies or phonorecords deposited in the Copyright Office be of the "best edition" of the work. The law states that "The 'best edition' of a work is the edition, published in the United States at any time before the date of deposit, that the Library of Congress determines to be most suitable for its purposes." (For works first published only in a country other than the United States, the law requires the deposit of the best edition as **first** published.)

When two or more editions of the same version of a work have been published, the one of the highest quality is generally considered to be the best edition. In judging quality, the Library of Congress will adhere to the criteria set forth below in all but exceptional circumstances.

Where differences between editions represent variations in copyrightable content, each edition is a separate version and "best edition" standards based on such differences do not apply. Each such version is a separate work for the purposes of the copyright law.

The criteria to be applied in determining the best edition of each of several types of material are listed below in descending order of importance. In deciding between two editions, a criterion-by-criterion comparison should be made. The edition which first fails to satisfy a criterion is to be considered of inferior quality and will not be an acceptable deposit. Example: If a comparison is made between two hardbound editions of a book, one a trade edition printed on acid-free paper, and the other a specially bound edition printed on average paper, the former will be the best edition because the type of paper is a more important criterion than the binding.

Under regulations of the Copyright Office, potential depositors may request authorization to deposit copies or phonorecords of other than the best edition of a specific work (e.g., a microform rather than a printed edition of a serial), by requesting "special relief" from the deposit requirements. All requests for special relief should be in writing and should state the reason(s) why the applicant cannot send the required deposit and what the applicant wishes to submit instead of the required deposit.

I. PRINTED TEXTUAL MATTER

A. *Paper, Binding, and Packaging:*
1. Archival-quality rather than less-permanent paper.
2. Hard cover rather than soft cover.
3. Library binding rather than commercial binding.
4. Trade edition rather than book club edition.
5. Sewn rather than glue-only binding.
6. Sewn or glued rather than stapled or spiral-bound.
7. Stapled rather than spiral-bound or plastic-bound.
8. Bound rather than looseleaf, except when future looseleaf insertions are to be issued. In the case of looseleaf materials, this includes the submission of all binders and indexes when they are part of the unit as published and offered for sale or distribution. Additionally, the regular and timely receipt of all appropriate looseleaf updates, supplements, and releases including supplemental binders issued to handle these expanded versions, is part of the requirement to properly maintain these publications.
9. Slip-cased rather than nonslip-cased.
10. With protective folders rather than without (for broadsides).
11. Rolled rather than folded (for broadsides).
12. With protective coatings rather than without (except broadsides, which should not be coated).

B. *Rarity:*
1. Special limited edition having the greatest number of special features.
2. Other limited edition rather than trade edition.
3. Special binding rather than trade binding.

C. *Illustrations:*
1. Illustrated rather than unillustrated.
2. Illustrations in color rather than black and white.

D. *Special Features:*
1. With thumb notches or index tabs rather than without.
2. With aids to use such as overlays and magnifiers rather than without.

E. *Size:*
1. Larger rather than smaller sizes. (Except that large-type editions for the partially-sighted are not required in place of editions employing type of more conventional size.)

II. PHOTOGRAPHS

A. Size and finish, in descending order of preference:
1. The most widely distributed edition.
2. 8 x 10-inch glossy print.
3. Other size or finish.

B. Unmounted rather than mounted.

C. Archival-quality rather than less-permanent paper stock or printing process.

III. MOTION PICTURES

A. Film rather than another medium. Film editions are listed below in descending order of preference.
1. Preprint material, by special arrangement.
2. Film gauge in which most widely distributed.
3. 35 mm rather than 16 mm.
4. 16 mm rather than 8 mm.
5. Special formats (e.g., 65 mm) only in exceptional cases.
6. Open reel rather than cartridge or cassette.

*This excerpt is taken in part from Volume 43, No. 2 of the *Federal Register* for Wednesday, January 4, 1978 (p. 766).

B. Videotape rather than videodisc. Videotape editions are listed below in descending order of preference.
1. Tape gauge in which most widely distributed.
2. Two-inch tape.
3. One-inch tape.
4. Three-quarter-inch tape cassette.
5. One-half-inch tape cassette.

IV. OTHER GRAPHIC MATTER

A. *Paper and Printing:*
1. Archival quality rather than less-permanent paper.
2. Color rather than black and white.

B. *Size and Content:*
1. Larger rather than smaller size.
2. In the case of cartographic works, editions with the greatest amount of information rather than those with less detail.

C. *Rarity:*
1. The most widely distributed edition rather than one of limited distribution.
2. In the case of a work published only in a limited, numbered edition, one copy outside the numbered series but otherwise identical.
3. A photographic reproduction of the original, by special arrangement only.

D. *Text and Other Materials:*
1. Works with annotations, accompanying tabular or textual matter, or other interpretative aids rather than those without them.

E. *Binding and Packaging:*
1. Bound rather than unbound.
2. If editions have different binding, apply the criteria in I.A.2-I.A.7, above.
4. Rolled rather than folded.
5. With protective coatings rather than without.

V. PHONORECORDS

A. Compact digital disc rather than a vinyl disc.
B. Vinyl disc rather than tape.
C. With special enclosures rather than without.
D. Open-reel rather than cartridge.
E. Cartridge rather than cassette.
F. Quadraphonic rather than stereophonic.
G. True stereophonic rather than monaural.
H. Monaural rather than electronically rechanneled stereo.

VI. MUSICAL COMPOSITIONS

A. *Fullness of Score:*
1. *Vocal music:*
 a. With orchestral accompaniment—
 i. Full score and parts, if any, rather than conductor's score and parts, if any. (In cases of compositions published only by rental, lease, or lending, this requirement is reduced to full score only.)

ii. Conductor's score and parts, if any, rather than condensed score and parts, if any. (In cases of compositions published only by rental, lease, or lending, this requirement is reduced to conductor's score only.)
 b. Unaccompanied: Open score (each part on separate staff) rather than closed score (all parts condensed to two staves).
2. *Instrumental music:*
 a. Full score and parts, if any, rather than conductor's score and parts, if any. (In cases of compositions published only by rental, lease, or lending, this requirement is reduced to full score only.)
 b. Conductor's score and parts, if any, rather than condensed score and parts, if any. (In cases of compositions published only by rental, lease, or lending, this requirement is reduced to conductor's score only.)

B. *Printing and Paper:*
1. Archival-quality rather than less-permanent paper.

C. *Binding and Packaging:*
1. Special limited editions rather than trade editions.
2. Bound rather than unbound.
3. If editions have different binding, apply the criteria in I.A.2-I.A.12, above.
4. With protective folders rather than without.

VII. MICROFORMS

A. *Related Materials:*
1. With indexes, study guides, or other printed matter rather than without.

B. *Permanence and Appearance:*
1. Silver halide rather than any other emulsion.
2. Positive rather than negative.
3. Color rather than black and white.

C. *Format (newspapers and newspaper-formatted serials):*
1. Reel microfilm rather than any other microform.

D. *Format (all other materials):*
1. Microfiche rather than reel microfilm.
2. Reel microfilm rather than microform cassettes.
3. Microfilm cassettes rather than micro-opaque prints.

E. *Size:*
1. 35 mm rather than 16 mm.

VIII. WORKS EXISTING IN MORE THAN ONE MEDIUM

Editions are listed below in descending order of preference.

A. Newspapers, dissertations and theses, newspaper-formatted serials:
1. Microform.
2. Printed matter.

B. All other materials:
1. Printed matter.
2. Microform.
3. Phonorecord.
(Effective: January 1, 1978.)

For further information on Copyright Office deposit regulations, see Part 202 of 37 CFR, Chapter II, or write to the Register of Copyrights, Library of Congress, Washington, D.C. 20559.

Circular

61

Copyright
Registration
for Computer
Programs

DEFINITION

"A 'computer program' is a set of statements or instructions to be used directly or indirectly in a computer in order to bring about a certain result."

WHAT TO SEND

- A Completed Form TX
- A $10.00 Non-refundable Filing Fee Payable to the Register of Copyrights
- One Copy of Identifying Material (See Below)

EXTENT OF COPYRIGHT PROTECTION

Copyright protection extends to the literary or textual expression contained in the computer program. Copyright protection is not available for ideas, program logic, algorithms, systems, methods, concepts, or layouts.

DESCRIBING BASIS OF CLAIM ON FORM TX

- Space 2. In the "Author of" space identify the copyrightable authorship in the computer program for which registration is sought; for example, AUTHOR OF "Text of computer program," "Text of user's manual and computer program text," etc. (Do not include in the claim any reference to design, physical form, or hardware.)
- Space 6. Complete this space only if the computer program contains a substantial amount of previously published, registered, or public domain material (for example, subroutines, modules, or textual material).

DEPOSIT REQUIREMENTS

For published or unpublished computer programs, one copy of identifying portions of the program, (first 25 and last 25 pages), reproduced in a form visually perceptible without the aid of a machine or device, either on paper or in microform, together with the page or equivalent unit containing the copyright notice, if any.

For a program less than 50 pages in length, a visually perceptible copy of the entire program. For a revised version of a program which has been previously published, previously registered, or which is in the public domain, if the revisions occur throughout the entire program, the first 25 and last 25 pages. If the revisions are not contained in the first and last 25 pages, any 50 pages representative of the revised material in the new program, together with the page or equivalent unit containing the copyright notice for the revised version, if any.

The Copyright Office believes that the best representation of the authorship in a computer program is a listing of the program in source code.

Where the applicant is unable or unwilling to deposit a source code listing, registration will proceed under our RULE OF DOUBT policy upon receipt of written assurance from the applicant that the work as deposited in object code contains copyrightable authorship.

If a published user's manual (or other printed documentation) accompanies the computer program, deposit one copy of the user's manual along with one copy of the identifying portion of the program.

SPECIAL RELIEF AND TRADE SECRETS

When a computer program contains trade secrets or other confidential material that the applicant is unwilling to disclose by depositing the first and last 25 pages in source code, the Copyright Office is willing to consider special relief requests enabling the applicant to deposit less than or other than the usual 50 pages of source code. Special relief requests for the following three deposit options are presently being granted upon receipt of the applicant's written request to the Chief, Examining Division for special relief:

- first and last 25 pages of source code with some portions blocked out, provided that the blocked-out portions are proportionately less than the material still remaining;

- at least the first and last ten pages of source code alone, with no blocked-out portions; or

- first and last 25 pages of object code plus any ten or more consecutive pages of source code, with no blocked-out portions.

LOCATION OF COPYRIGHT NOTICE
Section 201.20(g), 37 C.F.R.

(g) WORKS REPRODUCED IN MACHINE-READABLE COPIES

For works reproduced in machine-readable copies (such as magnetic tapes or disks, punched cards, or the like), from which the work cannot ordinarily be visually perceived except with the aid of a machine or device,[1] each of the following constitute examples of acceptable methods of affixation and position of notice:

(1) A notice embodied in the copies in machine-readable form in such a manner that on visually perceptible print-outs it appears either with or near the title, or at the end of the work;

(2) A notice that is displayed at the user's terminal at sign on;

(3) A notice that is continuously on terminal display; or

(4) A legible notice reproduced durably, so as to withstand normal use, on a gummed or other label securely affixed to the copies or to a box, reel, cartridge, cassette, or other container used as a permanent receptacle for the copies.

FORM OF COPYRIGHT NOTICE

Form of Notice for Visually Perceptible Copies

The notice for visually perceptible copies should contain all of the following three elements:

1. *The symbol* © (the letter C in a circle), or the word "Copyright," or the abbreviation "Copr."

2. *The year of first publication* of the work. In the case of compilations of derivative works incorporating previously published material, the year date of first publication of the compilation or derivative work is sufficient.

[1]Works published in a form requiring the use of a machine or device for purposes of optical enlargement (such as film, filmstrips, slide films, and works published in any variety of microform), and works published in visually perceptible form but used in connection with optical scanning devices, are not within this category.

3. *The name of the owner of copyright* in the work, or an abbreviation by which the name can be recognized, or a generally known alternative designation of the owner.
Example: © 1986 John Doe

FURTHER QUESTIONS:

If you have general information questions and wish to talk to an information specialist, call 202-479-0700.

TO ORDER FORMS:

Write to the Publications Section, LM-455, Copyright Office, Library of Congress, Washington, D.C. 20559 or call 202-287-9100, the Forms and Publications Hotline.

Please note that a copyright registration is effective on the date of receipt in the Copyright Office of all the required elements in acceptable form, regardless of the length of time it takes thereafter to process the application and mail the certificate of registration. The length of time required by the Copyright Office to process an application varies from time to time, depending on the amount of material received and the personnel available to handle it. It must also be kept in mind that it may take a number of days for mailed material to reach the Copyright Office and for the certificate of registration to reach the recipient after being mailed by the Copyright Office.

If you are filing an application for copyright registration in the Copyright Office, you will not receive an acknowledgement that your application has been received (the Office receives more than 500,000 applications annually), but you can expect:

- A letter or telephone call from a copyright examiner if further information is needed;
- A certificate of registration to indicate the work has been registered, or if the application cannot be accepted, a letter explaining why it has been rejected.

You may not receive either of these until 90 days have passed.

If you want to know when the Copyright Office received your material, you should send it via registered or certified mail and request a return receipt.

Deposit Requirements for Registration of Claims to Copyright in Visual Arts Material

IN GENERAL

To register a claim to copyright in a work of the visual arts, submit a properly completed application Form VA and a nonrefundable filing fee of $10.00. This material should be accompanied by an appropriate deposit, generally one complete copy of the work if unpublished, two complete copies of the best edition if the work was first published in the United States, and identifying material for certain types of work.

This circular presents a simplified version of the deposit requirements for registration of claims to copyright in visual arts material. It should be viewed only as a basic guide. The items given on pages 3 and 4 are only examples and are not meant to be restrictive. For more detailed information, write for a copy of ML-347 "Deposit Regulations of the Copyright Office." Mail to:

Publications Section, LM-455
Copyright Office
Library of Congress
Washington, D.C. 20559

BASIC DEFINITIONS

Complete Copy

A "complete copy" of an **unpublished** work is a copy that represents the complete copyrightable content of the work being registered. A complete copy of a **published** work is one that contains all elements of the unit of publication, including those which, if considered separately, would not be copyrightable subject matter. The copies deposited for registration should be physically undamaged.

Best Edition

The "best edition" is the edition published in the United States at any time before the date of deposit in the Copyright Office that the Library of Congress determines to be most suitable for its purposes. Generally, when more than one edition is available, the best edition is: larger rather than smaller; color rather than black and white; and printed on archival quality rather than less-permanent paper. Request Circular 7b, "Best Edition of Published Copyrighted Works for the Collections of the Library of Congress," for additional information.

Identifying Material (I.D. Material)

"Identifying material" or "I.D. material" generally consists of two-dimensional reproduction(s) or rendering(s) of a work in the form of photographic prints, transparencies, photocopies, or drawings that show the complete copyrightable content of the work being registered.

SPECIFICATIONS FOR VISUAL ARTS IDENTIFYING MATERIAL

Copyright Office regulations require the deposit of identifying material instead of copies for three-dimensional works and for works that have been applied to three-dimensional objects. Examples of such works include sculpture, toys, jewelry, artwork on plates, and fabric or textile attached to or part of a three-dimensional object such as furniture. Identifying material must also be submitted for any pictorial, graphic, or sculptural work that exceeds 96" in any dimension.

Identifying material is permitted but not required for registration of certain unpublished two-dimensional works, for example, fabric emblems, decals, greeting cards and picture postcards, maps, drawings, and paintings. Identifying material is permitted but not required for registration of the following unpublished or published works: artwork applied to T-shirts or other wearing apparel; bed, bath, and table linens; and jewelry cast only in base metal.

If you either choose or are required to deposit identifying material to register your claim, you should make sure the identifying material meets the following specifications:

- **Type of identifying material:** The material should consist of photographic prints, transparencies, photocopies, drawings, or similar two-dimensional reproductions or renderings of the work, in a form visually perceivable without the aid of a machine or device.

- **Color or black and white:** If the work is a pictorial or graphic work, the material should reproduce the actual colors employed in the work. In all other cases, the material may be in black and white or may consist of a reproduction of the actual colors.

- **Completeness:** As many pieces of identifying material should be submitted as are necessary to show clearly the entire copyrightable content of the work for which registration is being sought.

- **Number of sets:** Only one set of complete identifying material is required. **NOTE:** With respect to three-dimensional holograms, please write the Copyright Office for additional information.

2

TWO-DIMENSIONAL WORKS

Nature of Work	Required Deposit	
	Published	Unpublished
Advertisements (pictorial)	1 copy as published or prepublication camera-ready copy	Photocopy, proof, drawing, copy, or layout
Artwork for bed, bath and table linens or for wearing apparel (for example, heat transfers or decals already applied to T-shirts)	1 copy if it can be folded in a form not exceeding 4" in thickness; otherwise, I.D. material	same as published
Blueprints, architectural drawings, mechanical drawings, diagrams	1 complete copy	1 copy
Book jackets or record jackets	1 complete copy	1 copy
Commercial print published in newspaper or other periodical	One copy of entire page or pages	
Commercial print or label (for example, flyers, labels, brochures or catalogs used in connection with the sale of goods or services)	1 complete copy	1 copy
Contributions to Collective Works (Photographs, drawings, cartoons, etc., published as part of a periodical or anthology)	1 complete copy of the best edition of entire collective work, complete section containing contribution if published in newspaper, entire page containing contribution, contribution cut from the newspaper, or photocopy of contribution as it was published	
Fabric, textile, wallpaper, carpeting, floor tile, wrapping paper, yard goods	1 complete copy (or swatch) showing the design repeat and copyright notice	1 complete copy (or I.D. material if the work has not been fixed in repeat)

TWO-DIMENSIONAL WORKS

Nature of Work	Required Deposit	
	Published	Unpublished
Fabric emblems or patches, decals or heat transfers (not applied to clothing), bumper stickers, campaign buttons.	1 complete copy	1 copy or I.D. material
Greeting cards, picture postcards, stationery, business cards, calendars	1 complete copy	1 copy or I.D. material
Holograms (2-dimensional)	1 actual copy if image is visible without the aid of a machine or device; otherwise 2 sets of display instructions and 2 sets of I.D. material showing the displayed image	1 copy or display instructions and I.D. material of image
Maps or cartographic material	2 complete copies	1 copy or I.D. material
Patterns, cross-stitch graphs, stitchery brochures, needlework and craft kits	1 complete copy	1 copy or I.D. material
Pictorial or graphic works (for example, artwork, drawings, illustrations, paintings)	2 complete copies	1 copy or I.D. material
Pictorial or graphic works fixed only in machine readable form	I.D. material	I.D. material
Posters, photographs, prints, brochures, exhibition catalogs, calendars	2 complete copies	Copy or proofs, photocopy, contact sheets
"Limited edition" posters, prints or etchings (published in quantities of fewer than 5 copies, or 300 or fewer numbered copies if individual author is owner of copyright)	1 copy or I.D. material	
Oversize material (exceeding 96" in any dimension)	I.D. material	I.D. material

THREE-DIMENSIONAL WORKS

Nature of Work	Required Deposit	
	Published	Unpublished
Artwork or illustrations on 3-D objects (for example, artwork on plates, mugs)	I.D. material	I.D. material
Fabric or textile attached to or part of a 3-D object (such as furniture)	I.D. material	I.D. material
Games	1 complete copy if container is no larger than 12"x24"x6"; otherwise, I.D. material	1 copy if container is no larger than 12"x24"x6" or I.D. material
Globes, relief models, or relief maps	1 complete copy including the stand (I.D. material *not* acceptable)	1 complete copy or I.D. material
Jewelry	I.D. material or 1 copy if fixed only in the form of jewelry cast in base metal not exceeding 4" in any dimension	same as published
Pictorial matter and/or text on a box or container that can be flattened (contents of container are not claimed)	1 copy of box or container if it can be flattened or 1 paper label	1 copy or I.D. material
Prints or labels inseparable from a 3-dimensional object (for example, silk screen label on a bottle)	I.D. material	I.D. material
Sculptures, toys, dolls, molds, relief plaques, statues	I.D. material	I.D. material
Sculpture (for example, doll) in a box with copyrightable pictorial and/or textual material; claim in sculpture and artwork/text	I.D. material for sculpture plus 1 copy of box and any other printed material	I.D. material for sculpture plus copy of box or I.D. material
Oversize material (exceeding 96" in any dimension)	I.D. material	I.D. material

- **Size:** Photographic transparencies must be at least 35 mm in size and, if 3 x 3 inches or less, must be fixed in cardboard, plastic, or similar mounts; transparencies larger than 3 x 3 inches should be mounted. All types of identifying material other than photographic transparencies must be not less than 3 x 3 inches and not more than 9 x 12 inches, but preferably 8 x 10 inches. The image of the work should show clearly the entire copyrightable content of the work.

- **Title and dimension:** At least one piece of identifying material must give the title of the work on its front, back, or mount, and should include an exact measurement of one or more dimensions of the work.

Copyright Notice

For a work published with notice of copyright, the notice and its position on the work must be clearly shown on at least one piece of identifying material. If necessary because of the size or position of the notice, a separate drawing or similar reproduction may be submitted. Such reproduction should be no smaller than 3 x 3 inches and no larger than 9 x 12 inches, showing the exact appearance and content of the notice and its specific position on the work. For further information about the copyright notice, request Circular 3.

FOR MORE INFORMATION

For publications, call the Forms and Publications Hotline, 202-287-9100, or write:
Copyright Office
Publications Section, LM-455
Library of Congress
Washington, D.C. 20559

To speak with an information specialist or to request further information, call 202-479-0700, or write:
Copyright Office
Information Section, LM-401
Library of Congress
Washington, D.C. 20559

The Copyright Office has a number of brochures available covering many aspects of copyright law and regulations. They also have phone lines available for answering questions. If you have a specific question you can call one of the numbers listed. If you want to know about what information is available you should request Circular R2 - Publications of the Copyright Office and Circular 2 - Publications on Copyright. These can be obtained by calling the "Forms and Circulars Hotline" below or by writing to:

U. S. Copyright Office
Library of Congress
Washington, D.C. 20559

Public Information Number: (202) 479-0700
Forms and Circulars Hotline: (202) 707-9100
Reference & bibliography Section: (202) 707-6850
Certifications & Documents Section: (202) 202) 707-6787
Copyright General Counsel's Office: (202) 707-8380
Documents Unit: (202) 707-1759
Licensing Division: (202) 707-8150

FORM TX

UNITED STATES COPYRIGHT OFFICE

REGISTRATION NUMBER

TX TXU

EFFECTIVE DATE OF REGISTRATION

Month Day Year

DO NOT WRITE ABOVE THIS LINE. IF YOU NEED MORE SPACE, USE A SEPARATE CONTINUATION SHEET.

1

TITLE OF THIS WORK ▼

PREVIOUS OR ALTERNATIVE TITLES ▼

PUBLICATION AS A CONTRIBUTION If this work was published as a contribution to a periodical, serial, or collection, give information about the collective work in which the contribution appeared. **Title of Collective Work ▼**

If published in a periodical or serial give: **Volume ▼** **Number ▼** **Issue Date ▼** **On Pages ▼**

2

a

NAME OF AUTHOR ▼

DATES OF BIRTH AND DEATH
Year Born ▼ Year Died ▼

Was this contribution to the work a "work made for hire"?
☐ Yes
☐ No

AUTHOR'S NATIONALITY OR DOMICILE
Name of Country
OR { Citizen of ▶
Domiciled in ▶

WAS THIS AUTHOR'S CONTRIBUTION TO THE WORK
Anonymous? ☐ Yes ☐ No
Pseudonymous? ☐ Yes ☐ No

If the answer to either of these questions is "Yes," see detailed instructions

NATURE OF AUTHORSHIP Briefly describe nature of the material created by this author in which copyright is claimed. ▼

NOTE

Under the law, the "author" of a "work made for hire" is generally the employer, not the employee (see instructions). For any part of this work that was "made for hire" check "Yes" in the space provided, give the employer (or other person for whom the work was prepared) as "Author" of that part, and leave the space for dates of birth and death blank.

b

NAME OF AUTHOR ▼

DATES OF BIRTH AND DEATH
Year Born ▼ Year Died ▼

Was this contribution to the work a "work made for hire"?
☐ Yes
☐ No

AUTHOR'S NATIONALITY OR DOMICILE
Name of country
OR { Citizen of ▶
Domiciled in ▶

WAS THIS AUTHOR'S CONTRIBUTION TO THE WORK
Anonymous? ☐ Yes ☐ No
Pseudonymous? ☐ Yes ☐ No

If the answer to either of these questions is "Yes," see detailed instructions

NATURE OF AUTHORSHIP Briefly describe nature of the material created by this author in which copyright is claimed. ▼

c

NAME OF AUTHOR ▼

DATES OF BIRTH AND DEATH
Year Born ▼ Year Died ▼

Was this contribution to the work a "work made for hire"?
☐ Yes
☐ No

AUTHOR'S NATIONALITY OR DOMICILE
Name of Country
OR { Citizen of ▶
Domiciled in ▶

WAS THIS AUTHOR'S CONTRIBUTION TO THE WORK
Anonymous? ☐ Yes ☐ No
Pseudonymous? ☐ Yes ☐ No

If the answer to either of these questions is "Yes," see detailed instructions

NATURE OF AUTHORSHIP Briefly describe nature of the material created by this author in which copyright is claimed. ▼

3

YEAR IN WHICH CREATION OF THIS WORK WAS COMPLETED This information must be given in all cases.
◀ Year

DATE AND NATION OF FIRST PUBLICATION OF THIS PARTICULAR WORK
Complete this information Month ▶ Day ▶ Year ▶
ONLY if this work has been published.
◀ Nation

4

COPYRIGHT CLAIMANT(S) Name and address must be given even if the claimant is the same as the author given in space 2.▼

See instructions before completing this space.

TRANSFER If the claimant(s) named here in space 4 are different from the author(s) named in space 2, give a brief statement of how the claimant(s) obtained ownership of the copyright.▼

DO NOT WRITE HERE
OFFICE USE ONLY

APPLICATION RECEIVED

ONE DEPOSIT RECEIVED

TWO DEPOSITS RECEIVED

REMITTANCE NUMBER AND DATE

MORE ON BACK ▶ • Complete all applicable spaces (numbers 5-11) on the reverse side of this page.
• See detailed instructions. • Sign the form at line 10.

DO NOT WRITE HERE

Page 1 of _____ pages

DO NOT WRITE ABOVE THIS LINE. IF YOU NEED MORE SPACE, USE A SEPARATE CONTINUATION SHEET.

PREVIOUS REGISTRATION Has registration for this work, or for an earlier version of this work, already been made in the Copyright Office?

☐ Yes ☐ No If your answer is "Yes," why is another registration being sought? (Check appropriate box) ▼

☐ This is the first published edition of a work previously registered in unpublished form.

☐ This is the first application submitted by this author as copyright claimant.

☐ This is a changed version of the work, as shown by space 6 on this application.

If your answer is "Yes," give: **Previous Registration Number** ▼ **Year of Registration** ▼

5

DERIVATIVE WORK OR COMPILATION Complete both space 6a & 6b for a derivative work; complete only 6b for a compilation.

a. Preexisting Material Identify any preexisting work or works that this work is based on or incorporates. ▼

b. Material Added to This Work Give a brief, general statement of the material that has been added to this work and in which copyright is claimed. ▼

6

See instructions
before completing
this space.

MANUFACTURERS AND LOCATIONS If this is a published work consisting preponderantly of nondramatic literary material in English, the law may require that the copies be manufactured in the United States or Canada for full protection. If so, the names of the manufacturers who performed certain processes, and the places where these processes were performed **must** be given. See instructions for details.

Names of Manufacturers ▼ **Places of Manufacture** ▼

7

REPRODUCTION FOR USE OF BLIND OR PHYSICALLY HANDICAPPED INDIVIDUALS A signature on this form at space 10, and a check in one of the boxes here in space 8, constitutes a non-exclusive grant of permission to the Library of Congress to reproduce and distribute solely for the blind and physically handicapped and under the conditions and limitations prescribed by the regulations of the Copyright Office: (1) copies of the work identified in space 1 of this application in Braille (or similar tactile symbols); or (2) phonorecords embodying a fixation of a reading of that work; or (3) both.

a ☐ Copies and Phonorecords b ☐ Copies Only c ☐ Phonorecords Only

8

See instructions.

DEPOSIT ACCOUNT If the registration fee is to be charged to a Deposit Account established in the Copyright Office, give name and number of Account.

Name ▼ **Account Number** ▼

CORRESPONDENCE Give name and address to which correspondence about this application should be sent. Name/Address/Apt/City/State/Zip ▼

9

Area Code & Telephone Number ▶

Be sure to
give your
daytime phone
◀ number.

CERTIFICATION* I, the undersigned, hereby certify that I am the

Check one ▶

☐ author
☐ other copyright claimant
☐ owner of exclusive right(s)
☐ authorized agent of _____
 Name of author or other copyright claimant, or owner of exclusive right(s) ▲

of the work identified in this application and that the statements made by me in this application are correct to the best of my knowledge.

10

Typed or printed name and date ▼ If this is a published work, this date must be the same as or later than the date of publication given in space 3.

_____ date ▶ _____

☞ Handwritten signature (X) ▼

MAIL CERTIFI-CATE TO

Name ▼

Number/Street/Apartment Number ▼

City/State/ZIP ▼

Certificate will be mailed in window envelope

Have you:
• Completed all necessary spaces?
• Signed your application in space 10?
• Enclosed check or money order for $10 payable to *Register of Copyrights*?
• Enclosed your deposit material with the application and fee?

MAIL TO: Register of Copyrights, Library of Congress, Washington, D.C. 20559.

11

Filling Out Application Form TX

Detach and read these instructions before completing this form. Make sure all applicable spaces have been filled in before you return this form.

BASIC INFORMATION

When to Use This Form: Use Form TX for registration of published or unpublished non-dramatic literary works, excluding periodicals or serial issues. This class includes a wide variety of works: fiction, non-fiction, poetry, textbooks, reference works, directories, catalogs, advertising copy, compilations of information, and computer programs. For periodicals and serials, use Form SE.

Deposit to Accompany Application: An application for copyright registration must be accompanied by a deposit consisting of copies or phonorecords representing the entire work for which registration is to be made. The following are the general deposit requirements as set forth in the statute:

Unpublished Work: Deposit one complete copy (or phonorecord).

Published Work: Deposit two complete copies (or phonorecords) of the best edition.

Work First Published Outside the United States: Deposit one complete copy (or phonorecord) of the first foreign edition.

Contribution to a Collective Work: Deposit one complete copy (or phonorecord) of the best edition of the collective work.

The Copyright Notice: For published works, the law provides that a copyright notice in a specified form "shall be placed on all publicly distributed copies from which the work can be visually perceived." Use of the copyright notice is the responsibility of the copyright owner and does not require advance permission from the Copyright Office. The required form of the notice for copies generally consists of three elements: (1) the symbol "©", or the word "Copyright," or the abbreviation "Copr."; (2) the year of first publication; and (3) the name of the owner of copyright. For example: "© 1981 Constance Porter." The notice is to be affixed to the copies "in such manner and location as to give reasonable notice of the claim of copyright."

For further information about copyright registration, notice, or special questions relating to copyright problems, write:

Information and Publications Section, LM-455
Copyright Office
Library of Congress
Washington, D.C. 20559

LINE-BY-LINE INSTRUCTIONS

1 SPACE 1: Title

Title of This Work: Every work submitted for copyright registration must be given a title to identify that particular work. If the copies or phonorecords of the work bear a title (or an identifying phrase that could serve as a title), transcribe that wording *completely* and *exactly* on the application. Indexing of the registration and future identification of the work will depend on the information you give here.

Previous or Alternative Titles: Complete this space if there are any additional titles for the work under which someone searching for the registration might be likely to look, or under which a document pertaining to the work might be recorded.

Publication as a Contribution: If the work being registered is a contribution to a periodical, serial, or collection, give the title of the contribution in the "Title of this Work" space. Then, in the line headed "Publication as a Contribution," give information about the collective work in which the contribution appeared.

2 SPACE 2: Author(s)

General Instructions: After reading these instructions, decide who are the "authors" of this work for copyright purposes. Then, unless the work is a "collective work," give the requested information about every "author" who contributed any appreciable amount of copyrightable matter to this version of the work. If you need further space, request additional Continuation sheets. In the case of a collective work, such as an anthology, collection of essays, or encyclopedia, give information about the author of the collective work as a whole.

Name of Author: The fullest form of the author's name should be given. Unless the work was "made for hire," the individual who actually created the work is its "author." In the case of a work made for hire, the statute provides that "the employer or other person for whom the work was prepared is considered the author."

What is a "Work Made for Hire"? A "work made for hire" is defined as: (1) "a work prepared by an employee within the scope of his or her employment"; or (2) "a work specially ordered or commissioned for use as a contribution to a collective work, as a part of a motion picture or other audiovisual work, as a translation, as a supplementary work, as a compilation, as an instructional text, as a test, as answer material for a test, or as an atlas, if the parties expressly agree in a written instrument signed by them that the work shall be considered a work made for hire." If you have checked "Yes" to indicate that the work was "made for hire," you must give the full legal name of the employer (or other person for whom the work was prepared). You may also include the name of the employee along with the name of the employer (for example: "Elster Publishing Co., employer for hire of John Ferguson").

"Anonymous" or "Pseudonymous" Work: An author's contribution to a work is "anonymous" if that author is not identified on the copies or phonorecords of the work. An author's contribution to a work is "pseudonymous" if that author is identified on the copies or phonorecords under a fictitious name. If the work is "anonymous" you may: (1) leave the line blank; or (2) state "anonymous" on the line; or (3) reveal the author's identity. If the work is "pseudonymous" you may : (1) leave the line blank; or (2) give the pseudonym and identify it as such (for example: "Huntley Haverstock, pseudonym"); or (3) reveal the author's name, making clear which is the real name and which is the pseudonym (for example: "Judith Barton, whose pseudonym is Madeline Elster"). However, the citizenship or domicile of the author **must** be given in all cases.

Dates of Birth and Death: If the author is dead, the statute requires that the year of death be included in the application unless the work is anonymous or pseudonymous. The author's birth date is optional, but is useful as a form of identification. Leave this space blank if the author's contribution was a "work made for hire."

Author's Nationality or Domicile: Give the country of which the author is a citizen, or the country in which the author is domiciled. Nationality or domicile **must** be given in all cases.

Nature of Authorship: After the words "Nature of Authorship" give a brief general statement of the nature of this particular author's contribution to the work. Examples: "Entire text"; "Coauthor of entire text"; "Chapters 11-14"; "Editorial revisions"; "Compilation and English translation"; "New text."

3 SPACE 3: Creation and Publication

General Instructions: Do not confuse "creation" with "publication." Every application for copyright registration must state "the year in which creation of the work was completed." Give the date and nation of first publication only if the work has been published.

Creation: Under the statute, a work is "created" when it is fixed in a copy or phonorecord for the first time. Where a work has been prepared over a period of time, the part of the work existing in fixed form on a particular date constitutes the created work on that date. The date you give here should be the year in which the author completed the particular version for which registration is now being sought, even if other versions exist or if further changes or additions are planned.

Publication: The statute defines "publication" as "the distribution of copies or phonorecords of a work to the public by sale or other transfer of ownership, or by rental, lease, or lending"; a work is also "published" if there has been an "offering to distribute copies or phonorecords to a group of persons for purposes of further distribution, public performance, or public display." Give the full date (month, day, year) when, and the country where, publication first occurred. If first publication took place simultaneously in the United States and other countries, it is sufficient to state "U.S.A."

4 SPACE 4: Claimant(s)

Name(s) and Address(es) of Copyright Claimant(s): Give the name(s) and address(es) of the copyright claimant(s) in this work even if the claimant is the same as the author. Copyright in a work belongs initially to the author of the work (including, in the case of a work made for hire, the employer or other person for whom the work was prepared). The copyright claimant is either the author of the work or a person or organization to whom the copyright initially belonging to the author has been transferred.

Transfer: The statute provides that, if the copyright claimant is not the author, the application for registration must contain "a brief statement of how the claimant obtained ownership of the copyright." If any copyright claimant named in space 4 is not an author named in space 2, give a brief, general statement summarizing the means by which that claimant obtained ownership of the copyright. Examples: "By written contract"; "Transfer of all rights by author"; "Assignment"; "By will." Do not attach transfer documents or other attachments or riders.

5 SPACE 5: Previous Registration

General Instructions: The questions in space 5 are intended to find out whether an earlier registration has been made for this work and, if so, whether there is any basis for a new registration. As a general rule, only one basic copyright registration can be made for the same version of a particular work.

Same Version: If this version is substantially the same as the work covered by a previous registration, a second registration is not generally possible unless: (1) the work has been registered in unpublished form and a second registration is now being sought to cover this first published edition; or (2) someone other than the author is identified as copyright claimant in the earlier registration, and the author is now seeking registration in his or her own name. If either of these two exceptions apply, check the appropriate box and give the earlier registration number and date. Otherwise, do not submit Form TX; instead, write the Copyright Office for information about supplementary registration or recordation of transfers of copyright ownership.

Changed Version: If the work has been changed, and you are now seeking registration to cover the additions or revisions, check the last box in space 5, give the earlier registration number and date, and complete both parts of space 6 in accordance with the instructions below.

Previous Registration Number and Date: If more than one previous registration has been made for the work, give the number and date of the latest registration.

6 SPACE 6: Derivative Work or Compilation

General Instructions: Complete space 6 if this work is a "changed version," "compilation," or "derivative work," and if it incorporates one or more earlier works that have already been published or registered for copyright, or that have fallen into the public domain. A "compilation" is defined as "a work formed by the collection and assembling of preexisting materials or of data that are selected, coordinated, or arranged in such a way that the resulting work as a whole constitutes an original work of authorship." A "derivative work" is "a work based on one or more preexisting works." Examples of derivative works include translations, fictionalizations, abridgments, condensations, or "any other form in which a work may be recast, transformed, or adapted." Derivative works also include works "consisting of editorial revisions, annotations, or other modifications" if these changes, as a whole, represent an original work of authorship.

Preexisting Material (space 6a): For derivative works, complete this space and space 6b. In space 6a identify the preexisting work that has been recast, transformed, or adapted. An example of preexisting material might be: "Russian version of Goncharov's 'Oblomov'." Do not complete space 6a for compilations.

Material Added to This Work (space 6b): Give a brief, general statement of the new material covered by the copyright claim for which registration is sought. Derivative work examples include: "Foreword, editing, critical annotations"; "Translation"; "Chapters 11-17." If the work is a **compilation**, describe both the compilation itself and the material that has been compiled. Example: "Compilation of certain 1917 Speeches by Woodrow Wilson." A work may be both a derivative work and compilation, in which case a sample statement might be: "Compilation and additional new material."

7 SPACE 7: Manufacturing Provisions

General Instructions: The copyright statute currently provides, as a general rule, that the copies of a published work "consisting preponderantly of nondramatic literary material in the English language" be manufactured in the United States or Canada in order to be lawfully imported and publicly distributed in the United States. If the work being registered is unpublished or not in English, leave this space blank. Complete this space if registration is sought for a published work "consisting preponderantly of nondramatic literary material that is in the English language." Identify those who manufactured the copies and where those manufacturing processes were performed. As an exception to the manufacturing provisions, the statute prescribes that, where manufacture has taken place outside the United States or Canada, a maximum of 2000 copies of the foreign edition may be imported into the United States without affecting the copyright owners' rights. For this purpose, the Copyright Office will issue an Import Statement upon request and payment of a fee of $3 at the time of registration or at any later time. For further information about import statements, write for Form IS.

8 SPACE 8: Reproduction for Use of Blind or Physically Handicapped Individuals

General Instructions: One of the major programs of the Library of Congress is to provide Braille editions and special recordings of works for the exclusive use of the blind and physically handicapped. In an effort to simplify and speed up the copyright licensing procedures that are a necessary part of this program, section 710 of the copyright statute provides for the establishment of a voluntary licensing system to be tied in with copyright registration. Copyright Office regulations provide that you may grant a license for such reproduction and distribution solely for the use of persons who are certified by competent authority as unable to read normal printed material as a result of physical limitations. The license is entirely voluntary, nonexclusive, and may be terminated upon 90 days notice.

How to Grant the License: If you wish to grant it, check one of the three boxes in space 8. Your check in one of these boxes, together with your signature in space 10, will mean that the Library of Congress can proceed to reproduce and distribute under the license without further paperwork. For further information, write for Circular R63.

9,10,11 SPACE 9, 10, 11: Fee, Correspondence, Certification, Return Address

Deposit Account: If you maintain a Deposit Account in the Copyright Office, identify it in space 9. Otherwise leave the space blank and send the fee of $10 with your application and deposit.

Correspondence (space 9): This space should contain the name, address, area code, and telephone number of the person to be consulted if correspondence about this application becomes necessary.

Certification (space 10): The application can not be accepted unless it bears the date and the **handwritten signature** of the author or other copyright claimant, or of the owner of exclusive right(s), or of the duly authorized agent of author, claimant, or owner of exclusive right(s).

Address for Return of Certificate (space 11): The address box must be completed legibly since the certificate will be returned in a window envelope.

FORM SE
UNITED STATES COPYRIGHT OFFICE

REGISTRATION NUMBER

U

EFFECTIVE DATE OF REGISTRATION

Month	Day	Year

DO NOT WRITE ABOVE THIS LINE. IF YOU NEED MORE SPACE, USE A SEPARATE CONTINUATION SHEET.

1 TITLE OF THIS SERIAL ▼

Volume ▼	Number ▼	Date on Copies ▼	Frequency of Publication ▼

PREVIOUS OR ALTERNATIVE TITLES ▼

2

a

NAME OF AUTHOR ▼

DATES OF BIRTH AND DEATH
Year Born ▼ Year Died ▼

Was this contribution to the work a "work made for hire"?
☐ Yes
☐ No

AUTHOR'S NATIONALITY OR DOMICILE
Name of Country
OR { Citizen of ▶_____
Domiciled in ▶_____

WAS THIS AUTHOR'S CONTRIBUTION TO THE WORK
Anonymous? ☐ Yes ☐ No
Pseudonymous? ☐ Yes ☐ No
If the answer to either of these questions is "Yes," see detailed instructions.

NATURE OF AUTHORSHIP Briefly describe nature of the material created by this author in which copyright is claimed. ▼
☐ Collective Work Other:

b

NAME OF AUTHOR ▼

DATES OF BIRTH AND DEATH
Year Born ▼ Year Died ▼

Was this contribution to the work a "work made for hire"?
☐ Yes
☐ No

AUTHOR'S NATIONALITY OR DOMICILE
Name of country
OR { Citizen of ▶_____
Domiciled in ▶_____

WAS THIS AUTHOR'S CONTRIBUTION TO THE WORK
Anonymous? ☐ Yes ☐ No
Pseudonymous? ☐ Yes ☐ No
If the answer to either of these questions is "Yes," see detailed instructions.

NATURE OF AUTHORSHIP Briefly describe nature of the material created by this author in which copyright is claimed. ▼
☐ Collective Work Other:

c

NAME OF AUTHOR ▼

DATES OF BIRTH AND DEATH
Year Born ▼ Year Died ▼

Was this contribution to the work a "work made for hire"?
☐ Yes
☐ No

AUTHOR'S NATIONALITY OR DOMICILE
Name of Country
OR { Citizen of ▶_____
Domiciled in ▶_____

WAS THIS AUTHOR'S CONTRIBUTION TO THE WORK
Anonymous? ☐ Yes ☐ No
Pseudonymous? ☐ Yes ☐ No
If the answer to either of these questions is "Yes," see detailed instructions.

NATURE OF AUTHORSHIP Briefly describe nature of the material created by this author in which copyright is claimed. ▼
☐ Collective Work Other:

NOTE

Under the law, the "author" of a "work made for hire" is generally the employer, not the employee (see instructions). For any part of this work that was "made for hire" check "Yes" in the space provided, give the employer (or other person for whom the work was prepared) as "Author" of that part, and leave the space for dates of birth and death blank.

3

YEAR IN WHICH CREATION OF THIS ISSUE WAS COMPLETED This information must be given in all cases.
◀ Year

DATE AND NATION OF FIRST PUBLICATION OF THIS PARTICULAR ISSUE
Complete this information ONLY if this work has been published.
Month ▶_____ Day ▶_____ Year ▶_____ ◀ Nation

4

COPYRIGHT CLAIMANT(S) Name and address must be given even if the claimant is the same as the author given in space 2.▼

See instructions before completing this space.

TRANSFER If the claimant(s) named here in space 4 are different from the author(s) named in space 2, give a brief statement of how the claimant(s) obtained ownership of the copyright.▼

DO NOT WRITE HERE OFFICE USE ONLY

APPLICATION RECEIVED

ONE DEPOSIT RECEIVED

TWO DEPOSITS RECEIVED

REMITTANCE NUMBER AND DATE

MORE ON BACK ▶
• Complete all applicable spaces (numbers 5-11) on the reverse side of this page.
• See detailed instructions. • Sign the form at line 10.

DO NOT WRITE HERE

Page 1 of_____pages

DO NOT WRITE ABOVE THIS LINE. IF YOU NEED MORE SPACE, USE A SEPARATE CONTINUATION SHEET.

PREVIOUS REGISTRATION Has registration for this issue, or for an earlier version of this particular issue, already been made in the Copyright Office?

☐ Yes ☐ No If your answer is "Yes," why is another registration being sought? (Check appropriate box) ▼

a. ☐ This is the first published version of an issue previously registered in unpublished form.

b. ☐ This is the first application submitted by this author as copyright claimant.

c. ☐ This is a changed version of this issue, as shown by space 6 on this application.

If your answer is "Yes," give: **Previous Registration Number** ▼ **Year of Registration** ▼

5

DERIVATIVE WORK OR COMPILATION Complete both space 6a & 6b for a derivative work; complete only 6b for a compilation.

a. Preexisting Material Identify any preexisting work or works that this work is based on or incorporates. ▼

b. Material Added to This Work Give a brief, general statement of the material that has been added to this work and in which copyright is claimed.▼

See instructions before completing this space.

6

MANUFACTURERS AND LOCATIONS If this is a published work consisting preponderantly of nondramatic literary material in English, the law may require that the copies be manufactured in the United States or Canada for full protection. If so, the names of the manufacturers who performed certain processes, and the places where these processes were performed **must** be given. See instructions for details.

Names of Manufacturers ▼ **Places of Manufacture** ▼

7

REPRODUCTION FOR USE OF BLIND OR PHYSICALLY HANDICAPPED INDIVIDUALS A signature on this form at space 10, and a check in one of the boxes here in space 8, constitutes a non-exclusive grant of permission to the Library of Congress to reproduce and distribute solely for the blind and physically handicapped and under the conditions and limitations prescribed by the regulations of the Copyright Office: (1) copies of the work identified in space 1 of this application in Braille (or similar tactile symbols); or (2) phonorecords embodying a fixation of a reading of that work; or (3) both.

a ☐ Copies and Phonorecords **b** ☐ Copies Only **c** ☐ Phonorecords Only

See instructions.

8

DEPOSIT ACCOUNT If the registration fee is to be charged to a Deposit Account established in the Copyright Office, give name and number of Account.

Name ▼ **Account Number** ▼

9

CORRESPONDENCE Give name and address to which correspondence about this application should be sent. Name/Address/Apt/City/State/Zip ▼

Area Code & Telephone Number ▶

Be sure to give your daytime phone ◀ number.

CERTIFICATION* I, the undersigned, hereby certify that I am the

Check one ▶

☐ author
☐ other copyright claimant
☐ owner of exclusive right(s)
☐ authorized agent of _____

of the work identified in this application and that the statements made by me in this application are correct to the best of my knowledge.

Name of author or other copyright claimant, or owner of exclusive right(s) ▲

10

Typed or printed **name and date** ▼ If this is a published work, this date must be the same as or later than the date of publication given in space 3.

_____ date ▶ _____

Handwritten signature (X) ▼

MAIL CERTIFI-CATE TO

Name ▼

Number/Street/Apartment Number ▼

City/State/ZIP ▼

Certificate will be mailed in window envelope

Have you:
• Completed all necessary spaces?
• Signed your application in space 10?
• Enclosed check or money order for $10 payable to *Register of Copyrights?*
• Enclosed your deposit material with the application and fee?

MAIL TO: Register of Copyrights, Library of Congress, Washington, D.C. 20559.

11

Filling Out Application Form SE

Detach and read these instructions before completing this form. Make sure all applicable spaces have been filled in before you return this form.

BASIC INFORMATION

When To Use This Form: Use a separate Form SE for registration of each individual issue of a serial, Class SE. A serial is defined as a work issued or intended to be issued in successive parts bearing numerical or chronological designations and intended to be continued indefinitely. This class includes a variety of works: periodicals; newspapers; annuals; the journals, proceedings, transactions, etc., of societies. Do not use Form SE to register an individual contribution to a serial. Request Form TX for such contributions.

Deposit to Accompany Application: An application for copyright registration must be accompanied by a deposit consisting of copies or phonorecords representing the entire work for which registration is to be made. The following are the general deposit requirements as set forth in the statute:

Unpublished Work: Deposit one complete copy (or phonorecord).

Published Work: Deposit two complete copies (or phonorecords) of the best edition.

Work First Published Outside the United States: Deposit one complete copy (or phonorecord) of the first foreign edition.

Mailing Requirements: It is important that you send the application, the deposit copy or copies, and the $10 fee together in the same envelope or package. The Copyright Office cannot process them unless they are received together. Send to: *Register of Copyrights, Library of Congress, Washington, D.C. 20559.*

The Copyright Notice: For published works, the law provides that a copyright notice in a specified form "shall be placed on all publicly distributed copies from which the work can be visually perceived." Use of the copyright notice is the responsibility of the copyright owner and does not require advance permission from the Copyright Office. The required form of the notice for copies generally consists of three elements: (1) the symbol "©"; or the word "Copyright," or the abbreviation "Copr."; (2) the year of first publication; and (3) the name of the owner of copyright. For example: "© 1981 National News Publishers, Inc." The notice is to be affixed to the copies "in such manner and location as to give reasonable notice of the claim of copyright." For further information about copyright registration, notice, or special questions relating to copyright problems, write:

Information and Publications Section, LM-455
Copyright Office, Library of Congress, Washington, D.C. 20559

LINE-BY-LINE INSTRUCTIONS

1 SPACE 1: Title

Title of This Serial: Every work submitted for copyright registration must be given a title to identify that particular work. If the copies or phonorecords of the work bear a title (or an identifying phrase that could serve as a title), copy that wording *completely* and *exactly* on the application. Give the volume and number of the periodical issue for which you are seeking registration. The "Date on copies" in space 1 should be the date appearing on the actual copies (for example: "June 1981," "Winter 1981"). Indexing of the registration and future identification of the work will depend on the information you give here.

Previous or Alternative Titles: Complete this space only if there are any additional titles for the serial under which someone searching for the registration might be likely to look, or under which a document pertaining to the work might be recorded.

2 SPACE 2: Author(s)

General Instructions: After reading these instructions, decide who are the "authors" of this work for copyright purposes. In the case of a serial issue, the organization which directs the creation of the serial issue as a whole is generally considered the author of the "collective work" (see "Nature of Authorship") whether it employs a staff or uses the efforts of volunteers. Where, however, an individual is independently responsible for the serial issue, name that person as author of the "collective work."

Name of Author: The fullest form of the author's name should be given. In the case of a "work made for hire," the statute provides that "the employer or other person for whom the work was prepared is considered the author." If this issue is a "work made for hire," the author's name will be the full legal name of the hiring organization, corporation, or individual. The title of the periodical should not ordinarily be listed as "author" because the title itself does not usually correspond to a legal entity capable of authorship. When an individual creates an issue of a serial independently and not as an "employee" of an organization or corporation, that individual should be listed as the "author."

Author's Nationality or Domicile: Give the country of which the author is a citizen, or the country in which the author is domiciled. Nationality or domicile **must** be given in all cases. The citizenship of an organization formed under United States Federal or state law should be stated as "U.S.A."

What is a "Work Made for Hire"? A "work made for hire" is defined as: (1) "a work prepared by an employee within the scope of his or her employment"; or (2) "a work specially ordered or commissioned for use as a contribution to a collective work, as a part of a motion picture or other audiovisual work, as a translation, as a supplementary work, as a compilation, as an instructional text, as a test, as answer material for a test, or as an atlas, if the parties expressly agree in a written instrument signed by them that the work shall be considered a work made for hire." An organization that uses the efforts of volunteers in the creation of a "collective work" (see "Nature of Authorship") may also be considered the author of a "work made for hire" even though those volunteers were not specifically paid by the organization. In the case of a "work made for hire," give the full legal name of the employer and check "Yes" to indicate that the work was made for hire. You may also include the name of the employee along with the name of the employer (for example: "Elster Publishing Co., employer for hire of John Ferguson").

"Anonymous" or "Pseudonymous" Work: Leave this space **blank** if the serial is a "work made for hire." An author's contribution to a work is "anonymous" if that author is not identified on the copies or phonorecords of the work. An author's contribution to a work is "pseudonymous" if that author is identified on the copies or phonorecords under a fictitious name. If the work is "anonymous" you may: (1) leave the line blank; or (2) state "anonymous" on the line; or (3) reveal the author's identity. If the work is "pseudonymous" you may: (1) leave the line blank; or (2) give the pseudonym and identify it as such (for example: "Huntley Haverstock, pseudonym"); or (3) reveal the author's name, making clear which is the real name and which is the pseudonym (for example: "Judith Barton, whose pseudonym is Madeline Elster"). However, the citizenship or domicile of the author **must** be given in all cases.

Dates of Birth and Death: Leave this space blank if the author's contribution was a "work made for hire." If the author is dead, the statute requires that the year of death be included in the application unless the work is anonymous or pseudonymous. The author's birth date is optional, but is useful as a form of identification.

Nature of Authorship: Give a brief statement of the nature of the particular author's contribution to the work. If an organization directed, controlled, and supervised the creation of the serial issue as a whole, check the box "collective work." The term "collective work" means that the author is responsible for compilation and editorial revision, and may also be responsible for certain individual contributions to the serial issue. Further examples of "Authorship" which may apply both to organizational and to individual authors are "Entire text"; "Entire text and/or illustrations"; "Editorial revision, compilation, plus additional new material."

3 SPACE 3: Creation and Publication

General Instructions: Do not confuse "creation" with "publication." Every application for copyright registration must state "the year in which creation of the work was completed." Give the date and nation of first publication only if the work has been published.

Creation: Under the statute, a work is "created" when it is fixed in a copy or phonorecord for the first time. Where a work has been prepared over a period of time, the part of the work existing in fixed form on a particular date constitutes the created work on that date. The date you give here should be the year in which this particular issue was completed.

Publication: The statute defines "publication" as "the distribution of copies or phonorecords of a work to the public by sale or other transfer of ownership, or by rental, lease, or lending"; a work is also "published" if there has been an "offering to distribute copies or phonorecords to a group of persons for purposes of further distribution, public performance, or public display." Give the full date (month, day, year) when, and the country where, publication of this particular issue first occurred. If first publication took place simultaneously in the United States and other countries, it is sufficient to state "U.S.A."

4 SPACE 4: Claimant(s)

Name(s) and Address(es) of Copyright Claimant(s): This space must be completed. Give the name(s) and address(es) of the copyright claimant(s) of this work even if the claimant is the same as the author named in space 2. Copyright in a work belongs initially to the author of the work (including, in the case of a work made for hire, the employer or other person for whom the work was prepared). The copyright claimant is either the author of the work or a person or organization to whom the copyright initially belonging to the author has been transferred.

Transfer: The statute provides that, if the copyright claimant is not the author, the application for registration must contain "a brief statement of how the claimant obtained ownership of the copyright." A transfer of copyright ownership (other than one brought about by operation of law) must be in writing. If any copyright claimant named in space 4 is not an author named in space 2, give a brief, general statement describing the means by which that claimant obtained ownership of the copyright from the original author. Examples: "By written contract"; "Written transfer of all rights by author"; "Assignment"; "Inherited by will." Do not attach the actual document of transfer or other attachments or riders.

5 SPACE 5: Previous Registration

General Instructions: This space applies only rarely to serials. Complete space 5 if this particular issue has been registered earlier or if it contains a substantial amount of material that has been previously registered. Do not complete this space if the previous registrations are simply those made for earlier issues.

Previous Registration:
a. **Check this box** if this issue has been registered in unpublished form and a second registration is now sought to cover the first published edition.
b. **Check this box** if someone other than the author is identified as copyright claimant in the earlier registration and the author is now seeking registration in his or her own name. If the work in question is a contribution to a collective work, as opposed to the issue as a whole, file Form TX, not Form SE.
c. **Check this box** (and complete space 6) if this particular issue, or a substantial portion of the material in it, has been previously registered and you are now seeking registration for the additions and revisions which appear in this issue for the first time.

Previous Registration Number and Date: Complete this line if you checked one of the boxes above. If more than one previous registration has been made for the issue or for material in it, give only the number and year date for the latest registration.

6 SPACE 6: Derivative Work or Compilation

General Instructions: Complete space 6 if this issue is a "changed version," "compilation," or "derivative work," which incorporates one or more earlier works that have already been published or registered for copyright, or that have fallen into the public domain. Do not complete space 6 for an issue consisting of entirely new material appearing for the first time, such as a new issue of a continuing serial. A "compilation" is defined as "a work formed by the collection and assembling of preexisting materials or of data that are selected, coordinated, or arranged in such a way that the resulting work as a whole constitutes an original work of authorship." A "derivative work" is "a work based on one or more preexisting works." Examples of derivative works include translations, fictionalizations, abridgments, condensations, or "any other form in which a work may be recast, transformed, or adapted." Derivative works also include works "consisting of editorial revisions, annotations, or other modifications" if these changes, as a whole, represent an original work of authorship.

Preexisting Material (space 6a): For derivative works, complete this space and space 6b. In space 6a identify the preexisting work that has been recast, transformed, adapted, or updated. Example: "1978 Morgan Co. Sales Catalog." Do not complete space 6a for compilations.

Material Added to This Work (space 6b): Give a brief, general statement of the new material covered by the copyright claim for which registration is sought. **Derivative work** examples include: "Editorial revisions and additions to the Catalog"; "Translation"; "Additional material." If a periodical issue is a **compilation**, describe both the compilation itself and the material that has been compiled. Examples: "Compilation of previously published journal articles"; "Compilation of previously published data." An issue may be both a derivative work and a compilation, in which case a sample statement might be: "Compilation of [describe] and additional new material."

7 SPACE 7: Manufacturing Provisions

General Instructions: The copyright statute currently provides, as a general rule, that the copies of a published work "consisting preponderantly of nondramatic literary material in the English language" be manufactured in the United States or Canada in order to be lawfully imported and publicly distributed in the United States. If the work being registered is unpublished or not in English, leave this space blank. Complete this space if registration is sought for a published work "consisting preponderantly of nondramatic literary material that is in the English language." Identify those who manufactured the copies and where those manufacturing processes were performed. As an exception to the manufacturing provisions, the statute prescribes that, where manufacture has taken place outside the United States or Canada, a maximum of 2000 copies of the foreign edition may be imported into the United States without affecting the copyright owners' rights. For this purpose, the Copyright Office will issue an Import Statement upon request and payment of a fee of $3 at the time of registration or at any later time. For further information about import statements, write for Form IS.

8 SPACE 8: Reproduction for Use of Blind or Physically Handicapped Individuals

General Instructions: One of the major programs of the Library of Congress is to provide Braille editions and special recordings of works for the exclusive use of the blind and physically handicapped. In an effort to simplify and speed up the copyright licensing procedures that are a necessary part of this program, section 710 of the copyright statute provides for the establishment of a voluntary licensing system to be tied in with copyright registration. Copyright Office regulations provide that you may grant a license for such reproduction and distribution solely for the use of persons who are certified by competent authority as unable to read normal printed material as a result of physical limitations. The license is entirely voluntary, nonexclusive, and may be terminated upon 90 days notice.

How to Grant the License: If you wish to grant it, check one of the three boxes in space 8. Your check in one of these boxes, together with your signature in space 10, will mean that the Library of Congress can proceed to reproduce and distribute under the license without further paperwork. For further information, write for Circular R63.

9,10,11 SPACE 9, 10, 11: Fee, Correspondence, Certification, Return Address

Deposit Account: If you maintain a Deposit Account in the Copyright Office, identify it in space 9. Otherwise leave the space blank and send the fee of $10 with your application and deposit.

Correspondence (space 9): This space should contain the name, address, area code, and telephone number of the person to be consulted if correspondence about this application becomes necessary.

Certification (space 10): The application cannot be accepted unless it bears the date and the **handwritten signature** of the author or other copyright claimant, or of the owner of exclusive right(s), or of the duly authorized agent of the author, claimant, or owner of exclusive right(s).

Address for Return of Certificate (space 11): The address box must be completed legibly since the certificate will be returned in a window envelope.

FORM PA
UNITED STATES COPYRIGHT OFFICE

REGISTRATION NUMBER

PA PAU

EFFECTIVE DATE OF REGISTRATION

Month Day Year

DO NOT WRITE ABOVE THIS LINE. IF YOU NEED MORE SPACE, USE A SEPARATE CONTINUATION SHEET.

1

TITLE OF THIS WORK ▼

PREVIOUS OR ALTERNATIVE TITLES ▼

NATURE OF THIS WORK ▼ See instructions

2

a

NAME OF AUTHOR ▼

DATES OF BIRTH AND DEATH
Year Born ▼ Year Died ▼

Was this contribution to the work a "work made for hire"?
☐ Yes
☐ No

AUTHOR'S NATIONALITY OR DOMICILE
Name of Country
OR { Citizen of ▶ _____
{ Domiciled in ▶ _____

WAS THIS AUTHOR'S CONTRIBUTION TO THE WORK
Anonymous? ☐ Yes ☐ No
Pseudonymous? ☐ Yes ☐ No
If the answer to either of these questions is "Yes," see detailed instructions.

NATURE OF AUTHORSHIP Briefly describe nature of the material created by this author in which copyright is claimed. ▼

NOTE

Under the law, the "author" of a "work made for hire" is generally the employer, not the employee (see instructions). For any part of this work that was "made for hire" check "Yes" in the space provided, give the employer (or other person for whom the work was prepared) as "Author" of that part, and leave the space for dates of birth and death blank.

b

NAME OF AUTHOR ▼

DATES OF BIRTH AND DEATH
Year Born ▼ Year Died ▼

Was this contribution to the work a "work made for hire"?
☐ Yes
☐ No

AUTHOR'S NATIONALITY OR DOMICILE
Name of country
OR { Citizen of ▶ _____
{ Domiciled in ▶ _____

WAS THIS AUTHOR'S CONTRIBUTION TO THE WORK
Anonymous? ☐ Yes ☐ No
Pseudonymous? ☐ Yes ☐ No
If the answer to either of these questions is "Yes," see detailed instructions.

NATURE OF AUTHORSHIP Briefly describe nature of the material created by this author in which copyright is claimed. ▼

c

NAME OF AUTHOR ▼

DATES OF BIRTH AND DEATH
Year Born ▼ Year Died ▼

Was this contribution to the work a "work made for hire"?
☐ Yes
☐ No

AUTHOR'S NATIONALITY OR DOMICILE
Name of Country
OR { Citizen of ▶ _____
{ Domiciled in ▶ _____

WAS THIS AUTHOR'S CONTRIBUTION TO THE WORK
Anonymous? ☐ Yes ☐ No
Pseudonymous? ☐ Yes ☐ No
If the answer to either of these questions is "Yes," see detailed instructions.

NATURE OF AUTHORSHIP Briefly describe nature of the material created by this author in which copyright is claimed. ▼

3

YEAR IN WHICH CREATION OF THIS WORK WAS COMPLETED This information must be given in all cases.
◀ Year

DATE AND NATION OF FIRST PUBLICATION OF THIS PARTICULAR WORK
Complete this information ONLY if this work has been published.
Month ▶ _____ Day ▶ _____ Year ▶ _____
◀ Nation

4

COPYRIGHT CLAIMANT(S) Name and address must be given even if the claimant is the same as the author given in space 2.▼

See instructions before completing this space.

TRANSFER If the claimant(s) named here in space 4 are different from the author(s) named in space 2, give a brief statement of how the claimant(s) obtained ownership of the copyright.▼

MORE ON BACK ▶ • Complete all applicable spaces (numbers 5-9) on the reverse side of this page.
• See detailed instructions. • Sign the form at line 8.

DO NOT WRITE HERE

Page 1 of_____pages

DO NOT WRITE ABOVE THIS LINE. IF YOU NEED MORE SPACE, USE A SEPARATE CONTINUATION SHEET.

PREVIOUS REGISTRATION Has registration for this work, or for an earlier version of this work, already been made in the Copyright Office?

☐ Yes ☐ No If your answer is "Yes," why is another registration being sought? (Check appropriate box) ▼

☐ This is the first published edition of a work previously registered in unpublished form.

☐ This is the first application submitted by this author as copyright claimant.

☐ This is a changed version of the work, as shown by space 6 on this application.

If your answer is "Yes," give: **Previous Registration Number ▼** **Year of Registration ▼**

5

DERIVATIVE WORK OR COMPILATION Complete both space 6a & 6b for a derivative work; complete only 6b for a compilation.

a. Preexisting Material Identify any preexisting work or works that this work is based on or incorporates. ▼

b. Material Added to This Work Give a brief, general statement of the material that has been added to this work and in which copyright is claimed. ▼

6

See instructions before completing this space.

DEPOSIT ACCOUNT If the registration fee is to be charged to a Deposit Account established in the Copyright Office, give name and number of Account.

Name ▼ **Account Number ▼**

7

CORRESPONDENCE Give name and address to which correspondence about this application should be sent. Name/Address/Apt/City/State/Zip ▼

Area Code & Telephone Number ▶

Be sure to give your daytime phone ◀ number.

CERTIFICATION* I, the undersigned, hereby certify that I am the

Check only one ▼

☐ author

☐ other copyright claimant

☐ owner of exclusive right(s)

☐ authorized agent of _____
Name of author or other copyright claimant, or owner of exclusive right(s) ▲

of the work identified in this application and that the statements made by me in this application are correct to the best of my knowledge.

Typed or printed name and date ▼ If this is a published work, this date must be the same as or later than the date of publication given in space 3.

_____ date ▶ _____

Handwritten signature (X) ▼

8

* 17 U.S.C. § 506(e): Any person who knowingly makes a false representation of a material fact in the application for copyright registration provided for by section 409, or in any written statement filed in connection with the application, shall be fined not more than $2,500.

✰U.S. GOVERNMENT PRINTING OFFICE: 1987:181-531/60,000

July 1987-100,000

Filling Out Application Form PA

Detach and read these instructions before completing this form. Make sure all applicable spaces have been filled in before you return this form.

BASIC INFORMATION

When to Use This Form: Use Form PA for registration of published or unpublished works of the performing arts. This class includes works prepared for the purpose of being "performed" directly before an audience or indirectly "by means of any device or process." Works of the performing arts include: (1) musical works, including any accompanying words; (2) dramatic works, including any accompanying music; (3) pantomimes and choreographic works; and (4) motion pictures and other audiovisual works.

Deposit to Accompany Application: An application for copyright registration must be accompanied by a deposit consisting of copies or phonorecords representing the entire work for which registration is to be made. The following are the general deposit requirements as set forth in the statute:

Unpublished Work: Deposit one complete copy (or phonorecord).

Published Work: Deposit two complete copies (or phonorecords) of the best edition.

Work First Published Outside the United States: Deposit one complete copy (or phonorecord) of the first foreign edition.

Contribution to a Collective Work: Deposit one complete copy (or phonorecord) of the best edition of the collective work.

Motion Pictures: Deposit *both* of the following: (1) a separate written description of the contents of the motion picture; and (2) for a published work, one complete copy of the best edition of the motion picture; or, for an unpublished work, one complete copy of the motion picture or identifying material. Identifying material may be either an audiorecording of the entire soundtrack or one frame enlargement or similar visual print from each 10-minute segment.

The Copyright Notice: For published works, the law provides that a copyright notice in a specified form "shall be placed on all publicly distributed copies from which the work can be visually perceived." Use of the copyright notice is the responsibility of the copyright owner and does not require advance permission from the Copyright Office. The required form of the notice for copies generally consists of three elements: (1) the symbol "©", or the word "Copyright," or the abbreviation "Copr."; (2) the year of first publication; and (3) the name of the owner of copyright. For example: "© 1981 Constance Porter." The notice is to be affixed to the copies "in such manner and location as to give reasonable notice of the claim of copyright."

For further information about copyright registration, notice, or special questions relating to copyright problems, write:

Information and Publications Section, LM-455
Copyright Office
Library of Congress
Washington, D.C. 20559

LINE-BY-LINE INSTRUCTIONS

1 SPACE 1: Title

Title of This Work: Every work submitted for copyright registration must be given a title to identify that particular work. If the copies or phonorecords of the work bear a title (or an identifying phrase that could serve as a title), transcribe that wording *completely* and *exactly* on the application. Indexing of the registration and future identification of the work will depend on the information you give here. If the work you are registering is an entire "collective work" (such as a collection of plays or songs), give the overall title of the collection. If you are registering one or more individual contributions to a collective work, give the title of each contribution, followed by the title of the collection. Example: "'A Song for Elinda' in *Old and New Ballads for Old and New People.*"

Previous or Alternative Titles: Complete this space if there are any additional titles for the work under which someone searching for the registration might be likely to look, or under which a document pertaining to the work might be recorded.

Nature of This Work: Briefly describe the general nature or character of the work being registered for copyright. Examples: "Music"; "Song Lyrics"; "Words and Music"; "Drama"; "Musical Play"; "Choreography"; "Pantomime"; "Motion Picture"; "Audiovisual Work."

2 SPACE 2: Author(s)

General Instructions: After reading these instructions, decide who are the "authors" of this work for copyright purposes. Then, unless the work is a "collective work," give the requested information about every "author" who contributed any appreciable amount of copyrightable matter to this version of the work. If you need further space, request additional Continuation Sheets. In the case of a collective work, such as a songbook or a collection of plays, give information about the author of the collective work as a whole.

Name of Author: The fullest form of the author's name should be given. Unless the work was "made for hire," the individual who actually created the work is its "author." In the case of a work made for hire, the statute provides that "the employer or other person for whom the work was prepared is considered the author."

What is a "Work Made for Hire"? A "work made for hire" is defined as: (1) "a work prepared by an employee within the scope of his or her employment"; or (2) "a work specially ordered or commissioned for use as a contribution to a collective work, as a part of a motion picture or other audiovisual work, as a translation, as a supplementary work, as a compilation, as an instructional text, as a test, as answer material for a test, or as an atlas, if the parties expressly agree in a written instrument signed by them that the work shall be considered a work made for hire." If you have checked "Yes" to indicate that the work was "made for hire," you must give the full legal name of the employer (or other person for whom the work was prepared). You may also include the name of the employee along with the name of the employer (for example: "Elster Music Co., employer for hire of John Ferguson").

"Anonymous" or "Pseudonymous" Work: An author's contribution to a work is "anonymous" if that author is not identified on the copies or phonorecords of the work. An author's contribution to a work is "pseudonymous" if that author is identified on the copies or phonorecords under a fictitious name. If the work is "anonymous" you may: (1) leave the line blank; or (2) state "anonymous" on the line; or (3) reveal the author's identity. If the work is "pseudonymous" you may: (1) leave the line blank; or (2) give the pseudonym and identify it as such (for example: "Huntley Haverstock, pseudonym"); or (3) reveal the author's name, making clear which is the real name and which is the pseudonym (for example: "Judith Barton, whose pseudonym is Madeline Elster"). However, the citizenship or domicile of the author **must** be given in all cases.

Dates of Birth and Death: If the author is dead, the statute requires that the year of death be included in the application unless the work is anonymous or pseudonymous. The author's birth date is optional, but is useful as a form of identification. Leave this space blank if the author's contribution was a "work made for hire."

Author's Nationality or Domicile: Give the country of which the author is a citizen, or the country in which the author is domiciled. Nationality or domicile **must** be given in all cases.

Nature of Authorship: Give a brief general statement of the nature of this particular author's contribution to the work. Examples: "Words"; "Co-Author of Music"; "Words and Music"; "Arrangement"; "Co-Author of Book and Lyrics"; "Dramatization"; "Screen Play"; "Compilation and English Translation"; "Editorial Revisions."

3 SPACE 3: Creation and Publication

General Instructions: Do not confuse "creation" with "publication." Every application for copyright registration must state "the year in which creation of the work was completed." Give the date and nation of first publication only if the work has been published.

Creation: Under the statute, a work is "created" when it is fixed in a copy or phonorecord for the first time. Where a work has been prepared over a period of time, the part of the work existing in fixed form on a particular date constitutes the created work on that date. The date you give here should be the year in which the author completed the particular version for which registration is now being sought, even if other versions exist or if further changes or additions are planned.

Publication: The statute defines "publication" as "the distribution of copies or phonorecords of a work to the public by sale or other transfer of ownership, or by rental, lease, or lending"; a work is also "published" if there has been an "offering to distribute copies or phonorecords to a group of persons for purposes of further distribution, public performance, or public display." Give the full date (month, day, year) when, and the country where, publication first occurred. If first publication took place simultaneously in the United States and other countries, it is sufficient to state "U.S.A."

4 SPACE 4: Claimant(s)

Name(s) and Address(es) of Copyright Claimant(s): Give the name(s) and address(es) of the copyright claimant(s) in this work even if the claimant is the same as the author. Copyright in a work belongs initially to the author of the work (including, in the case of a work made for hire, the employer or other person for whom the work was prepared). The copyright claimant is either the author of the work or a person or organization to whom the copyright initially belonging to the author has been transferred.

Transfer: The statute provides that, if the copyright claimant is not the author, the application for registration must contain "a brief statement of how the claimant obtained ownership of the copyright." If any copyright claimant named in space 4 is not an author named in space 2, give a brief, general statement summarizing the means by which that claimant obtained ownership of the copyright. Examples: "By written contract"; "Transfer of all rights by author"; "Assignment"; "By will." Do not attach transfer documents or other attachments or riders.

5 SPACE 5: Previous Registration

General Instructions: The questions in space 5 are intended to find out whether an earlier registration has been made for this work and, if so, whether there is any basis for a new registration. As a general rule, only one basic copyright registration can be made for the same version of a particular work.

Same Version: If this version is substantially the same as the work covered by a previous registration, a second registration is not generally possible unless: (1) the work has been registered in unpublished form and a second registration is now being sought to cover this first published edition; or (2) someone other than the author is identified as copyright claimant in the earlier registration, and the author is now seeking registration in his or her own name. If either of these two exceptions apply, check the appropriate box and give the

earlier registration number and date. Otherwise, do not submit Form PA; instead, write the Copyright Office for information about supplementary registration or recordation of transfers of copyright ownership.

Changed Version: If the work has been changed, and you are now seeking registration to cover the additions or revisions, check the last box in space 5, give the earlier registration number and date, and complete both parts of space 6 in accordance with the instructions below.

Previous Registration Number and Date: If more than one previous registration has been made for the work, give the number and date of the latest registration.

6 SPACE 6: Derivative Work or Compilation

General Instructions: Complete space 6 if this work is a "changed version," "compilation," or "derivative work," and if it incorporates one or more earlier works that have already been published or registered for copyright, or that have fallen into the public domain. A "compilation" is defined as "a work formed by the collection and assembling of preexisting materials or of data that are selected, coordinated, or arranged in such a way that the resulting work as a whole constitutes an original work of authorship." A "derivative work" is "a work based on one or more preexisting works." Examples of derivative works include musical arrangements, dramatizations, translations, abridgments, condensations, motion picture versions, or "any other form in which a work may be recast, transformed, or adapted." Derivative works also include works "consisting of editorial revisions, annotations, or other modifications" if these changes, as a whole, represent an original work of authorship.

Preexisting Material (space 6a): Complete this space **and** space 6b for derivative works. In this space identify the preexisting work that has been recast, transformed, or adapted. For example, the preexisting material might be: "French version of Hugo's 'Le Roi s'amuse'." Do not complete this space for compilations.

Material Added to This Work (space 6b): Give a brief, general statement of the **additional** new material covered by the copyright claim for which registration is sought. In the case of a derivative work, identify this new material. Examples: "Arrangement for piano and orchestra"; "Dramatization for television"; "New film version"; "Revisions throughout; Act III completely new." If the work is a compilation, give a brief, general statement describing both the material that has been compiled **and** the compilation itself. Example: "Compilation of 19th Century Military Songs."

7,8,9 SPACE 7, 8, 9: Fee, Correspondence, Certification, Return Address

Deposit Account: If you maintain a Deposit Account in the Copyright Office, identify it in space 7. Otherwise leave the space blank and send the fee of $10 with your application and deposit.

Correspondence (space 7): This space should contain the name, address, area code, and telephone number of the person to be consulted if correspondence about this application becomes necessary.

Certification (space 8): The application cannot be accepted unless it bears the date and the **handwritten signature** of the author or other copyright claimant, or of the owner of exclusive right(s), or of the duly authorized agent of the author, claimant, or owner of exclusive right(s).

Address for Return of Certificate (space 9): The address box must be completed legibly since the certificate will be returned in a window envelope.

MORE INFORMATION

How To Register a Recorded Work:
If the musical or dramatic work that you are registering has been recorded (as a tape, disk, or cassette), you may choose either copyright application Form PA or Form SR, Performing Arts or Sound Recordings, depending on the purpose of the registration.

Form PA should be used to register the underlying musical composition or dramatic work. Form SR has been developed specifically to register a "sound recording" as defined by the Copyright Act—a work resulting from the "fixation of a series of sounds," separate and distinct from the underlying musical or dramatic work. Form SR should be used when the copyright claim is limited to the sound recording itself. (In one instance, Form SR may also be used to file for a copyright registration for both kinds of works—see (4) below.) Therefore:

(1) File Form PA if you are seeking to register the musical or dramatic work, not the "sound recording," even though what you deposit for copyright purposes may be in the form of a phonorecord.

(2) File Form PA if you are seeking to register the audio portion of an audiovisual work, such as a motion picture soundtrack; these are considered integral parts of the audiovisual work.

(3) File Form SR if you are seeking to register the "sound recording" itself, that is, the work that results from the fixation of a series of musical, spoken, or other sounds, but not the underlying musical or dramatic work.

(4) File Form SR if you are the copyright claimant for both the underlying musical or dramatic work and the sound recording, *and* you prefer to register both on the same form.

(5) File both forms PA and SR if the copyright claimant for the underlying work and sound recording differ, or you prefer to have separate registration for them.

"Copies" and "Phonorecords":
To register for copyright, you are required to deposit "copies" or "phonorecords." These are defined as follows:

Musical compositions may be embodied (fixed) in "copies," objects from which a work can be read or visually perceived, directly or with the aid of a machine or device, such as manuscripts, books, sheet music, film, and videotape. They may also be fixed in "phonorecords," objects embodying fixations of sounds, such as tapes and phonograph disks, commonly known as phonograph records. For example, a song (the work to be registered) can be reproduced in sheet music ("copies") or phonograph records ("phonorecords"), or both.

FORM VA
UNITED STATES COPYRIGHT OFFICE

REGISTRATION NUMBER

VA VAU

EFFECTIVE DATE OF REGISTRATION

Month Day Year

DO NOT WRITE ABOVE THIS LINE. IF YOU NEED MORE SPACE, USE A SEPARATE CONTINUATION SHEET.

1

TITLE OF THIS WORK ▼

NATURE OF THIS WORK ▼ See instructions

PREVIOUS OR ALTERNATIVE TITLES ▼

PUBLICATION AS A CONTRIBUTION If this work was published as a contribution to a periodical, serial, or collection, give information about the collective work in which the contribution appeared. **Title of Collective Work ▼**

If published in a periodical or serial give: **Volume ▼** **Number ▼** **Issue Date ▼** **On Pages ▼**

2

a

NAME OF AUTHOR ▼

DATES OF BIRTH AND DEATH
Year Born ▼ Year Died ▼

Was this contribution to the work a "work made for hire"?
☐ Yes
☐ No

AUTHOR'S NATIQNALITY OR DOMICILE
Name of Country
OR { Citizen of ▶
Domiciled in ▶

WAS THIS AUTHOR'S CONTRIBUTION TO THE WORK
Anonymous? ☐ Yes ☐ No
Pseudonymous? ☐ Yes ☐ No

If the answer to either of these questions is "Yes," see detailed instructions.

NATURE OF AUTHORSHIP Briefly describe nature of the material created by this author in which copyright is claimed. ▼

NOTE

Under the law, the "author" of a "work made for hire" is generally the employer, not the employee (see instructions). For any part of this work that was "made for hire" check "Yes" in the space provided, give the employer (or other person for whom the work was prepared) as "Author" of that part, and leave the space for dates of birth and death blank.

b

NAME OF AUTHOR ▼

DATES OF BIRTH AND DEATH
Year Born ▼ Year Died ▼

Was this contribution to the work a "work made for hire"?
☐ Yes
☐ No

AUTHOR'S NATIONALITY OR DOMICILE
Name of country
OR { Citizen of ▶
Domiciled in ▶

WAS THIS AUTHOR'S CONTRIBUTION TO THE WORK
Anonymous? ☐ Yes ☐ No
Pseudonymous? ☐ Yes ☐ No

If the answer to either of these questions is "Yes," see detailed instructions.

NATURE OF AUTHORSHIP Briefly describe nature of the material created by this author in which copyright is claimed. ▼

c

NAME OF AUTHOR ▼

DATES OF BIRTH AND DEATH
Year Born ▼ Year Died ▼

Was this contribution to the work a "work made for hire"?
☐ Yes
☐ No

AUTHOR'S NATIONALITY OR DOMICILE
Name of Country
OR { Citizen of ▶
Domiciled in ▶

WAS THIS AUTHOR'S CONTRIBUTION TO THE WORK
Anonymous? ☐ Yes ☐ No
Pseudonymous? ☐ Yes ☐ No

If the answer to either of these questions is "Yes," see detailed instructions.

NATURE OF AUTHORSHIP Briefly describe nature of the material created by this author in which copyright is claimed. ▼

3

YEAR IN WHICH CREATION OF THIS WORK WAS COMPLETED This information must be given in all cases.
◄ Year

DATE AND NATION OF FIRST PUBLICATION OF THIS PARTICULAR WORK
Complete this information ONLY if this work has been published.
Month ▶ Day ▶ Year ▶ ◄ Nation

4

COPYRIGHT CLAIMANT(S) Name and address must be given even if the claimant is the same as the author given in space 2.▼

See instructions before completing this space.

TRANSFER If the claimant(s) named here in space 4 are different from the author(s) named in space 2, give a brief statement of how the claimant(s) obtained ownership of the copyright.▼

DO NOT WRITE HERE
OFFICE USE ONLY

APPLICATION RECEIVED

ONE DEPOSIT RECEIVED

TWO DEPOSITS RECEIVED

REMITTANCE NUMBER AND DATE

MORE ON BACK ▶
• Complete all applicable spaces (numbers 5-9) on the reverse side of this page.
• See detailed instructions.
• Sign the form at line 8.

DO NOT WRITE HERE

Page 1 of _____ pages

DO NOT WRITE ABOVE THIS LINE. IF YOU NEED MORE SPACE, USE A SEPARATE CONTINUATION SHEET.

PREVIOUS REGISTRATION Has registration for this work, or for an earlier version of this work, already been made in the Copyright Office?
☐ Yes ☐ No If your answer is "Yes," why is another registration being sought? (Check appropriate box) ▼

☐ This is the first published edition of a work previously registered in unpublished form.

☐ This is the first application submitted by this author as copyright claimant.

☐ This is a changed version of the work, as shown by space 6 on this application.

If your answer is "Yes," give: **Previous Registration Number** ▼ **Year of Registration** ▼

5

DERIVATIVE WORK OR COMPILATION Complete both space 6a & 6b for a derivative work; complete only 6b for a compilation.
a. **Preexisting Material** Identify any preexisting work or works that this work is based on or incorporates. ▼

b. **Material Added to This Work** Give a brief, general statement of the material that has been added to this work and in which copyright is claimed. ▼

6

See instructions before completing this space.

DEPOSIT ACCOUNT If the registration fee is to be charged to a Deposit Account established in the Copyright Office, give name and number of Account.
Name ▼ **Account Number** ▼

7

CORRESPONDENCE Give name and address to which correspondence about this application should be sent. Name/Address/Apt/City/State/Zip ▼

Area Code & Telephone Number ▶

Be sure to give your daytime phone ◀ number.

CERTIFICATION* I, the undersigned, hereby certify that I am the
Check only one ▼
☐ author
☐ other copyright claimant
☐ owner of exclusive right(s)
☐ authorized agent of_____
　　　　Name of author or other copyright claimant, or owner of exclusive right(s) ▲

8

of the work identified in this application and that the statements made
by me in this application are correct to the best of my knowledge.

Typed or printed name and date ▼ If this is a published work, this date must be the same as or later than the date of publication given in space 3.

_____ date ▶ _____

👉 Handwritten signature (X) ▼

MAIL CERTIFI-CATE TO

Certificate will be mailed in window envelope

Name ▼

Number/Street/Apartment Number ▼

City/State/ZIP ▼

Have you:
● Completed all necessary spaces?
● Signed your application in space 8?
● Enclosed check or money order for $10 payable to *Register of Copyrights*?
● Enclosed your deposit material with the application and fee?

MAIL TO: Register of Copyrights, Library of Congress, Washington, D.C. 20559.

9

Filling Out Application Form VA

Detach and read these instructions before completing this form. Make sure all applicable spaces have been filled in before you return this form.

BASIC INFORMATION

When to Use This Form: Use Form VA for copyright registration of published or unpublished works of the visual arts. This category consists of "pictorial, graphic, or sculptural works," including two-dimensional and three-dimensional works of fine, graphic, and applied art, photographs, prints and art reproductions, maps, globes, charts, technical drawings, diagrams, and models.

What Does Copyright Protect? Copyright in a work of the visual arts protects those pictorial, graphic, or sculptural elements that, either alone or in combination, represent an "original work of authorship." The statute declares: "In no case does copyright protection for an original work of authorship extend to any idea, procedure, process, system, method of operation, concept, principle, or discovery, regardless of the form in which it is described, explained, illustrated, or embodied in such work."

Works of Artistic Craftsmanship and Designs: "Works of artistic craftsmanship" are registrable on Form VA, but the statute makes clear that protection extends to "their form" and not to "their mechanical or utilitarian aspects." The "design of a useful article" is considered copyrightable "only if, and only to the extent that, such design incorporates pictorial, graphic, or sculptural features that can be identified separately from, and are capable of existing independently of, the utilitarian aspects of the article."

Labels and Advertisements: Works prepared for use in connection with the sale or advertisement of goods and services are registrable if they contain "original work of authorship." Use Form VA if the copyrightable material in the work you are registering is mainly pictorial or graphic; use Form TX if it consists mainly of text. **NOTE:** Words and short phrases such as names, titles, and slogans cannot be protected by copyright, and the same is true of standard symbols, emblems, and other commonly used graphic designs that are in the public domain. When used commercially, material of that sort can sometimes be protected under state laws of unfair competition or under the Federal trademark laws. For information about trademark registration, write to the Commissioner of Patents and Trademarks, Washington, D.C. 20231.

Deposit to Accompany Application: An application for copyright registration must be accompanied by a deposit consisting of copies representing the entire work for which registration is to be made.

Unpublished Work: Deposit one complete copy.

Published Work: Deposit two complete copies of the best edition.

Work First Published Outside the United States: Deposit one complete copy of the first foreign edition.

Contribution to a Collective Work: Deposit one complete copy of the best edition of the collective work.

The Copyright Notice: For published works, the law provides that a copyright notice in a specified form "shall be placed on all publicly distributed copies from which the work can be visually perceived." Use of the copyright notice is the responsibility of the copyright owner and does not require advance permission from the Copyright Office. The required form of the notice for copies generally consists of three elements: (1) the symbol "©", or the word "Copyright," or the abbreviation "Copr."; (2) the year of first publication; and (3) the name of the owner of copyright. For example: "© 1981 Constance Porter." The notice is to be affixed to the copies "in such manner and location as to give reasonable notice of the claim of copyright."

For further information about copyright registration, notice, or special questions relating to copyright problems, write:

Information and Publications Section, LM-455
Copyright Office, Library of Congress, Washington, D.C. 20559

LINE-BY-LINE INSTRUCTIONS

1 SPACE 1: Title

Title of This Work: Every work submitted for copyright registration must be given a title to identify that particular work. If the copies of the work bear a title (or an identifying phrase that could serve as a title), transcribe that wording *completely* and *exactly* on the application. Indexing of the registration and future identification of the work will depend on the information you give here.

Previous or Alternative Titles: Complete this space if there are any additional titles for the work under which someone searching for the registration might be likely to look, or under which a document pertaining to the work might be recorded.

Publication as a Contribution: If the work being registered is a contribution to a periodical, serial, or collection, give the title of the contribution in the "Title of This Work" space. Then, in the line headed "Publication as a Contribution," give information about the collective work in which the contribution appeared.

Nature of This Work: Briefly describe the general nature or character of the pictorial, graphic, or sculptural work being registered for copyright. Examples: "Oil Painting"; "Charcoal Drawing"; "Etching"; "Sculpture"; "Map"; "Photograph"; "Scale Model"; "Lithographic Print"; "Jewelry Design"; "Fabric Design."

2 SPACE 2: Author(s)

General Instructions: After reading these instructions, decide who are the "authors" of this work for copyright purposes. Then, unless the work is a "collective work," give the requested information about every "author" who contributed any appreciable amount of copyrightable matter to this version of the work. If you need further space, request additional Continuation Sheets. In the case of a collective work, such as a catalog of paintings or collection of cartoons by various authors, give information about the author of the collective work as a whole.

Name of Author: The fullest form of the author's name should be given. Unless the work was "made for hire," the individual who actually created the work is its "author." In the case of a work made for hire, the statute provides that "the employer or other person for whom the work was prepared is considered the author."

What is a "Work Made for Hire"? A "work made for hire" is defined as: (1) "a work prepared by an employee within the scope of his or her employment"; or (2) "a work specially ordered or commissioned for use as a contribution to a collective work, as a part of a motion picture or other audiovisual work, as a translation, as a supplementary work, as a compilation, as an instructional text, as a test, as answer material for a test, or as an atlas, if the parties expressly agree in a written instrument signed by them that the work shall be considered a work made for hire." If you have checked "Yes" to indicate that the work was "made for hire," you must give the full legal name of the employer (or other person for whom the work was prepared). You may also include the name of the employee along with the name of the employer (for example: "Elster Publishing Co., employer for hire of John Ferguson").

"Anonymous" or "Pseudonymous" Work: An author's contribution to a work is "anonymous" if that author is not identified on the copies or phonorecords of the work. An author's contribution to a work is "pseudonymous" if that author is identified on the copies or phonorecords under a fictitious name. If the work is "anonymous" you may: (1) leave the line blank; or (2) state "anonymous" on the line; or (3) reveal the author's identity. If the work is "pseudonymous" you may: (1) leave the line blank; or (2) give the pseudonym and identify it as such (for example: "Huntley Haverstock, pseudonym"); or (3) reveal the author's name, making clear which is the real name and which is the pseudonym (for example: "Henry Leek, whose pseudonym is Priam Farrel"). However, the citizenship or domicile of the author **must** be given in all cases.

Dates of Birth and Death: If the author is dead, the statute requires that the year of death be included in the application unless the work is anonymous or pseudonymous. The author's birth date is optional, but is useful as a form of identification. Leave this space blank if the author's contribution was a "work made for hire."

Author's Nationality or Domicile: Give the country of which the author is a citizen, or the country in which the author is domiciled. Nationality or domicile **must** be given in all cases.

Nature of Authorship: Give a brief general statement of the nature of this particular author's contribution to the work. Examples: "Painting"; "Photograph"; "Silk Screen Reproduction"; "Co-author of Cartographic Material"; "Technical Drawing"; "Text and Artwork."

3 SPACE 3: Creation and Publication

General Instructions: Do not confuse "creation" with "publication." Every application for copyright registration must state "the year in which creation of the work was completed." Give the date and nation of first publication only if the work has been published.

Creation: Under the statute, a work is "created" when it is fixed in a copy or phonorecord for the first time. Where a work has been prepared over a period of time, the part of the work existing in fixed form on a particular date constitutes the created work on that date. The date you give here should be the year in which the author completed the particular version for which registration is now being sought, even if other versions exist or if further changes or additions are planned.

Publication: The statute defines "publication" as "the distribution of copies or phonorecords of a work to the public by sale or other transfer of ownership, or by rental, lease, or lending"; a work is also "published" if there has been an "offering to distribute copies or phonorecords to a group of persons for purposes of further distribution, public performance, or public display." Give the full date (month, day, year) when, and the country where, publication first occurred. If first publication took place simultaneously in the United States and other countries, it is sufficient to state "U.S.A."

4 SPACE 4: Claimant(s)

Name(s) and Address(es) of Copyright Claimant(s): Give the name(s) and address(es) of the copyright claimant(s) in this work even if the claimant is the same as the author. Copyright in a work belongs initially to the author of the work (including, in the case of a work made for hire, the employer or other person for whom the work was prepared). The copyright claimant is either the author of the work or a person or organization to whom the copyright initially belonging to the author has been transferred.

Transfer: The statute provides that, if the copyright claimant is not the author, the application for registration must contain "a brief statement of how the claimant obtained ownership of the copyright." If any copyright claimant named in space 4 is not an author named in space 2, give a brief, general statement summarizing the means by which that claimant obtained ownership of the copyright. Examples: "By written contract"; "Transfer of all rights by author"; "Assignment"; "By will." Do not attach transfer documents or other attachments or riders.

5 SPACE 5: Previous Registration

General Instructions: The questions in space 5 are intended to find out whether an earlier registration has been made for this work and, if so, whether there is any basis for a new registration. As a rule, only one basic copyright registration can be made for the same version of a particular work.

Same Version: If this version is substantially the same as the work covered by a previous registration, a second registration is not generally possible unless: (1) the work has been registered in unpublished form and a second registration is now being sought to cover this first published edition; or (2) someone other than the author is identified as copyright claimant in the earlier registration, and the author is now seeking registration in his or her own name. If either of these two exceptions apply, check the appropriate box and give the earlier registration number and date. Otherwise, do not submit Form VA; instead, write the Copyright Office for information about supplementary registration or recordation of transfers of copyright ownership.

Changed Version: If the work has been changed, and you are now seeking registration to cover the additions or revisions, check the last box in space 5, give the earlier registration number and date, and complete both parts of space 6 in accordance with the instructions below.

Previous Registration Number and Date: If more than one previous registration has been made for the work, give the number and date of the latest registration.

6 SPACE 6: Derivative Work or Compilation

General Instructions: Complete space 6 if this work is a "changed version," "compilation," or "derivative work," and if it incorporates one or more earlier works that have already been published or registered for copyright, or that have fallen into the public domain. A "compilation" is defined as "a work formed by the collection and assembling of preexisting materials or of data that are selected, coordinated, or arranged in such a way that the resulting work as a whole constitutes an original work of authorship." A "derivative work" is "a work based on one or more preexisting works." Examples of derivative works include reproductions of works of art, sculptures based on drawings, lithographs based on paintings, maps based on previously published sources, or "any other form in which a work may be recast, transformed, or adapted." Derivative works also include works "consisting of editorial revisions, annotations, or other modifications" if these changes, as a whole, represent an original work of authorship.

Preexisting Material (space 6a): Complete this space **and** space 6b for derivative works. In this space identify the preexisting work that has been recast, transformed, or adapted. Examples of preexisting material might be "Grunewald Altarpiece"; or "19th century quilt design." Do not complete this space for compilations.

Material Added to This Work (space 6b): Give a brief, general statement of the **additional** new material covered by the copyright claim for which registration is sought. In the case of a derivative work, identify this new material. Examples: "Adaptation of design and additional artistic work"; "Reproduction of painting by photolithography"; "Additional cartographic material"; "Compilation of photographs." If the work is a compilation, give a brief, general statement describing both the material that has been compiled **and** the compilation itself. Example: "Compilation of 19th Century Political Cartoons."

7,8,9 SPACE 7, 8, 9: Fee, Correspondence, Certification, Return Address

Deposit Account: If you maintain a Deposit Account in the Copyright Office, identify it in space 7. Otherwise leave the space blank and send the fee of $10 with your application and deposit.

Correspondence (space 7): This space should contain the name, address, area code, and telephone number of the person to be consulted if correspondence about this application becomes necessary.

Certification (space 8): The application cannot be accepted unless it bears the date and the **handwritten signature** of the author or other copyright claimant, or of the owner of exclusive right(s), or of the duly authorized agent of the author, claimant, or owner of exclusive right(s).

Address for Return of Certificate (space 9): The address box must be completed legibly since the certificate will be returned in a window envelope.

MORE INFORMATION

Form of Deposit for Works of the Visual Arts

Exceptions to General Deposit Requirements: As explained on the reverse side of this page, the statutory deposit requirements (generally one copy for unpublished works and two copies for published works) will vary for particular kinds of works of the visual arts. The copyright law authorizes the Register of Copyrights to issue regulations specifying "the administrative classes into which works are to be placed for purposes of deposit and registration, and the nature of the copies or phonorecords to be deposited in the various classes specified." For particular classes, the regulations may require or permit "the deposit of identifying material instead of copies or phonorecords," or "the deposit of only one copy or phonorecord where two would normally be required."

What Should You Deposit? The detailed requirements with respect to the kind of deposit to accompany an application on Form VA are contained in the Copyright Office Regulations. The following does not cover all of the deposit requirements, but is intended to give you some general guidance.

For an Unpublished Work, the material deposited should represent the entire copyrightable content of the work for which registration is being sought.

For a Published Work, the material deposited should generally consist of two complete copies of the best edition. Exceptions: (1) For certain types of works, one complete copy may be deposited instead of two. These include greeting cards, postcards, stationery, labels, advertisements, scientific drawings, and globes; (2) For most three-dimensional sculptural works, and for certain two-dimensional works, the Copyright Office Regulations require deposit of identifying material (photographs or drawings in a specified form) rather than copies; and (3) Under certain circumstances, for works published in five copies or less or in limited, numbered editions, the deposit may consist of one copy or of identifying reproductions.

FORM SR
UNITED STATES COPYRIGHT OFFICE

REGISTRATION NUMBER

SR SRU

EFFECTIVE DATE OF REGISTRATION

Month Day Year

DO NOT WRITE ABOVE THIS LINE. IF YOU NEED MORE SPACE, USE A SEPARATE CONTINUATION SHEET.

1

TITLE OF THIS WORK ▼

PREVIOUS OR ALTERNATIVE TITLES ▼

NATURE OF MATERIAL RECORDED ▼ See instructions
- ☐ Musical ☐ Musical-Dramatic
- ☐ Dramatic ☐ Literary
- ☐ Other _____

2

a

NAME OF AUTHOR ▼

DATES OF BIRTH AND DEATH
Year Born ▼ Year Died ▼

Was this contribution to the work a "work made for hire"?
- ☐ Yes
- ☐ No

AUTHOR'S NATIONALITY OR DOMICILE
Name of Country
OR { Citizen of ▶ _____
{ Domiciled in ▶ _____

WAS THIS AUTHOR'S CONTRIBUTION TO THE WORK
Anonymous? ☐ Yes ☐ No
Pseudonymous? ☐ Yes ☐ No
If the answer to either of these questions is "Yes," see detailed instructions.

NATURE OF AUTHORSHIP Briefly describe nature of the material created by this author in which copyright is claimed. ▼

b

NAME OF AUTHOR ▼

DATES OF BIRTH AND DEATH
Year Born ▼ Year Died ▼

Was this contribution to the work a "work made for hire"?
- ☐ Yes
- ☐ No

AUTHOR'S NATIONALITY OR DOMICILE
Name of country
OR { Citizen of ▶ _____
{ Domiciled in ▶ _____

WAS THIS AUTHOR'S CONTRIBUTION TO THE WORK
Anonymous? ☐ Yes ☐ No
Pseudonymous? ☐ Yes ☐ No
If the answer to either of these questions is "Yes," see detailed instructions.

NATURE OF AUTHORSHIP Briefly describe nature of the material created by this author in which copyright is claimed. ▼

c

NAME OF AUTHOR ▼

DATES OF BIRTH AND DEATH
Year Born ▼ Year Died ▼

Was this contribution to the work a "work made for hire"?
- ☐ Yes
- ☐ No

AUTHOR'S NATIONALITY OR DOMICILE
Name of Country
OR { Citizen of ▶ _____
{ Domiciled in ▶ _____

WAS THIS AUTHOR'S CONTRIBUTION TO THE WORK
Anonymous? ☐ Yes ☐ No
Pseudonymous? ☐ Yes ☐ No
If the answer to either of these questions is "Yes," see detailed instructions.

NATURE OF AUTHORSHIP Briefly describe nature of the material created by this author in which copyright is claimed. ▼

NOTE
Under the law, the "author" of a "work made for hire" is generally the employer, not the employee (see instructions). For any part of this work that was "made for hire" check "Yes" in the space provided, give the employer (or other person for whom the work was prepared) as "Author" of that part, and leave the space for dates of birth and death blank.

3

YEAR IN WHICH CREATION OF THIS WORK WAS COMPLETED This information must be given in all cases.
_____ ◀ Year

DATE AND NATION OF FIRST PUBLICATION OF THIS PARTICULAR WORK
Complete this information ONLY if this work has been published.
Month ▶ _____ Day ▶ _____ Year ▶ _____
_____ ◀ Nation

4

COPYRIGHT CLAIMANT(S) Name and address must be given even if the claimant is the same as the author given in space 2.▼

TRANSFER If the claimant(s) named here in space 4 are different from the author(s) named in space 2, give a brief statement of how the claimant(s) obtained ownership of the copyright.▼

See instructions before completing this space.

DO NOT WRITE HERE / OFFICE USE ONLY

APPLICATION RECEIVED

ONE DEPOSIT RECEIVED

TWO DEPOSITS RECEIVED

REMITTANCE NUMBER AND DATE

MORE ON BACK ▶
- Complete all applicable spaces (numbers 5-9) on the reverse side of this page
- See detailed instructions.
- Sign the form at line 8.

DO NOT WRITE HERE

Page 1 of _____ pages

FORM SR

DO NOT WRITE ABOVE THIS LINE. IF YOU NEED MORE SPACE, USE A SEPARATE CONTINUATION SHEET.

PREVIOUS REGISTRATION Has registration for this work, or for an earlier version of this work, already been made in the Copyright Office?

☐ Yes ☐ No If your answer is "Yes," why is another registration being sought? (Check appropriate box) ▼

☐ This is the first published edition of a work previously registered in unpublished form.

☐ This is the first application submitted by this author as copyright claimant.

☐ This is a changed version of the work, as shown by space 6 on this application.

If your answer is "Yes," give: **Previous Registration Number** ▼ **Year of Registration** ▼

5

DERIVATIVE WORK OR COMPILATION Complete both space 6a & 6b for a derivative work; complete only 6b for a compilation.

a. Preexisting Material Identify any preexisting work or works that this work is based on or incorporates. ▼

b. Material Added to This Work Give a brief, general statement of the material that has been added to this work and in which copyright is claimed. ▼

6

See instructions before completing this space.

DEPOSIT ACCOUNT If the registration fee is to be charged to a Deposit Account established in the Copyright Office, give name and number of Account.

Name ▼ **Account Number** ▼

7

CORRESPONDENCE Give name and address to which correspondence about this application should be sent. Name/Address/Apt/City/State/Zip ▼

Area Code & Telephone Number ▶

Be sure to give your daytime phone ◀ number.

CERTIFICATION* I, the undersigned, hereby certify that I am the

Check one ▼

☐ author

☐ other copyright claimant

☐ owner of exclusive right(s)

☐ authorized agent of _____
 Name of author or other copyright claimant, or owner of exclusive right(s) ▲

of the work identified in this application and that the statements made by me in this application are correct to the best of my knowledge.

8

Typed or printed name and date ▼ If this is a published work, this date must be the same as or later than the date of publication given in space 3.

_____ date ▶ _____

☞ **Handwritten signature (X)** ▼

MAIL CERTIFI-CATE TO

Certificate will be mailed in window envelope

Name ▼

Number/Street/Apartment Number ▼

City/State/ZIP ▼

Have you:
- Completed all necessary spaces?
- Signed your application in space 8?
- Enclosed check or money order for $10 payable to *Register of Copyrights?*
- Enclosed your deposit material with the application and fee?

MAIL TO: Register of Copyrights, Library of Congress, Washington, D.C. 20559.

9

Filling Out Application Form SR

Detach and read these instructions before completing this form. Make sure all applicable spaces have been filled in before you return this form.

BASIC INFORMATION

When to Use This Form: Use Form SR for copyright registration of published or unpublished sound recordings. It should be used where the copyright claim is limited to the sound recording itself, and it may also be used where the same copyright claimant is seeking simultaneous registration of the underlying musical, dramatic, or literary work embodied in the phonorecord.

With one exception, "sound recordings" are works that result from the fixation of a series of musical, spoken, or other sounds. The exception is for the audio portions of audiovisual works, such as a motion picture soundtrack or an audio cassette accompanying a filmstrip; these are considered a part of the audiovisual work as a whole.

Deposit to Accompany Application: An application for copyright registration of a sound recording must be accompanied by a deposit consisting of phonorecords representing the entire work for which registration is to be made.

Unpublished Work: Deposit one complete phonorecord.

Published Work: Deposit two complete phonorecords of the best edition, together with "any printed or other visually perceptible material" published with the phonorecords.

Work First Published Outside the United States: Deposit one complete phonorecord of the first foreign edition.

Contribution to a Collective Work: Deposit one complete phonorecord of the best edition of the collective work.

The Copyright Notice: For published sound recordings, the law provides that a copyright notice in a specified form "shall be placed on all publicly distributed phonorecords of the sound recording." Use of the copyright notice is the responsibility of the copyright owner and does not require advance permission from the Copyright Office. The required form of the notice for phonorecords of sound recordings consists of three elements: (1) the symbol "℗" (the letter "P" in a circle); (2) the year of first publication of the sound recording; and (3) the name of the owner of copyright. For example: "℗ 1981 Rittenhouse Record Co." The notice is to be "placed on the surface of the phonorecord, or on the label or container, in such manner and location as to give reasonable notice of the claim of copyright." For further information about copyright, write: Information and Publications Section, LM-455
Copyright Office, Library of Congress, Washington, D.C. 20559

LINE-BY-LINE INSTRUCTIONS

1 SPACE 1: Title

Title of This Work: Every work submitted for copyright registration must be given a title to identify that particular work. If the phonorecords or any accompanying printed material bear a title (or an identifying phrase that could serve as a title), transcribe that wording completely and exactly on the application. Indexing of the registration and future identification of the work may depend on the information you give here.

Nature of Material Recorded: Indicate the general type or character of the works or other material embodied in the recording. The box marked "Literary" should be checked for nondramatic spoken material of all sorts, including narration, interviews, panel discussions, and training material. If the material recorded is not musical, dramatic, or literary in nature, check "Other" and briefly describe the type of sounds fixed in the recording. For example: "Sound Effects"; "Bird Calls"; "Crowd Noises."

Previous or Alternative Titles: Complete this space if there are any additional titles for the work under which someone searching for the registration might be likely to look, or under which a document pertaining to the work might be recorded.

2 SPACE 2: Author(s)

General Instructions: After reading these instructions, decide who are the "authors" of this work for copyright purposes. Then, unless the work is a "collective work," give the requested information about every "author" who contributed any appreciable amount of copyrightable matter to this version of the work. If you need further space, request additional Continuation Sheets. In the case of a collective work, such as a collection of previously published or registered sound recordings, give information about the author of the collective work as a whole. If you are submitting this Form SR to cover the recorded musical, dramatic, or literary work as well as the sound recording itself, it is important for space 2 to include full information about the various authors of all of the material covered by the copyright claim, making clear the nature of each author's contribution.

Name of Author: The fullest form of the author's name should be given. Unless the work was "made for hire," the individual who actually created the work is its "author." In the case of a work made for hire, the statute provides that "the employer or other person for whom the work was prepared is considered the author."

What is a "Work Made for Hire"? A "work made for hire" is defined as: (1) "a work prepared by an employee within the scope of his or her employment"; or (2) "a work specially ordered or commissioned for use as a contribution to a collective work, as a part of a motion picture or other audiovisual work, as a translation, as a supplementary work, as a compilation, as an instructional text, as a test, as answer material for a test, or as an atlas, if the parties expressly agree in a written instrument signed by them that the work shall be considered a work made for hire." If you have checked "Yes" to indicate that the work was "made for hire," you must give the full legal name of the employer (or other person for whom the work was prepared). You may also include the name of the employee along with the name of the employer (for example: "Elster Record Co., employer for hire of John Ferguson").

"Anonymous" or "Pseudonymous" Work: An author's contribution to a work is "anonymous" if that author is not identified on the copies or phonorecords of the work. An author's contribution to a work is "pseudonymous" if that author is identified on the copies or phonorecords under a fictitious name. If the work is "anonymous" you may: (1) leave the line blank; or (2) state "anonymous" on the line; or (3) reveal the author's identity. If the work is "pseudonymous" you may: (1) leave the line blank; or (2) give the pseudonym and identify it as such (for example: "Huntley Haverstock, pseudonym"); or (3) reveal the author's name, making clear which is the real name and which is the pseudonym (for example: "Judith Barton, whose pseudonym is Madeline Elster"). However, the citizenship or domicile of the author must be given in all cases.

Dates of Birth and Death: If the author is dead, the statute requires that the year of death be included in the application unless the work is anonymous or pseudonymous. The author's birth date is optional, but is useful as a form of identification. Leave this space blank if the author's contribution was a "work made for hire."

Author's Nationality or Domicile: Give the country of which the author is a citizen, or the country in which the author is domiciled. Nationality or domicile must be given in all cases.

Nature of Authorship: Give a brief general statement of the nature of this particular author's contribution to the work. If you are submitting this Form SR to cover both the sound recording and the underlying musical, dramatic, or literary work, make sure that the precise nature of each author's contribution is reflected here. Examples where the authorship pertains to the recording: "Sound Recording"; "Performance and Recording"; "Compilation and Remixing of Sounds." Examples where the authorship pertains to both the recording and the underlying work: "Words, Music, Performance, Recording"; "Arrangement of Music and Recording"; "Compilation of Poems and Reading."

3 SPACE 3: Creation and Publication

General Instructions: Do not confuse "creation" with "publication." Every application for copyright registration must state "the year in which creation of the work was completed." Give the date and nation of first publication only if the work has been published.

Creation: Under the statute, a work is "created" when it is fixed in a copy or phonorecord for the first time. Where a work has been prepared over a period of time, the part of the work existing in fixed form on a particular date constitutes the created work on that date. The date you give here should be the year in which the author completed the particular version for which registration is now being sought, even if other versions exist or if further changes or additions are planned.

Publication: The statute defines "publication" as "the distribution of copies or phonorecords of a work to the public by sale or other transfer of ownership, or by rental, lease, or lending"; a work is also "published" if there has been an "offering to distribute copies or phonorecords to a group of persons for purposes of further distribution, public performance, or public display." Give the full date (month, day, year) when, and the country where, publication first occurred. If first publication took place simultaneously in the United States and other countries, it is sufficient to state "U.S.A."

4 SPACE 4: Claimant(s)

Name(s) and Address(es) of Copyright Claimant(s): Give the name(s) and address(es) of the copyright claimant(s) in this work even if the claimant is the same as the author. Copyright in a work belongs initially to the author of the work (including, in the case of a work made for hire, the employer or other person for whom the work was prepared). The copyright claimant is either the author of the work or a person or organization to whom the copyright initially belonging to the author has been transferred.

Transfer: The statute provides that, if the copyright claimant is not the author, the application for registration must contain "a brief statement of how the claimant obtained ownership of the copyright." If any copyright claimant named in space 4 is not an author named in space 2, give a brief, general statement summarizing the means by which that claimant obtained ownership of the copyright. Examples: "By written contract"; "Transfer of all rights by author"; "Assignment"; "By will." Do not attach transfer documents or other attachments or riders.

5 SPACE 5: Previous Registration

General Instructions: The questions in space 5 are intended to find out whether an earlier registration has been made for this work and, if so, whether there is any basis for a new registration. As a rule, only one basic copyright registration can be made for the same version of a particular work.

Same Version: If this version is substantially the same as the work covered by a previous registration, a second registration is not generally possible unless: (1) the work has been registered in unpublished form and a second registration is now being sought to cover this first published edition; or (2) someone other than the author is identified as copyright claimant in the earlier registration, and the author is now seeking registration in his or her own name. If either of these two exceptions apply, check the appropriate box and give the earlier registration number and date. Otherwise, do not submit Form SR; instead, write the Copyright Office for information about supplementary registration or recordation of transfers of copyright ownership.

Changed Version: If the work has been changed, and you are now seeking registration to cover the additions or revisions, check the last box in space 5, give the earlier registration number and date, and complete both parts of space 6 in accordance with the instructions below.

Previous Registration Number and Date: If more than one previous registration has been made for the work, give the number and date of the latest registration.

6 SPACE 6: Derivative Work or Compilation

General Instructions: Complete space 6 if this work is a "changed version," "compilation," or "derivative work," and if it incorporates one or more earlier works that have already been published or registered for copyright, or that have fallen into the public domain, or sound recordings that were fixed before February 15, 1972. A "compilation" is defined as "a work formed by the collection and assembling of preexisting materials or of data that are selected, coordinated, or arranged in such a way that the resulting work as a whole constitutes an original work of authorship." A "derivative work" is "a work based on one or more preexisting works." Examples of derivative works include recordings reissued with substantial editorial revisions or abridgments of the recorded sounds, and recordings republished with new recorded material, or "any other form in which a work may be recast, transformed, or adapted." Derivative works also include works "consisting of editorial revisions, annotations, or other modifications" if these changes, as a whole, represent an original work of authorship.

Preexisting Material (space 6a): Complete this space **and** space 6b for derivative works. In this space identify the preexisting work that has been recast, transformed, or adapted. For example, the preexisting material might be: "1970 recording by Sperryville Symphony of Bach Double Concerto." Do not complete this space for compilations.

Material Added to This Work (space 6b): Give a brief, general statement of the **additional** new material covered by the copyright claim for which registration is sought. In the case of a derivative work, identify this new material. Examples: "Recorded performances on bands 1 and 3"; "Remixed sounds from original multitrack sound sources"; "New words, arrangement, and additional sounds." If the work is a compilation, give a brief, general statement describing both the material that has been compiled **and** the compilation itself. Example: "Compilation of 1938 Recordings by various swing bands."

7,8,9 SPACE 7, 8, 9: Fee, Correspondence, Certification, Return Address

Deposit Account: If you maintain a Deposit Account in the Copyright Office, identify it in space 7. Otherwise leave the space blank and send the fee of $10 with your application and deposit.

Correspondence (space 7): This space should contain the name, address, area code, and telephone number of the person to be consulted if correspondence about this application becomes necessary.

Certification (space 8): The application cannot be accepted unless it bears the date and the **handwritten signature** of the author or other copyright claimant, or of the owner of exclusive right(s), or of the duly authorized agent of the author, claimant, or owner of exclusive right(s).

Address for Return of Certificate (space 9): The address box must be completed legibly since the certificate will be returned in a window envelope.

MORE INFORMATION

"Works": "Works" are the basic subject matter of copyright; they are what authors create and copyright protects. The statute draws a sharp distinction between the "work" and "any material object in which the work is embodied."

"Copies" and "Phonorecords": These are the two types of material objects in which "works" are embodied. In general, **copies** are objects from which a work can be read or visually perceived, directly or with the aid of a machine or device, such as manuscripts, books, sheet music, film, and videotape. **Phonorecords** are objects embodying fixations of sounds, such as audio tapes and phonograph disks. For example, a song (the "work") can be reproduced in sheet music ("copies") or phonograph disks ("phonorecords"), or both.

"Sound Recordings": These are "works," not "copies" or "phonorecords." "Sound recordings" are "works that result from the fixation of a series of musical, spoken, or other sounds, but not including the sounds accompanying a motion picture or other audiovisual work." Example: When a record company issues a new release, the release will typically involve two distinct "works": the "musical work" that has been recorded, and the "sound recording" as a separate work in itself. The material objects that the record company sends out are "phonorecords": physical reproductions of both the "musical work" and the "sound recording."

Should You File More Than One Application?
If your work consists of a recorded musical, dramatic, or literary work, and both that "work," and the sound recording as a separate "work," are eligible for registration, the application form you should file depends on the following:

File Only Form SR if: The copyright claimant is the same for both the musical, dramatic, or literary work and for the sound recording, and you are seeking a single registration to cover both of these "works."

File Only Form PA (or Form TX) if: You are seeking to register only the musical, dramatic, or literary work, not the sound recording. Form PA is appropriate for works of the performing arts; Form TX is for nondramatic literary works.

Separate Applications Should Be Filed on Form PA (or Form TX) and on Form SR if: (1) The copyright claimant for the musical, dramatic, or literary work is different from the copyright claimant for the sound recording; or (2) You prefer to have separate registrations for the musical, dramatic, or literary work and for the sound recording.

FORM RE

UNITED STATES COPYRIGHT OFFICE

REGISTRATION NUMBER

EFFECTIVE DATE OF RENEWAL REGISTRATION

...................
(Month) (Day) (Year)

DO NOT WRITE ABOVE THIS LINE. FOR COPYRIGHT OFFICE USE ONLY

① Renewal Claimant(s)

RENEWAL CLAIMANT(S), ADDRESS(ES), AND STATEMENT OF CLAIM: (See Instructions)

1
Name ...
Address ...
Claiming as ...
(Use appropriate statement from instructions)

2
Name ...
Address ...
Claiming as ...
(Use appropriate statement from instructions)

3
Name ...
Address ...
Claiming as ...
(Use appropriate statement from instructions)

② Work Renewed

TITLE OF WORK IN WHICH RENEWAL IS CLAIMED:

RENEWABLE MATTER:

CONTRIBUTION TO PERIODICAL OR COMPOSITE WORK:

Title of periodical or composite work: ...

If a periodical or other serial, give: Vol. No. Issue Date ...

③ Author(s)

AUTHOR(S) OF RENEWABLE MATTER:

④ Facts of Original Registration

ORIGINAL REGISTRATION NUMBER: | **ORIGINAL COPYRIGHT CLAIMANT:**

...

ORIGINAL DATE OF COPYRIGHT:

• If the original registration for this work was made in published form, give:

DATE OF PUBLICATION: ...
(Month) (Day) (Year)

OR

• If the original registration for this work was made in unpublished form, give:

DATE OF REGISTRATION: ...
(Month) (Day) (Year)

RENEWAL FOR GROUP OF WORKS BY SAME AUTHOR: To make a single registration for a group of works by the same individual author published as contributions to periodicals (see instructions), give full information about each contribution. If more space is needed, request continuation sheet (Form RE/CON).

⑤ **Renewal for Group of Works**

1
Title of Contribution: ...
Title of Periodical: Vol. ... No. ... Issue Date
Date of Publication: Registration Number:
(Month) (Day) (Year)

2
Title of Contribution: ...
Title of Periodical: Vol. ... No. ... Issue Date
Date of Publication: Registration Number:
(Month) (Day) (Year)

3
Title of Contribution: ...
Title of Periodical: Vol. ... No. ... Issue Date
Date of Publication: Registration Number:
(Month) (Day) (Year)

4
Title of Contribution: ...
Title of Periodical: Vol. ... No. ... Issue Date
Date of Publication: Registration Number:
(Month) (Day) (Year)

5
Title of Contribution: ...
Title of Periodical: Vol. ... No. ... Issue Date
Date of Publication: Registration Number:
(Month) (Day) (Year)

6
Title of Contribution: ...
Title of Periodical: Vol. ... No. ... Issue Date
Date of Publication: Registration Number:
(Month) (Day) (Year)

7
Title of Contribution: ...
Title of Periodical: Vol. ... No. ... Issue Date
Date of Publication: Registration Number:
(Month) (Day) (Year)

DEPOSIT ACCOUNT: (If the registration fee is to be charged to a Deposit Account established in the Copyright Office, give name and number of Account.)

Name: ..

Account Number: ..

CORRESPONDENCE: (Give name and address to which correspondence about this application should be sent.)

Name: ..
Address: .. (Apt.)
(City) (State) (ZIP)

⑥ **Fee and Correspondence**

CERTIFICATION: I, the undersigned, hereby certify that I am the: (Check one)
☐ renewal claimant ☐ duly authorized agent of: ..
(Name of renewal claimant)

of the work identified in this application, and that the statements made by me in this application are correct to the best of my knowledge.

👉 Handwritten signature: (X) ..

Typed or printed name: ..

Date: ..

⑦ **Certification (Application must be signed)**

..
(Name)
..
(Number, Street and Apartment Number)
..
(City) (State) (ZIP code)

MAIL CERTIFICATE TO

(Certificate will be mailed in window envelope)

⑧ **Address for Return of Certificate**

APPLICATION
FOR
Renewal Registration

HOW TO REGISTER A RENEWAL CLAIM:

- **First:** Study the information on this page and make sure you know the answers to two questions:

 (1) What are the renewal time limits in your case?

 (2) Who can claim the renewal?

- **Second:** Turn this page over and read through the specific instructions for filling out Form RE. Make sure, before starting to complete the form, that the copyright is now eligible for renewal, that you are authorized to file a renewal claim, and that you have all of the information about the copyright you will need.

- **Third:** Complete all applicable spaces on Form RE, following the line-by-line instructions on the back of this page. Use typewriter, or print the information in dark ink.

- **Fourth:** Detach this sheet and send your completed Form RE to: Register of Copyrights, Library of Congress, Washington, D.C. 20559. Unless you have a Deposit Account in the Copyright Office, your application must be accompanied by a check or money order for $6, payable to: *Register of Copyrights*. Do not send copies, phonorecords, or supporting documents with your renewal application.

WHAT IS RENEWAL OF COPYRIGHT? For works originally copyrighted between January 1, 1950 and December 31, 1977, the statute now in effect provides for a first term of copyright protection lasting for 28 years, with the possibility of renewal for a second term of 47 years. If a valid renewal registration is made for a work, its total copyright term is 75 years (a first term of 28 years, plus a renewal term of 47 years). Example: For a work copyrighted in 1960, the first term will expire in 1988, but it renewed at the proper time the copyright will last through the end of 2035.

SOME BASIC POINTS ABOUT RENEWAL:

(1) There are strict time limits and deadlines for renewing a copyright.

(2) Only certain persons who fall into specific categories named in the law can claim renewal.

(3) The new copyright law does away with renewal requirements for works first copyrighted after 1977. However, copyrights that were already in their first copyright term on January 1, 1978 (that is, works originally copyrighted between January 1, 1950 and December 31, 1977) **still have to be renewed** in order to be protected for a second term.

TIME LIMITS FOR RENEWAL REGISTRATION: The new copyright statute provides that, in order to renew a copyright, the renewal application and fee must be received in the Copyright Office "within one year prior to the expiration of the copyright." It also provides that all terms of copyright will run through the end of the year in which they would otherwise expire. Since all copyright terms will expire on December 31st of their last year, all periods for renewal registration will run from December 31st of the 27th year of the copyright, and will end on December 31st of the following year.

To determine the time limits for renewal in your case:

(1) First, find out the date of original copyright for the work. (In the case of works originally registered in unpublished form, the date of copyright is the date of registration; for published works, copyright begins on the date of first publication.)

(2) Then add 28 years to the year the work was originally copyrighted.

Your answer will be the calendar year during which the copyright will be eligible for renewal, and December 31st of that year will be the renewal deadline. Example: a work originally copyrighted on April 19, 1957, will be eligible for renewal between December 31, 1984, and December 31, 1985.

WHO MAY CLAIM RENEWAL: Renewal copyright may be claimed only by those persons specified in the law. Except in the case of four specific types of works, the law gives the right to claim renewal to the individual author of the work, regardless of who owned the copyright during the original term. If the author is dead, the statute gives the right to claim renewal to certain of the author's beneficiaries (widow and children, executors, or next of kin, depending on the circumstances). The present owner (proprietor) of the copyright is entitled to claim renewal only in four specified cases, as explained in more detail on the reverse of this page.

CAUTION: Renewal registration is possible only if an acceptable application and fee are **received** in the Copyright Office during the renewal period and before the renewal deadline. If an acceptable application and fee are not received before the renewal deadline, the work falls into the public domain and the copyright cannot be renewed. The Copyright Office has no discretion to extend the renewal time limits.

INSTRUCTIONS FOR COMPLETING FORM RE

SPACE 1: RENEWAL CLAIM(S)

• *General Instructions:* In order for this application to result in a valid renewal, space 1 must identify one or more of the persons who are entitled to renew the copyright under the statute. Give the full name and address of each claimant, with a statement of the basis of each claim, using the wording given in these instructions.

• *Persons Entitled to Renew:*

A. The following persons may claim renewal in all types of works except those enumerated in Paragraph B, below:

1. The author, if living. State the claim as: *the author.*

2. The widow, widower, and/or children of the author, if the author is not living. State the claim as: *the widow (widower) of the author*
(Name of author)

and/or *the child (children) of the deceased author*
(Name of author)

3. The author's executor(s), if the author left a will and if there is no surviving widow, widower, or child. State the claim as: *the executor(s) of the author*
.
(Name of author)

4. The next of kin of the author, if the author left no will and if there is no surviving widow, widower, or child. State the claim as: *the next of kin of the deceased author* *there being no will.*
(Name of author)

B. In the case of the following four types of works, the proprietor (owner of the copyright at the time of renewal registration) may claim renewal:

1. Posthumous work (a work as to which no copyright assignment or other contract for exploitation has occurred during the author's lifetime). State the claim as: *proprietor of copyright in a posthumous work.*

2. Periodical, cyclopedic, or other composite work. State the claim as: *proprietor of copyright in a composite work.*

3. "Work copyrighted by a corporate body otherwise than as assignee or licensee of the individual author." State the claim as: *proprietor of copyright in a work copyrighted by a corporate body otherwise than as assignee or licensee of the individual author.* (This type of claim is considered appropriate in relatively few cases.)

4. Work copyrighted by an employer for whom such work was made for hire. State the claim as: *proprietor of copyright in a work made for hire.*

SPACE 2: WORK RENEWED

• *General Instructions:* This space is to identify the particular work being renewed. The information given here should agree with that appearing in the certificate of original registration.

• *Title:* Give the full title of the work, together with any subtitles or descriptive wording included with the title in the original registration. In the case of a musical composition, give the specific instrumentation of the work.

• *Renewable Matter:* Copyright in a new version of a previous work (such as an arrangement, translation, dramatization, compilation, or work republished with new matter) covers only the additions, changes, or other new material appearing for the first time in that version. If this work was a new version, state in general the new matter upon which copyright was claimed.

• *Contribution to Periodical, Serial, or other Composite Work:* Separate renewal registration is possible for a work published as a contribution to a periodical, serial, or other composite work, whether the contribution was copyrighted independently or as part of the larger work in which it appeared. Each contribution published in a separate issue ordinarily requires a separate renewal registration. However, the new law provides an alternative, permitting groups of periodical contributions by the same individual author to be combined under a single renewal application and fee in certain cases.

If this renewal application covers a single contribution, give all of the requested information in space 2. If you are seeking to renew a group of contributions, include a reference such as "See space 5" in space 2 and give the requested information about all of the contributions in space 5.

SPACE 3: AUTHOR(S)

• *General Instructions:* The copyright secured in a new version of a work is independent of any copyright protection in material published earlier. The only "authors" of a new version are those who contributed copyrightable matter to it. Thus, for renewal purposes, the person who wrote the original version on which the new work is based cannot be regarded as an "author" of the new version, unless that person also contributed to the new matter.

• *Authors of Renewable Matter:* Give the full names of all authors who contributed copyrightable matter to this particular version of the work.

SPACE 4: FACTS OF ORIGINAL REGISTRATION

• *General Instructions:* Each item in space 4 should agree with the information appearing in the original registration for the work. If the work being renewed is a single contribution to a periodical or composite work that was not separately registered, give information about the particular issue in which the contribution appeared. You may leave this space blank if you are completing space 5.

• *Original Registration Number:* Give the full registration number, which is a series of numerical digits, preceded by one or more letters. The registration

number appears in the upper right hand corner of the certificate of registration.

• *Original Copyright Claimant:* Give the name in which ownership of the copyright was claimed in the original registration.

• *Date of Publication or Registration:* Give only one date. If the original registration gave a publication date, it should be transcribed here; otherwise the registration was for an unpublished work, and the date of registration should be given.

SPACE 5: GROUP RENEWALS

• *General Instructions:* A single renewal registration can be made for a group of works if **all** of the following statutory conditions are met: (1) all of the works were written by the same author, who is named in space 3 and who is or was an individual (not an employer for hire); (2) all of the works were first published as contributions to periodicals (including newspapers) and were copyrighted on their first publication; (3) the renewal claimant or claimants, and the basis of claim or claims, as stated in space 1, is the same for all of the works; (4) the renewal application and fee are "received not more than 28 or less than 27 years after the 31st day of December of the calendar year in which all of the works were first published"; and (5) the renewal application identifies each work separately, including the periodical containing it and the date of first publication.

Time Limits for Group Renewals: To be renewed as a group, all of the contributions must have been first published during the same calendar year. For example, suppose six contributions by the same author were published on April 1, 1960, July 1, 1960, November 1, 1960, February 1, 1961, July 1, 1961, and March 1, 1962. The three 1960 copyrights can be combined and renewed at any time during 1988, and the two 1961 copyrights can be renewed as a group during 1989, but the 1962 copyright must be renewed by itself, in 1990.

Identification of Each Work: Give all of the requested information for each contribution. The registration number should be that for the contribution itself if it was separately registered, and the registration number for the periodical issue if it was not.

SPACES 6, 7 AND 8: FEE, MAILING INSTRUCTIONS, AND CERTIFICATION

• *Deposit Account and Mailing Instructions (Space 6):* If you maintain a Deposit Account in the Copyright Office, identify it in space 6. Otherwise, you will need to send the renewal registration fee of $6 with your form. The space headed "Correspondence" should contain the name and address of the person to be consulted if correspondence about the form becomes necessary

• *Certification (Space 7):* The renewal application is not acceptable unless it bears the handwritten signature of the renewal claimant or the duly authorized agent of the renewal claimant.

• *Address for Return of Certificate (Space 8):* The address box must be completed legibly, since the certificate will be returned in a window envelope.

FORM CA
UNITED STATES COPYRIGHT OFFICE

REGISTRATION NUMBER

TX	TXU	PA	PAU	VA	VAU	SR	SRU	RE

Effective Date of Supplementary Registration

.
MONTH DAY YEAR

DO NOT WRITE ABOVE THIS LINE. FOR COPYRIGHT OFFICE USE ONLY

(A)
Basic Instructions

TITLE OF WORK:

REGISTRATION NUMBER OF BASIC REGISTRATION: | **YEAR OF BASIC REGISTRATION:**

NAME(S) OF AUTHOR(S): | **NAME(S) OF COPYRIGHT CLAIMANT(S):**

(B)
Correction

LOCATION AND NATURE OF INCORRECT INFORMATION IN BASIC REGISTRATION:
Line Number Line Heading or Description .

INCORRECT INFORMATION AS IT APPEARS IN BASIC REGISTRATION:

CORRECTED INFORMATION:

EXPLANATION OF CORRECTION: (Optional)

(C)
Amplification

LOCATION AND NATURE OF INFORMATION IN BASIC REGISTRATION TO BE AMPLIFIED:
Line Number Line Heading or Description .

AMPLIFIED INFORMATION:

EXPLANATION OF AMPLIFIED INFORMATION: (Optional)

CONTINUATION OF: (Check which) ☐ PART B OR ☐ PART C

D
Continuation

DEPOSIT ACCOUNT: If the registration fee is to be charged to a Deposit Account established in the Copyright Office, give name and number of Account:

Name . Account Number

E
Deposit Account and Mailing Instructions

CORRESPONDENCE: Give name and address to which correspondence should be sent:

Name . Apt. No.

Address. .
　　　　　　(Number and Street)　　　　　　　　　(City)　　　　(State)　　　　(ZIP Code)

CERTIFICATION ✱ I, the undersigned, hereby certify that I am the: (Check one)

☐ author ☐ other copyright claimant ☐ owner of exclusive right(s) ☐ authorized agent of: .
　　　　　　　　　　　　　　　　　　　　　　　　　　　　　(Name of author or other copyright claimant, or owner of exclusive right(s))

of the work identified in this application and that the statements made by me in this application are correct to the best of my knowledge.

F
Certification (Application must be signed)

Handwritten signature: (X) .

Typed or printed name. .

Date: .

✱ 17 USC §506(e): FALSE REPRESENTATION — Any person who knowingly makes a false representation of a material fact in the application for copyright registration provided for by section 409, or in any written statement filed in connection with the application, shall be fined not more than $2,500.

. .
　　　　　　　　　(Name)

. .
　　(Number, Street and Apartment Number)

. .
　(City)　　　(State)　　(ZIP code)

MAIL CERTIFICATE TO

(Certificate will be mailed in window envelope)

G
Address for Return of Certificate

USE THIS FORM WHEN:

- An earlier registration has been made in the Copyright Office; and

- Some of the facts given in that registration are incorrect or incomplete; and

- You want to place the correct or complete facts on record.

FORM CA

UNITED STATES COPYRIGHT OFFICE
LIBRARY OF CONGRESS
WASHINGTON, D.C. 20559

Application for
Supplementary Copyright Registration

To Correct or Amplify Information Given in the
Copyright Office Record of an Earlier Registration

What is "Supplementary Copyright Registration"? Supplementary registration is a special type of copyright registration provided for in section 408(d) of the copyright law.

Purpose of Supplementary Registration. As a rule, only one basic copyright registration can be made for the same work. To take care of cases where information in the basic registration turns out to be incorrect or incomplete, the law provides for "the filing of an application for supplementary registration, to correct an error in a copyright registration or to amplify the information given in a registration."

Earlier Registration Necessary. Supplementary registration can be made only if a basic copyright registration for the same work has already been completed.

Who May File. Once basic registration has been made for a work, any author or other copyright claimant, or owner of any exclusive right in the work, who wishes to correct or amplify the information given in the basic registration, may submit Form CA.

Please Note:

- Do not use Form CA to correct errors in statements on the copies or phonorecords of the work in question, or to reflect changes in the content of the work. If the work has been changed substantially, you should consider making an entirely new registration for the revised version to cover the additions or revisions.

- Do not use Form CA as a substitute for renewal registration. For works originally copyrighted between January 1, 1950 and December 31, 1977, registration of a renewal claim within strict time limits is necessary to extend the first 28-year copyright term to the full term of 75 years. This cannot be done by filing Form CA.

- Do not use Form CA as a substitute for recording a transfer of copyright or other document pertaining to rights under a copyright. Recording a document under section 205 of the statute gives all persons constructive notice of the facts stated in the document and may have other important consequences in cases of infringement or conflicting transfers. Supplementary registration does not have that legal effect.

How to Apply for Supplementary Registration:

First: Study the information on this page to make sure that filing an application on Form CA is the best procedure to follow in your case.

Second: Turn this page over and read through the specific instructions for filling out Form CA. Make sure, before starting to complete the form, that you have all of the detailed information about the basic registration you will need.

Third: Complete all applicable spaces on this form, following the line-by-line instructions on the back of this page. Use typewriter, or print the information in dark ink.

Fourth: Detach this sheet and send your completed Form CA to: Register of Copyrights, Library of Congress, Washington, D.C. 20559. Unless you have a Deposit Account in the Copyright Office, your application must be accompanied by a non-refundable filing fee in the form of a check or money order for $10 payable to: *Register of Copyrights.* Do not send copies, phonorecords, or supporting documents with your application, since they cannot be made part of the record of a supplementary registration.

What Happens When a Supplementary Registration is Made? When a supplementary registration is completed, the Copyright Office will assign it a new registration number in the appropriate registration category, and issue a certificate of supplementary registration under that number. The basic registration will not be expunged or cancelled, and the two registrations will both stand in the Copyright Office records. The supplementary registration will have the effect of calling the public's attention to a possible error or omission in the basic registration, and of placing the correct facts or the additional information on official record. Moreover, if the person on whose behalf Form CA is submitted is the same as the person identified as copyright claimant in the basic registration, the Copyright Office will place a note referring to the supplementary registration in its records of the basic registration.

PLEASE READ DETAILED INSTRUCTIONS ON REVERSE

INSTRUCTIONS
For Completing FORM CA (Supplementary Registration)

PART A: BASIC INSTRUCTIONS

• *General Instructions:* The information in this part identifies the basic registration to be corrected or amplified. Each item must agree exactly with the information as it already appears in the basic registration (even if the purpose of filing Form CA is to change one of these items).

• *Title of Work:* Give the title as it appears in the basic registration, including previous or alternative titles if they appear.

• *Registration Number:* This is a series of numerical digits, preceded by one or more letters. The registration number appears in the upper right hand corner of the certificate of registration.

• *Registration Date:* Give the year when the basic registration was completed.

• *Name(s) of Author(s) and Name(s) of Copyright Claimant(s):* Give all of the names as they appear in the basic registration.

PART B: CORRECTION

• *General Instructions:* Complete this part **only** if information in the basic registration was incorrect at the time that basic registration was made. Leave this part blank and complete Part C, instead, if your purpose is to add, update, or clarify information rather than to rectify an actual error.

• *Location and Nature of Incorrect Information:* Give the line number and the heading or description of the space in the basic registration where the error occurs (for example: "Line number 3 . . . Citizenship of author").

• *Incorrect Information as it Appears in Basic Registration:* Transcribe the erroneous statement exactly as it appears in the basic registration.

• *Corrected Information:* Give the statement as it should have appeared.

• *Explanation of Correction (Optional):* If you wish, you may add an explanation of the error or its correction.

PART C: AMPLIFICATION

• *General Instructions:* Complete this part if you want to provide any of the following: (1) additional information that could have been given but was omitted at the time of basic registration; (2) changes in facts, such as changes of title or address of claimant, that have occurred since the basic registration; or (3) explanations clarifying information in the basic registration.

• *Location and Nature of Information to be Amplified:* Give the line number and the heading or description of the space in the basic registration where the information to be amplified appears.

• *Amplified Information:* Give a statement of the added, updated, or explanatory information as clearly and succinctly as possible.

• *Explanation of Amplification (Optional):* If you wish, you may add an explanation of the amplification.

PARTS D, E, F, G: CONTINUATION, FEE, MAILING INSTRUCTIONS AND CERTIFICATION

• *Continuation (Part D):* Use this space if you do not have enough room in Parts B or C.

• *Deposit Account and Mailing Instructions (Part E):* If you maintain a Deposit Account in the Copyright Office, identify it in Part E. Otherwise, you will need to send the non-refundable filing fee of $10 with your form. The space headed "Correspondence" should contain the name and address of the person to be consulted if correspondence about the form becomes necessary.

• *Certification (Part F):* The application is not acceptable unless it bears the handwritten signature of the author, or other copyright claimant, or of the owner of exclusive right(s), or of the duly authorized agent of such author, claimant, or owner.

• *Address for Return of Certificate (Part G):* The address box must be completed legibly, since the certificate will be returned in a window envelope.

ADJUNCT APPLICATION
for
Copyright Registration for a
Group of Contributions to Periodicals

FORM GR/CP

UNITED STATES COPYRIGHT OFFICE

REGISTRATION NUMBER
TX PA VA

EFFECTIVE DATE OF REGISTRATION

.
 (Month) (Day) (Year)

FORM GR/CP RECEIVED

Page _____ of _____ pages

- Use this adjunct form only if your are making a single registration for a group of contributions to periodicals, and you are also filing a basic application on Form TX, Form PA, or Form VA. Follow the instructions, attached.
- Number each line in Part B consecutively. Use additional Forms GR/CP if you need more space.
- Submit this adjunct form with the basic application form. Clip (do not tape or staple) and fold all sheets together before submitting them.

DO NOT WRITE ABOVE THIS LINE. FOR COPYRIGHT OFFICE USE ONLY

(A)

Identification of Application

IDENTIFICATION OF BASIC APPLICATION:
- This application for copyright registration for a group of contributions to periodicals is submitted as an adjunct to an application filed on: (Check which)

☐ Form TX ☐ Form PA ☐ Form VA

IDENTIFICATION OF AUTHOR AND CLAIMANT: (Give the name of the author and the name of the copyright claimant in all of the contributions listed in Part B of this form. The names should be the same as the names given in spaces 2 and 4 of the basic application.)

Name of Author: .

Name of Copyright Claimant: .

(B)

Registration For Group of Contributions

COPYRIGHT REGISTRATION FOR A GROUP OF CONTRIBUTIONS TO PERIODICALS: (To make a single registration for a group of works by the same individual author, all first published as contributions to periodicals within a 12-month period (see instructions), give full information about each contribution. If more space is needed, use additional Forms GR/CP.)

☐ Title of Contribution: .
Title of Periodical: . Vol. No. Issue Date Pages.
Date of First Publication: . Nation of First Publication .
 (Month) (Day) (Year) (Country)

☐ Title of Contribution: .
Title of Periodical: . Vol. No. Issue Date Pages.
Date of First Publication: . Nation of First Publication .
 (Month) (Day) (Year) (Country)

☐ Title of Contribution: .
Title of Periodical: . Vol. No. Issue Date Pages.
Date of First Publication: . Nation of First Publication .
 (Month) (Day) (Year) (Country)

☐ Title of Contribution: .
Title of Periodical: . Vol. No. Issue Date Pages.
Date of First Publication: . Nation of First Publication .
 (Month) (Day) (Year) (Country)

☐ Title of Contribution: .
Title of Periodical: . Vol. No. Issue Date Pages.
Date of First Publication: . Nation of First Publication .
 (Month) (Day) (Year) (Country)

☐ Title of Contribution: .
Title of Periodical: . Vol. No. Issue Date Pages.
Date of First Publication: . Nation of First Publication .
 (Month) (Day) (Year) (Country)

☐ Title of Contribution: .
Title of Periodical: . Vol. No. Issue Date Pages.
Date of First Publication: . Nation of First Publication .
 (Month) (Day) (Year) (Country)

DO NOT WRITE ABOVE THIS LINE. FOR COPYRIGHT OFFICE USE ONLY

☐ Title of Contribution: ..
Title of Periodical: Vol..... No..... Issue Date........ Pages........
Date of First Publication:.................................... Nation of First Publication....................
(Month) (Day) (Year) (Country)

Ⓑ
Continued

☐ Title of Contribution: ..
Title of Periodical: Vol..... No..... Issue Date........ Pages........
Date of First Publication:.................................... Nation of First Publication....................
(Month) (Day) (Year) (Country)

☐ Title of Contribution: ..
Title of Periodical: Vol..... No..... Issue Date........ Pages........
Date of First Publication:.................................... Nation of First Publication....................
(Month) (Day) (Year) (Country)

☐ Title of Contribution: ..
Title of Periodical: Vol..... No..... Issue Date........ Pages........
Date of First Publication:.................................... Nation of First Publication....................
(Month) (Day) (Year) (Country)

☐ Title of Contribution: ..
Title of Periodical: Vol..... No..... Issue Date........ Pages........
Date of First Publication:.................................... Nation of First Publication....................
(Month) (Day) (Year) (Country)

☐ Title of Contribution: ..
Title of Periodical: Vol..... No..... Issue Date........ Pages........
Date of First Publication:.................................... Nation of First Publication....................
(Month) (Day) (Year) (Country)

☐ Title of Contribution: ..
Title of Periodical: Vol..... No..... Issue Date........ Pages........
Date of First Publication:.................................... Nation of First Publication....................
(Month) (Day) (Year) (Country)

☐ Title of Contribution: ..
Title of Periodical: Vol..... No..... Issue Date........ Pages........
Date of First Publication:.................................... Nation of First Publication....................
(Month) (Day) (Year) (Country)

☐ Title of Contribution: ..
Title of Periodical: Vol..... No..... Issue Date........ Pages........
Date of First Publication:.................................... Nation of First Publication....................
(Month) (Day) (Year) (Country)

☐ Title of Contribution: ..
Title of Periodical: Vol..... No..... Issue Date........ Pages........
Date of First Publication:.................................... Nation of First Publication....................
(Month) (Day) (Year) (Country)

☐ Title of Contribution: ..
Title of Periodical: Vol..... No..... Issue Date........ Pages........
Date of First Publication:.................................... Nation of First Publication....................
(Month) (Day) (Year) (Country)

☐ Title of Contribution: ..
Title of Periodical: Vol..... No..... Issue Date........ Pages........
Date of First Publication:.................................... Nation of First Publication....................
(Month) (Day) (Year) (Country)

⭒ U.S. GOVERNMENT PRINTING OFFICE: 1978—261-022/12 Apr. 1978—300,000

THIS FORM:

- Can be used solely as an adjunct to a basic application for copyright registration.
- Is not acceptable unless submitted together with Form TX, Form PA, or Form VA.
- Is acceptable only if the group of works listed on it all qualify for a single copyright registration under 17 U.S.C. § 408 (c)(2).

ADJUNCT APPLICATION
for Copyright Registration for a Group of Contributions to Periodicals

WHEN TO USE FORM GR/CP: Form GR/CP is the appropriate adjunct application form to use when you are submitting a basic application on Form TX, Form PA, or Form VA, for a group of works that qualify for a single registration under section 408(c)(2) of the copyright statute.

WHEN DOES A GROUP OF WORKS QUALIFY FOR A SINGLE REGISTRATION UNDER 17 U.S.C. §408 (c)(2)? The statute provides that a single copyright registration for a group of works can be made if **all** of the following conditions are met:

(1) All of the works are by the same author, who is an individual (not an employer for hire); and

(2) All of the works were first published as contributions to periodicals (including newspapers) within a twelve-month period; and

(3) Each of the contributions as first published bore a separate copyright notice, and the name of the owner of copyright in the work (or an abbreviation or alternative designation of the owner) was the same in each notice; and

(4) One copy of the entire periodical issue or newspaper section in which each contribution was first published must be deposited with the application; and

(5) The application must identify each contribution separately, including the periodical containing it and the date of its first publication.

How to Apply for Group Registration:

First: Study the information on this page to make sure that all of the works you want to register together as a group qualify for a single registration.

Second: Turn this page over and read through the detailed instructions for group registration. Decide which form you should use for the basic registration (Form TX for nondramatic literary works; or Form PA for musical, dramatic, and other works of the performing arts; or Form VA for pictorial and graphic works). Be sure that you have all of the information you need before you start filling out both the basic and the adjunct application forms.

Third: Complete the basic application form, following the detailed instructions accompanying it **and the special instructions on the reverse of this page**.

Fourth: Complete the adjunct application on Form GR/CP and mail it, together with the basic application form and the required copy of each contribution, to: Register of Copyrights. Library of Congress, Washington, D.C. 20559. Unless you have a Deposit Account in the Copyright Office, your application and copies must be accompanied by a check or money order for $10, payable to: *Register of Copyrights.*

PROCEDURE FOR GROUP REGISTRATION

TWO APPLICATION FORMS MUST BE FILED

When you apply for a single registration to cover a group of contributions to periodicals, you must submit two application forms:

(1) A basic application on either Form TX, or Form PA, or Form VA. It must contain all of the information required for copyright registration except the titles and information concerning publication of the contributions.

(2) An adjunct application on Form GR/CP. The purpose of this form is to provide separate identification for each of the contributions and to give information about their first publication, as required by the statute.

WHICH BASIC APPLICATION FORM TO USE

The basic application form you choose to submit should be determined by the nature of the contributions you are registering. As long as they meet the statutory qualifications for group registration (outlined on the reverse of this page), the contributions can be registered together even if they are entirely different in nature, type, or content. However, you must choose which of three forms is generally the most appropriate on which to submit your basic application:

Form TX: for nondramatic literary works consisting primarily of text. Examples are fiction, verse, articles, news stories, features, essays, reviews, editorials, columns, quizzes, puzzles, and advertising copy.

Form PA: for works of the performing arts. Examples are music, drama, choreography, and pantomimes.

Form VA: for works of the visual arts. Examples are photographs, drawings, paintings, prints, art reproductions, cartoons, comic strips, charts, diagrams, maps, pictorial ornamentation, and pictorial or graphic material published as advertising.

If your contributions differ in nature, choose the form most suitable for the majority of them. However, if any of the contributions consists preponderantly of nondramatic text matter in English, you should file Form TX for the entire group. This is because Form TX is the only form containing spaces for information about the manufacture of copies, which the statute requires to be given for certain works.

REGISTRATION FEE FOR GROUP REGISTRATION

The fee for registration of a group of contributions to periodicals is $10, no matter how many contributions are listed on Form GR/CP. Unless you maintain a Deposit Account in the Copyright Office, the registration fee must accompany your application forms and copies. Make your remittance payable to: *Register of Copyrights.*

WHAT COPIES SHOULD BE DEPOSITED FOR GROUP REGISTRATION?

The application forms you file for group registration must be accompanied by one complete copy of each contribution listed in Form GR/CP, exactly as the contribution was first published in a periodical. The deposit must consist of the entire issue of the periodical containing the contribution; or, if the contribution was first published in a newspaper, the deposit should consist of the entire section in which the contribution appeared. Tear sheets or proof copies are not acceptable for deposit.

COPYRIGHT NOTICE REQUIREMENTS

For published works, the law provides that a copyright notice in a specified form "shall be placed" on all publicly distributed copies from which the work can be visually perceived." The required form of the notice generally consists of three elements: (1) the symbol "©", or the word "Copyright", or the abbreviation "Copr."; (2) the year of first publication of the work; and (3) the name of the owner of copyright in the work, or an abbreviation or alternative form of the name. For example: "© 1978 Samuel Craig".

Among the conditions for group registration of contributions to periodicals, the statute establishes two requirements involving the copyright notice:

(1) Each of the contributions as first published must have borne a separate copyright notice; and

(2) "The name of the owner of copyright in the work, or an abbreviation by which the name can be recognized, or a generally known alternative designation of the owner" must have been the same in each notice.

HOW TO FILL OUT THE BASIC APPLICATION FORM WHEN APPLYING FOR GROUP REGISTRATION

In general, the instructions for filling out the basic application (Form TX, Form PA, or Form VA) apply to group registrations. In addition, please observe the following specific instructions:

Space 1 (Title): Do not give information concerning any of the contributions in space 1 of the basic application. Instead, in the block headed "Title of this Work", state: "See Form GR/CP, attached". Leave the other blocks in space 1 blank.

Space 2 (Author): Give the name and other information concerning the author of all of the contributions listed in Form GR/CP. To qualify for group registration, all of the contributions must have been written by the same individual author.

Space 3 (Creation and Publication): In the block calling for the year of creation, give the year of creation of the last of the contributions to be completed. Leave the block calling for the date and nation of first publication blank.

Space 4 (Claimant): Give all of the requested information, which must be the same for all of the contributions listed on Form GR/CP.

Other spaces: Complete all of the applicable spaces, and be sure that the form is signed in the certification space.

HOW TO FILL OUT FORM GR/CP

PART A: IDENTIFICATION OF APPLICATION

• **Identification of Basic Application:** Indicate, by checking one of the boxes, which of the basic application forms (Form TX, or Form PA, or Form VA) you are filing for registration.

• **Identification of Author and Claimant:** Give the name of the individual author exactly as it appears in line 2 of the basic application, and give the name of the copyright claimant exactly as it appears in line 4. These must be the same for all of the contributions listed in Part B of Form GR/CP.

PART B: REGISTRATION FOR GROUP OF CONTRIBUTIONS

• **General Instructions:** Under the statute, a group of contributions to periodicals will qualify for a single registration only if the application "identifies each work separately, including the periodical containing it and its date of first publication." Part B of the Form GR/CP provides lines enough to list 19 separate contributions; if you need more space, use additional Forms GR/CP. If possible, list the contributions in the order of their publication, giving the earliest first. Number each line consecutively.

• **Important:** All of the contributions listed on Form GR/CP must have been published within a single twelve-month period. This does not mean that all of the contributions must have been published during the same calendar year, but it does mean that, to be grouped in a single application, the earliest and latest contributions must not have been published more than twelve months apart. Example: Contributions published on April 1, 1978, July 1, 1978, and March 1, 1979, could be grouped together, but a contribution published on April 15, 1979, could not be registered with them as part of the group.

• **Title of Contribution:** Each contribution must be given a title that is capable of identifying that particular work and of distinguishing it from others. If the contribution as published in the periodical bears a title (or an identifying phrase that could serve as a title), transcribe its wording completely and exactly.

• **Identification of Periodical:** Give the over-all title of the periodical in which the contribution was first published, together with the volume and issue number (if any) and the issue date.

• **Pages:** Give the number of the page of the periodical issue on which the contribution appeared. If the contribution covered more than one page, give the inclusive pages, if possible.

• **First Publication:** The statute defines "publication" as "the distribution of copies or phonorecords of a work to the public by sale or other transfer of ownership, or by rental, lease, or lending"; a work is also "published" if there has been an "offering to distribute copies or phonorecords to a group of persons for purposes of further distribution, public performance, or public display." Give the full date (month, day, and year) when, and the country where, publication of the periodical issue containing the contribution first occurred. If first publication took place simultaneously in the United States and other countries, it is sufficient to state "U.S.A."

NOTE: The advantage of group registration is that it allows any number of works published within a twelve-month period to be registered "on the basis of a single deposit, application, and registration fee." On the other hand, group registration may also have disadvantages under certain circumstances. If infringement of a published work begins before the work has been registered, the copyright owner can still obtain the ordinary remedies for copyright infringement (including injunctions, actual damages and profits, and impounding and disposition of infringing articles). However, in that situation—where the copyright in a published work is infringed before registration is made—the owner cannot obtain special remedies (statutory damages and attorney's fees) unless registration was made within three months after first publication of the work.

INDEX

Self Help Law Books

Available from: Sphinx Publishing, P. O. Box 2005, Clearwater, Florida 34617

Real Estate Law

Landlords' Rights and Duties in Florida 2d Ed., With Forms & Caselaw $15.85 ☐
Explains laws about evictions, security deposits, discrimination, abandoned property, housing codes, bad checks, residential and nonresidential tenancies, self-storage and mobile home parks.

Land Trusts in Florida, With Forms & Caselaw **2nd Ed.** $21.15 ☐
Explains how trusts can avoid probate, keep assets secret, avoid liability and litigation, and more.

How to Draft Real Estate Contracts, With Forms **2nd Ed.** $12.65 ☐
Explains each clause used in real estate contracts and includes 5 different forms to save you money.

How to Draft Real Estate Leases, With Forms **2nd Ed.** $12.65 ☐
Explains each clause used in leases and includes five leases (residential, commercial and mini-storage).

Real Estate Brokers' Rights and Duties in Florida, With Caselaw $15.85 ☐
Explains Florida laws regarding all aspects of real estate brokerage business.

Business Law

How to Start a Business in Florida, With Forms $12.65 ☐
Explains Florida laws about fictitious names, licenses, trademarks, partnerships, unemployment compensation, sales tax, regulatory laws, federal taxes, and more.

How to Win in Small Claims Court in Florida, With Forms **2nd Ed.** $15.85 ☐
Explains how to file, settle, argue, defend your case and includes forms for claims, garnishment, etc.

How to Form a Simple Corporation in Florida, With Forms $15.85 ☐
Explains advantages, disadvantages, types of corporations, start-up procedures, stock laws, etc.

How to Form a Nonprofit Corporation in Florida, With Forms $15.85 ☐
Explains types of nonprofit corps., start-up procedures, charitable solicitation, tax exemptions, etc.

How to Register a United States Trademark, With Forms **2nd Ed.** $15.85 ☐
Explains types of trademarks and step-by-step procedures for registration.

How to Register a United States Copyright, With Forms **2nd Ed.** $15.85 ☐
Explains what can and cannot be copyrighted and step-by-step procedures for registration.

Family Law

How to Make a Florida Will, With Forms $10.55 ☐
Explains joint tenancy, homestead, spouses' rights, guardians, personal representatives, living wills, I/T/F bank accounts, and more, and includes 14 forms.

Social Security Benefits Handbook $10.55 ☐
Explains eligibility, applications, Medicare, Disability, Computations, Reductions, Limits, and more.

How to Raise (or Lower) Your Child Support in Florida, With Forms $15.85 ☐
Explains how to petition the court to modify child support payments, with all forms.

How to File for Divorce in Florida, With Forms $21.15 ☐
Explains Florida laws regarding divorce, property settlements and child custody and support, Includes forms for simplified and uncontested divorces and explains the procedures in simple language.

How to Change Your Name in Florida, With Forms $10.55 ☐
Explains Florida laws regarding names and includes forms for changing name with or without court action.

Now available! Legal forms on computer diskettes.

Name _____

Address _____

City, State _____ Zip _____

We pay shipping!
All prices include Florida Sales Tax.
Out-of State orders deduct 6%

90-2.....